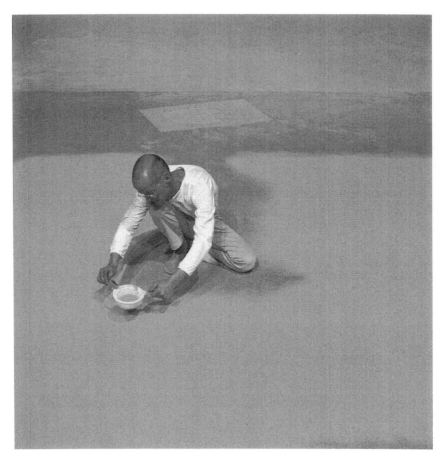

Plate 2

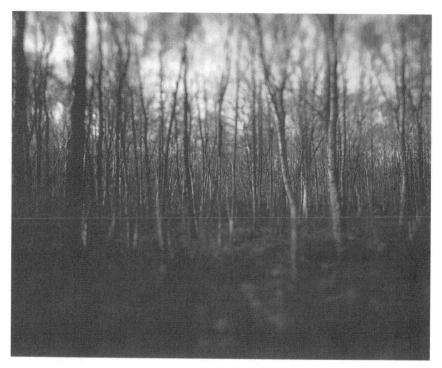

Plate 3

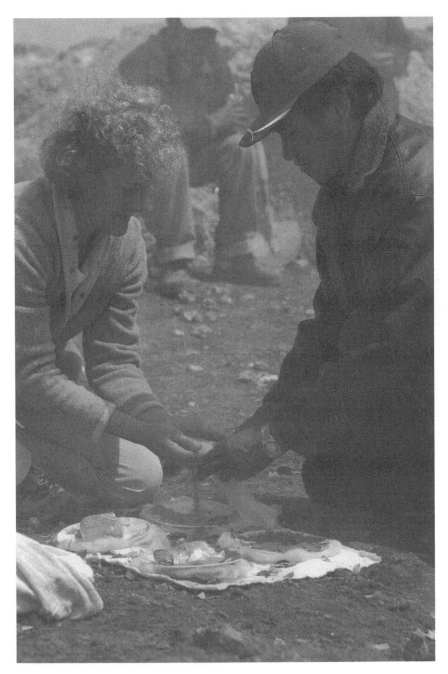

Plate 4

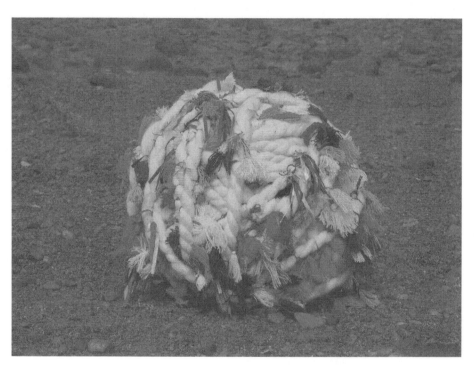

Plate 5

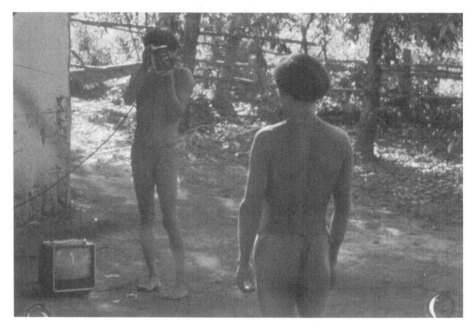

Plate 6

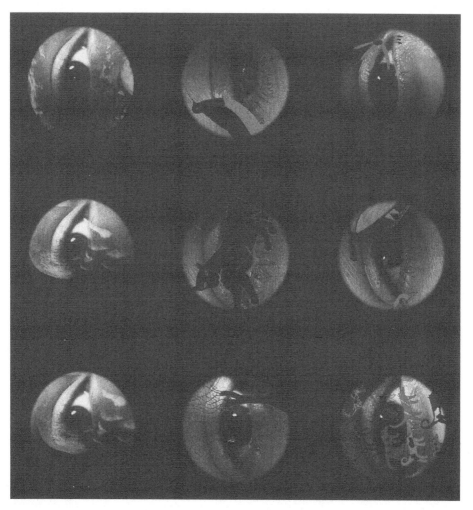

Plate 7

Plate 8

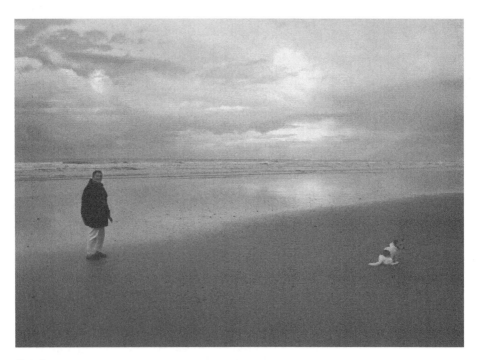

Plate 9

Between Art and Anthropology

Between Art and Anthropology

Contemporary Ethnographic Practice

Edited by
Arnd Schneider and Christopher Wright

B L O O M S B U R Y

LONDON · NEW DELHI · NEW YORK · SYDNEY

Bloomsbury Academic

An imprint of Bloomsbury Publishing Plc

50 Bedford Square
London
WC1B 3DP
UK

1385 Broadway
New York
NY 10018
USA

www.bloomsbury.com

Bloomsbury is a registered trade mark of Bloomsbury Publishing Plc

First published in 2010 by Berg
Reprinted by Bloomsbury Academic 2013, 2014

© Arnd Schneider and Christopher Wright 2010

Arnd Schneider and Christopher Wright have asserted their right under the Copyright,
Designs and Patents Act, 1988, to be identified as Author of this work.

British Library Cataloguing-in-Publication Data
A catalogue record for this book is available from the British Library.

ISBN: HB: 978-1-8478-8501-2
PB: 978-1-8478-8500-5

Library of Congress Cataloging-in-Publication Data
Between art and anthropology: contemporary ethnographic practice/edited by
Arnd Schneider,
Christopher Wright. — English ed. p. cm.
Includes bibliographical references and index.
ISBN 978-1-84788-501-2 – ISBN 978-1-84788-500-5 (pbk.)
1. Art and anthropology. I. Schneider, Arnd, 1960– II. Wright, Christopher.
N72.A56B48 2010
701'.03–dc22
2010021843

Typeset by JS Typesetting Ltd, Porthcawl, Mid Glamorgan
Printed and bound by CPI Group (UK) Ltd, Croydon, CR0 4YY

Contents

Plates

Figures

Notes on Contributors

Mohini Chandra is an artist who lives and works in the Australia-Pacific region. Chandra has exhibited in a number of international exhibitions, including *Paradise Now? Contemporary Art from the Pacific* at the Asia Society and Museum in New York (2004) and as part of the *Eastbound: Hidden Histories* projects at Christ Church Spitalfields in London (2007).

Rebecca Empson is Lecturer in Social Anthropology at University College London. She co-wrote the article 'Fieldworks: A Review' with Haidy Geismar published in *Cambridge Anthropology* Volume 24 (Cambridge University Press 2003) and co-curated the exhibition *Assembling Bodies: Art, Science & Imagination* (March 2009–November 2010) at the University of Cambridge Museum of Archaeology & Anthropology. Her forthcoming monograph, *Harnessing Fortune*, will be published by Oxford University Press in 2010.

Steven Feld is Distinguished Professor of Anthropology and Music at the University of New Mexico and Professor II at the Institute of Music Research, University of Oslo. Trained first as a musician and composer, then later as a filmmaker and anthropologist, he has worked in textual, sound, visual, performance and installation media since 1975 on projects in Papua New Guinea, Europe, and Ghana. (www.voxlox.net)

Anna Grimshaw teaches courses in ethnographic cinema, visual culture, experimental ethnography, and ethnographic filmmaking in the Graduate Institute for the Liberal Arts at Emory University. She is the author of *The Ethnographer's Eye* (Cambridge University Press 2001) and co-author, with Amanda Ravetz, of *Observational Cinema: Anthropology, Film and the Exploration of Social Life* (Indiana University Press 2009).

Tatsuo Inagaki is a visual artist who has exhibited internationally. He is also a professor in the Faculty of Intercultural Communication at Hosei University, Japan.

Lucy R. Lippard is a writer, activist and author of twenty-one books on contemporary art and cultural criticism, most recently *On the Beaten Track: Tourism, Art, and Place* (New Press 2000) and *Down Country: The Tano of the Galisteo Basin, 1250–1782* (Museum of New Mexico Press 2010). In 2007, she curated *Weather Report: Art and Climate Change* (Boulder Museum of Contemporary Art 2007). She

lives in rural Galisteo, New Mexico, and for fourteen years has edited the monthly community newsletter, *El Puente de Galisteo.*

George E. Marcus is Chancellor's Professor of Anthropology at the University of California, Irvine. He was co-editor with James Clifford of *Writing Culture: The Poetics and Politics of Ethnography* (University of California Press 1986), co-author with Michael Fischer of *Anthropology as Culture Critique* (University of Chicago Press 1986) and co-editor with Fred Myers of *The Traffic In Culture: Refiguring Art and Anthropology* (University of California Press 1995). In 2005, he founded a Center for Ethnography at UCI (www.socsci.uci.edu/~ethnog/), including a project to conceive of experiments in the course of fieldwork that benefit from modes of inquiry and research developed in performance, installation and conceptual art, as well as design studio practices.

Susan Ossman is Professor of Anthropology at the University of California, Riverside. She has pursued research on aesthetics, media, politics and migration in North Africa, Europe, the Middle East and North America. Her books include *Three Faces of Beauty: Casablanca, Cairo, Paris* (Duke University Press 2002) and *The Places We Share: Migration, Subjectivity and Global Mobility* (Lexington Books 2007). Her upcoming book explores the lives of serial migrants, people who have lived in several countries. She is also preparing a series of exhibitions of her artwork, including *The Fabric of Fieldwork* organized in collaboration with Wessie Ling at the Brunei Gallery in 2012.

Elspeth Owen has for many years taught at The Open University, and lives and works near Cambridge, England. She delights primarily in working with the sense of touch – as a potter, photographer and performer (www.imaginedcorners.net). She has always been interested in coaxing the academy to take an interest in earthiness and play. Her ceramic work is in public collections worldwide. Over the past ten years she and Anna Grimshaw have been working in the crevices between art and anthropology. Recently, she has gained a new perspective through being a grandmother.

Morgan Perkins is Associate Professor of Anthropology and Art and Director of the Museum Studies Program at the State University of New York–Potsdam. He is the editor (with Howard Morphy) of *The Anthropology of Art* (Blackwell 2006) and has curated several exhibitions of contemporary art. Much of his current research explores the relationship between contemporary art and art education with a particular focus upon Native North American and Chinese art.

Amanda Ravetz is Research Fellow at the Manchester Institute for Research and Innovation in Art and Design (MIRIAD), Manchester Metropolitan University. She trained as a painter at the Central School of Art and Design and later completed a doctorate in Social Anthropology with Visual Media at the University of Manchester, where she also lectured. With Anna Grimshaw, she is the author of *Observational Cinema: Anthropology, Film, and the Exploration of Social Life* (Indiana University Press 2009).

Rosanna Raymond is an artist, curator and writer. Born in New Zealand, Raymond is of Samoan-Palagi descent and currently lives and works in London. She was a founding member of the acclaimed art collective Pacific Sisters. A published writer, with art works held in museum and private collections around the world, Raymond has forged a role for herself over the past fifteen years as a producer and commentator on contemporary Pacific Island culture, both in Aotearoa/New Zealand, the UK and the US, working within museums and higher education institutions as an artist, performer, curator, guest speaker and workshop leader.

Virginia Ryan is an Australian-born visual artist who trained at the Canberra School of Art, Australia and the Edinburgh School of Art Therapy, Scotland. She presently lives and works between Italy and West Africa. Since 1981, she has also lived and worked – often in collaboration with artists and musicians – in Egypt, Brazil, Scotland and the former Yugoslavia. She is co-founder of the Foundation of Contemporary Art, Ghana (www.fcaghana.org). Her work continues to focus on land, memory and identity. She has exhibited internationally since 1980. Her website is www.virginiaryan.com.

Amiria Salmond is a Research Fellow in the Department of Social Anthropology at the University of Auckland. Formerly a curator at the University of Cambridge Museum of Archaeology and Anthropology, she has written on the history and contemporary importance of artefact-oriented ethography. Her research interests include visual and practice-based methodologies, indigenous anthropology and the dynamics of cultural change. She is the author of *Museums, Anthropology and Imperial Exchange* (Cambridge University Press 2005) and co-edited *Thinking Through Things: Theorising Artefacts Ethnographically* with Martin Holbraad and Sari Wastell (Routledge 2007). She co-curated the exhibition *Pasifika Styles* with Rosanna Raymond.

Arnd Schneider (editor) is Professor of Social Anthropology at the Institute of Social Anthropology, University of Oslo. Arnd Schneider writes on contemporary art and anthropology, migration and ethnographic film. His main publications include *Futures Lost: Identity and Nostalgia among Italian Immigrants in Argentina* (Peter Lang 2000), *Mafia for Beginners* (Ikon Books 1994), *Appropriation as Practice: Art and Identity in Argentina* (Palgrave 2006) and, with Carmen Bernand and Mónica Quijada, *Homogeneidad y Nación* (CSIC Madrid 2004). He was a co-organizer of the conference *Fieldworks: Dialogues between Art and Anthropology* (Tate Modern 2003) and edited, with Christopher Wright, *Contemporary Art and Anthropology* (Berg 2006).

Victoria Walters is a Research Associate in the Faculty of Creative Arts, University of the West of England, Bristol, working between visual culture, ethnography and art practice. She holds a doctorate from the University of Ulster in Visual Culture and her thesis focused on Joseph Beuys' sculptural practice as an expanded language and healing discourse that engages with the Celtic world. Victoria's publications include *Beuysian Legacies in Ireland and Beyond: Art, Culture and Politics*, co-edited with

Dr Christa-Maria Lerm Hayes (Lit Verlag, forthcoming), and a chapter on "Joseph Beuys and the Performance of Celtic Identity" in *21st Century Celts* (University of Wales Press, forthcoming).

Christopher Wright (editor) is a lecturer in the Anthropology Department at Goldsmiths, University of London. He teaches on the MA Visual Anthropology course and is currently carrying out research on First Nation video artists in British Columbia, Canada. He continues to collaborate with UK-based artists, most recently with photographer Dave Lewis, and has previously carried out research on photography and material culture in the Solomon Islands. He was a co-organizer of the conference *Fieldworks: Dialogues between Art and Anthropology* (Tate Modern 2003), and edited, with Arnd Schneider, *Contemporary Art and Anthropology* (Berg 2006).

John Wynne teaches at the University of the Arts, London and has a PhD from Goldsmiths, University of London. He is a sound artist whose practice includes installations and award-winning radio pieces which hover on the boundary between documentation and abstraction, large scale architectural sound drawings and vast multi-channel sculptural installations using recycled hi-fi speakers. His work with endangered languages includes a project with click languages in the Kalahari and another with one of Canada's indigenous languages, Gitxsanimaax. His work with heart and lung transplant patients, with photographer Tim Wainwright, led to a book *Transplant* (Royal Brompton and Harefield Arts 2008), an installation and a half-hour commission for BBC Radio. His 2009 installation for 300 speakers, player piano and vacuum cleaner became the first work of sound art in the Saatchi collection.

Acknowledgements

We would like to thank all our contributors for their stimulating responses to the themes of this volume, and also for their trust and patience whilst working with us. We would also like to thank the anonymous reviewers for their helpful and constructive suggestions. Particular thanks go to Tristan Palmer and Anna Wright, our editors at Berg, for seeing this book through to final publication.

We are extremely grateful to all the institutions and individuals who have helped us with our research and made visual and written materials available to us, often waiving or reducing fees for copyright permission. In particular, António Ole whose incredible artwork *Township Wall* is featured on the cover, and Nadine Siegert (Iwalewa House, University of Bayreuth) who facilitated contact with António.

We are especially grateful to the Institute of Social Anthropology, University of Oslo, for a generous grant towards the publication of the colour plate section in the book.

We would also like to thank colleagues, hosts and audiences at the following institutions and venues to whom we have presented our ideas over the years: Goldsmiths, London (Roger Sansi-Roca, Mao Mollona and Steve Nugent), Museum of Cultural History/Ethnographic Section, University of Oslo (Øyvind Fuglerud and Arne Perminow), University College London (Christopher Pinney, Susanne Kuechler and Graeme Were), the Nobel Peace Center, Olso (*Art Beyond Reason* conference and Thomas Hylland Eriksen), the Norwegian University of Science and Technology, Trondheim (Ruth Woods), Academy of Fine Arts, Munich (Susanne Witzgall), University of Manchester (Rupert Cox and Andrew Irving), CNRS (Caterina Pasqualino) and Musée du Quai Branly, Paris (Anne-Christine Taylor), Ethnography Department/Niedersächsisches Landesmuseum, Hanover (Anna Schmid), Museo Provincial de Bellas Artes and Subsecretaría de Cultura, Corrientes, Argentina (Gabriel Romero, Carlos Lezcano and Fernanda Tocalino), the State University of New York at New Paltz (Rimer Cardillo), Universidad del Cine, Buenos Aires (Julio Sánchez), the Tate Modern Education Department (Andrew Brighton and Dominic Willsdon), University of Aberdeen (Tim Ingold), University of Bayreuth (Kurt Beck and Tobias Wendl), University of Bologna (Eugenia Scarzanella), University of Frankfurt/Main (Hans-Peter Hahn, Holger Jebens and Karl-Heinz Kohl), University of Mayence (Matthias Krings), University of Turin (Leslie Hernández and Luisa Passerini), panel convenors at the ASA conference, Auckland (Patrick Laviolette and Wendy Cowling), SIEF conference, Derry (Victoria Walters), and the AAA, Philadelphia (Jay Ruby).

A NOTE ON ILLUSTRATIONS AND COPYRIGHTED MATERIAL

Every reasonable effort has been made to trace and acknowledge the ownership of copyrighted material (including illustrations) included in this book. Any errors that may have occurred are inadvertent and will be corrected in subsequent editions, provided notification is sent to the editors.

Between Art and Anthropology
Arnd Schneider and Christopher Wright

This book is a new exploration of the border zones between art and anthropology practices in recent decades. It is concerned with the movements in between these fields and with the possible locations of these practices. It argues that primary divisions between the fields, from either of the two disciplines, often mask an ensemble of heterogeneous discourses that in fact have much common ground. We conceive of these encounters as a series of processes, or movements in flux and offer here some admittedly momentary snapshots of some of these instances of arrested movement. A simple analogy is the flow of two liquid coloured paints that are mixed on a surface, where not only do new colours evolve but skeins and threads of both colours are interwoven and intermingled, and yet in places remain completely separate. Despite the two colours maintaining their original identities in places, together they achieve new colours and forms. To think concretely of paintings and the many examples and possibilities where colours are not 'mixed' to achieve a new colour, but are overlaid, encrusted, veiled and sculpted, also suggests how their materiality and relief qualities are fore-grounded, rather than their values as colours. At the same time, such joined separateness also leads to a new perception of the colours themselves; one that could not have been achieved without the encounter of 'mixing' with the other.

It is this 'interactive power' of distinct colours when seen together that is also apparent in António Ole's *Township Wall* (2004),[1] the work that we chose as the cover image for this book. For us it demonstrates how, out of clearly defined yet proximate colours, materials, and conceptual differences (here, for example, doors, windows, wall panels, tools, signs and other fragments) a new composite structure can evolve. *Township Wall* also resonates with other tropes that reveal the traffic between art and anthropology, such as appropriation (of others through text and visual media), as well as materiality and texture (the sensory capacities of material expression). Importantly, António Ole's work is a clear statement about overcoming 'chromophobia', which, coupled with 'iconophobia', is not only a charge levelled against anthropology for its history of problems dealing with images, but also against the contemporary artworld, and its sometimes ambivalent relation to colour. As much as anthropology and knowledge production in the social sciences more generally have felt threatened by images (as well as colour and other forms of sensory experience), so, too, the contemporary artworld has arguably anaesthetized some of the 'affects' of colour perceptions within the restricted spaces of artificially white cubes (read: galleries).[2] David Batchelor's critique of a certain Western (sic!) fear of colour suggests that it is in part based on precisely the kinds of 'affects' colour can have:

chromophobia manifests itself in the many and varied attempts to purge colour from culture, to devalue colour, to diminish its significance, to deny its complexity ... this purging of colour is usually accomplished in one of two ways. In the first colour is made out to be the property of some 'foreign' body – usually the feminine, the oriental, the primitive, the infantile, the vulgar, the queer or the pathological. In the second, colour is relegated to the realm of the superficial, the supplementary, the inessential or the cosmetic ... Colour is dangerous, or it is trivial, or it is both.[3]

Hence, for some, the attempted containment of colour in artificially white cubes is as revealing of this power ascribed to colour as is the lack of it in other realms of cultural experience.

The kinds of insistence on colour that are a feature of Ole's work are a rejoinder to anthropology to pay attention to colour and affect in its approaches towards images and the field of the visual – an area that it has in some respects found problematic for a long time. Certain currents within anthropology have also continued to take refuge in an equivalent 'iconophobia', as Lucian Taylor points out in his important article with the same title.[4] In relation to non-fiction film, this kind of anti-aestheticism was first voiced in the 1930s and 1940s in Europe by documentary film makers like the brilliant Joris Ivens in relation to his films of the Borinage in northern France. He felt that the visually stark black-and-white images he initially made of miners living and working in terrible conditions were simply too beautiful (for example, *Misery in the Borinage,* 1933). Whereas Ivens had previously extolled at length the virtues of film's ability to approach senses of place and both record and evoke a kind of 'sensory memory' (importantly, all areas that, in relation to film, remain little explored within anthropology), in this case he thought the beauty of the images would distract from the message to which he wanted to alert the world.[5] As Ivens puts it, 'Our aim was to prevent agreeable photographic effects distracting the audience from the unpleasant truths we were showing.'[6] This has been a recurring feature of much anthropological criticism of the use of images in presenting anthropological research since then.[7] As Taylor points out, within much anthropology, 'Visuality itself becomes merely ancillary, illustrative rather than constitutive of anthropological knowledge.'[8] This is a key point and the subject of ongoing struggle within the discipline.

That anthropology still retains a residue of this iconophobia is hardly news to those within the discipline, but it is precisely in the area between art and anthropology that some extraordinary new work is being produced – a range of which we address in this book. What is of concern to us here is that the particular kinds of phobia involved are continually being prodded, challenged and re-negotiated by work that effectively occurs in this in-between area that we are interested in exploring and encouraging. As Taylor goes on to say of the various examples of anthropological iconophobia that he documents, 'the most striking quality of these examples is the extraordinary anxiety the academic authors evince towards images, especially film images. The filmic detachment of words and things (if indeed this is what films do) is characterized in a quasi-religious idiom as sinful.'[9] For Taylor, this anthropological iconophobia is the recapitulation of a body of 1960s work by French film theorists that argues that the 'hypertrophy' of cinema regresses viewers to an infantile stage –

'Stuck in their seats, in a dark antisocial cinema, spectators cannot help but renounce all voluntary control, regress into an infantile, dreamlike state, and give themselves up to the spectacle unfolding before their eyes on the two-dimensional screen.'[10] This kind of negative critique of cinema's supposedly captivating or enthralling powers, however, was not only voiced by film critics, but also by practitioners of experimental, materialist, and structuralist film – who wanted instead to make the viewer aware of the artifice of the filmic apparatus. Of course, within visual practice and within anthropology, there is always the potential to explore the sensual possibilities of the chosen medium in relation to the affects on audiences while also being critically aware of the artificial construction of representations. The blanket condemnation of formally experimental visual and audio work within much anthropology has resulted in a strangely rarefied situation in terms of the amounts of visual material produced within anthropology – outside of certain kinds of non-fiction film making there is little in the way of exploration of new possibilities.

What does this mean for our concerns in this book? Of course, the formal qualities of a work are not detachable from the work as a whole, and anthropologists' desire to embrace a kind of anti-aestheticism or ignore the affects of images has resulted in a climate where experimentation in formal and other terms is too often denigrated. Anthropologists have for too long been overly dismissive of formal experimentation not only in terms of expanding the range of methodologies and forms of presentation involved in exhibiting anthropological work, but also in the sense of 'policing' the kinds of work produced by research students. The latter are often involved in producing a whole range of material outcomes during fieldwork, but many of these seldom make it through to the actual PhD. The current publishing climate and research assessment procedures (certainly, in the US and the UK, as well as in other countries that are keen to imitate Anglo-Saxon 'audit cultures') are all limiting factors in terms of promoting experimentation. But, these factors aside, there is a general and often relatively 'silent' – perhaps all the more pervasive for being so silent – kind of entrenched conservatism when it comes to the kinds of new work we are directly advocating here. The tension between maintaining the standards of the discipline and developing new forms of anthropological knowledge has for too long been overly weighted in favour of the former. Perhaps there is a concern that the relation of experimental work to ethical concerns is more fraught than is the case for work that fulfils already well-established parameters for anthropological writing. Certainly, initiatives, such as the development of audio visual and arts-practice based PhDs in the UK, are at least a sign that academia is starting to respond to the need to expand the kinds of endeavours and outcomes that count as 'research' in academic work. Our concern is to encourage the kinds of experimentation that would result in new and dynamic directions for both contemporary art practices that revolve around various kinds of documentation, and to enlarge the range of work being produced within anthropology and within visual anthropology in particular.

Clearly, an issue at stake with Ole's and other artists' practice is not just their value in informing critiques of anthropology's iconophobia but the ways in which the work speaks to debates around contemporary art practices that involve cross-cultural traffic of various kinds. The transnational proliferation of 'white cubes' – seen

by some[11] as a positive sign that artists, such as Ole from Angola, can compete as 'international artists' in their own right – but the question is on whose terms is this visibility made possible? The increasing production of work for the 'biennale circuit' has led some critics to denounce the increasing internationalization of contemporary art as a reduction of productive differences that is responsible for homogenizing art in certain ways. Clearly, for Enwezor and Oguibe, the aim is to move beyond the art critic Thomas McEvilley's 'incarcerating' 'neo-colonial' questions to the artist Ouattara – 'where were you born?' – as if that were the primary definition of relevance to his work, and take account of their assertion that work by contemporary African artists is 'integral to a highly dispersed international language'.[12] Of course, the desirability of this 'international language' is subject to much debate – and the debates are similar to those put forward by James Weiner in relation to the reduction of difference brought about by the rise of indigenous media projects.[13] What is of direct relevance is the ability of artists like Ole to appropriate materials from a wide range of sources, and the way in which this is part of the discourses of power and containment that are still bound up with approaches to contemporary African art.

INTER-SPACES

Although the volume of work being produced by individuals working in this border zone between the fields of art and anthropology is increasing, a number of recent writings and conference initiatives have shown how tenuous and fragile any formal dialogues can remain, despite much common ground. The three-day conference 'Fieldworks: Dialogues between Art and Anthropology', which we organized at Tate Modern in 2003, was a key event in this ongoing debate, and a number of the chapters in this volume were based on earlier versions of presentations at that conference.[14] The contributions that we have invited for this book address those inter-spaces between art and anthropology with a view to plotting some of the recent interactions and appropriations that have moved between the two fields, as well as hopefully suggesting jumping off points for further work – both practical and academic. Lucy Lippard writes about artists who work directly with communities and thus directly reflect issues around the kinds of 'relations'[15] involved in such embedded projects, and socially engaged 'conversation' art,[16] which are significant for future art anthropology dialogues. George Marcus reflects more generally on the notion of fieldwork, and how performative aspects of anthropology and theatre art can meet in experimental ways. Tatsuo Inagaki delivers a succinct example of an artist who has appropriated the anthropological idea of fieldwork in different locales, whilst anthropologist Susan Ossman explores her own painting practices as a new way of producing ethnographic knowledge. Victoria Walters shows how experimental encroachments into anthropological terrain by one of the great icons of twentieth-century art, Joseph Beuys, can be usefully compared to the neo-shamanic artworks of contemporary artist Marcus Coates. Amanda Ravetz, Anna Grimshaw and Elspeth Owen's contribution is a prime example of precisely what is at stake in collaborations between artists and anthropologists, and how differences can be useful as starting points for new practices. Collaborations also figure as the main trope in Steve Feld and Virginia Ryan's piece,

highlighting the different sense qualities that an anthropologist/musician/sound artist (Feld) and a visual artist (Ryan) can bring to such a project. Similarly, Amiria Salmond and Rosanna Raymond work out a complementary relationship where cultural and methodological difference evolves into new productive work. Christopher Wright asks about the different meanings of 'context' for artists and anthropologists, by looking at a film by the artist and 'backyard anthropologist' Cameron Jamie. John Wynne addresses ethics as a major concern for contemporary art-anthropology encounters. Both Rebecca Empson and Mohini Chandra, in their contribution, and Morgan Perkins writing about Chinese and Haudenosaunee (Iroquois) artists, highlight the arenas of identity politics, post-coloniality, and exhibition making.

One of our concerns here is with an anthropological practice *with* artists (rather than one that remains *of* artists) and, conversely, an art practice *with* anthropologists. For us this would lead to exciting new possibilities for work that pushes both fields in new directions, while at the same time acknowledging differences, and in fact at times using those differences as productive irritants (as clearly shown in the Grimshaw/Owen/Ravetz chapter in this volume). 'Difference' here means not only distinct practical approaches that can remain largely separate despite new hybrid contact zones, and despite the overlap in terms of attempts to document aspects of culture, but also more fundamental differences concerning approaches to cognition and ethics. Although such divisions can seemingly keep the two endeavours apart at points, these differences can also be turned into productive building blocks for new approaches to research and representation within both fields.

One such area (but not the only one) that can make difference productive concerns ethics. Taking their inspiration from philosopher Emmanuel Levinas, Benson and O'Neill[17] have argued that in many anthropological fieldwork encounters there remain fundamental differences between anthropologists and research subjects. These differences in terms of power, economics and politics, educational training, and self-ascribed identities cannot presuppose the existence of a relationship as mere 'equals' but must take difference into account *ab initio*. Difference, in other words, is always there, and has to be taken into account and used in order to make the encounter productive.

Similarly, in the encounter between the disciplines of art and anthropology, difference can be used as a productive resource. What are the conceptual interstices and fault lines between art and anthropology practices? How can art practices and theory connect usefully with recent theoretical concerns in anthropology? The range of connections is wide and might include approaches to art and material object related issues, agency and 'relational aesthetics', different ontological levels of cognition (as in different notions of ' perspectivism', 'animism', and 'naturalism', for example, in the recent work of Eduardo Viveiros de Castro, Philippe Descola, and Tim Ingold), theorizing around power, religion, globalization and new political movements.[18]

SENSES

One particular range of practice and theory that cuts across both art and anthropology concerns a recent emphasis on the senses within anthropology. In terms of

writing, and partly inspired by phenomenological approaches, this has resulted in a growing literature on the 'anthropology of the senses'. With few exceptions, however, these have remained studies of the role of senses in various cultural settings and have sadly not been read for their implications for anthropological methodologies and strategies of representation and exhibition. Some have argued for greater sensibility during fieldwork and also in later writing, much as the 'Writing Culture' critique was concerned largely with textual representation. One notable recent exception is the work of Steve Feld, who since his landmark ethnography *Sound and Sentiment,*[19] has been one of the foremost examples of combining sound research with sound practice within anthropology, and where his training and continuing practice as a jazz musician seamlessly inform his anthropological work, and vice versa. More recently, Feld has taken up the challenge of another sense medium, in collaborating with visual artist Virginia Ryan to produce *Castaways* (2008), a multi-media project combining approaches from anthropology, visual and sound art practices (see their chapter in this book).

The 'Doors of Perception' (to paraphrase Aldous Huxley) for art-anthropology collaborations have perhaps only just been pushed open and many future scenarios can be conceived. Just think of the possibility of working with smell (rather than on smell). This field has been prominently explored by Sissel Tolaas who, trained both in chemistry and visual arts, works with the sensory potential of smell, in both research and artistic representation, as well as for commercial applications with the international company International Flavors & Fragrances Inc. Smell is arguably the sense most resistant to direct (i.e. not second order, derived) research by social scientists, anthropologists included; yet Tolaas proposes new avenues here, crossing the senses of vision and smell. For instance, in her project *The Smell of Fear* (2006)[20] she distilled the sweat emanated by fifteen adult men in a moment of fear and incorporated these distillations into a gloss, white emulsion with which she painted the walls of a contemporary art gallery (see Plate 1). In the exhibition, what one might call olfactory 'spectators' then move, somewhat puzzled and repulsed, along the empty walls of the 'white cube' space, only to find that the apperceptive object to be beheld is not one of visual pleasures but one of malodorous smell. Yet the white walls of the gallery also deny any visual representation of the original agents of these smells, leaving the visitors alone to this one sense and perhaps a fictive construction of the male characters behind it.

Tolaas has taken her method into many other arenas, for instance, by sampling the odours on the streets of major world cities, such as London, Paris and Berlin and distilling an array of perfumes (or fragrances) out of them, providing a rich olfactory mapping. In one of her latest projects, she has begun to work with linguists to investigate the connotations and registers of smell in different languages. As a thought experiment, it would be fascinating to contemplate such olfactory representation for anthropological research. Rather than provide yet another visual representation (as text, film or photographic image), the visitor to such a smell exhibition would get an entirely different sense (sic!) of the anthropological experience in the field, as well as the smell universe of the research subjects.

The full epistemological implications of such new research and exhibition practices remain to be explored, and there are, of course, other artists who have worked

with smell, and other sensory perceptions, one of them being Wolfgang Laib, who has used flower pollen and bees' wax in large-scale installations (see Plate 2).

When read together, two recent articles by the anthropologist Tim Ingold[21] suggest a range of possibilities for work between art and anthropology. Ingold is concerned with how to understand and represent our experience of the weather as opposed to the supposed material sub-strata of the landscape:

> far from facing each other on either side of an impenetrable division between the real and the immaterial, earth and sky are inextricably linked within one indivisible field. Painters know this. They know that to paint what is conventionally called a 'landscape' is to paint both earth and sky, and that earth and sky blend in the perception of a world in continuous formation ... the visual perception of this earth-sky, unlike that of objects in the landscape, is in the first place an experience of light. I believe we can learn from them.[22]

It is this animism in terms of representing experience that suggests many potentials for fertile exploration of the ground between art and anthropology and, as Ingold goes on to develop in 'Rethinking the Animate', where he talks of a reconciliation between animism and science:

> all science depends on observation, and all observation depends on participation ... a close coupling in perception and action between the observer and those aspects of the world that are the focus of attention. If science is to be a coherent knowledge practice, it must be rebuilt on the foundation of openness rather than closure, engagement rather than detachment ... Knowing must be reconnected with being, epistemology with ontology, thought with life.[23]

Together these articles suggest a truly innovative and challenging new direction for visual anthropology and contemporary art, and the work of the artist Cristina Saez (see Plate 3) is one example of thinking through some of Ingold's concerns. Saez was directly influenced by Ingold's writing on perception of the environment and was concerned with exploring what it would mean to put some of it into practice. In her large photographic prints of forests she uses selective blurring, which has the effect of unsettling the viewer in the sense that in replicating more closely what the eye actually experiences in those spaces – a small section of the forest in focus and the rest above and below, out of focus – it throws us back on ourselves and means we alternate between seeing the print as a flat two-dimensional image and inhabiting – dwelling-in – the image in a way that is not usual; she effectively represents Ingold's earth-sky world.

Another key area of convergence between art and anthropology has centred around two key figures in each field – Nicolas Bourriaud in contemporary art/art history and Alfred Gell in anthropology. Read together, their two widely known books – *Relational Aesthetics*[24] and *Art and Agency*[25] respectively – chart similar territory and, especially in relation to the art historian Hans Belting's call for an 'anthropology of the image'[26] they are useful counterpoints to each other. The posthumously published *Art and Agency* is Gell's attempt at a systematic consideration of art objects

and the kinds of things that happen around art, as agents capable of creating affects, whereas Bourriaud is exploring the widespread concern for artworks that work on or through social relations – either altering them in some way of using them directly as the artist's 'material'.

RELATIONAL ART PRACTICE: THE WORK OF TERESA PEREDA

Recoleción/Restitución (*Recollection/Restitution*), a recent work by Argentine artist Teresa Pereda, shows how sensuous qualities of materials can be used for relational practices of appropriation. In *Recolección/Restitución*, Pereda goes beyond the mere *post facto* 'return' acknowledgements and appreciation of collaboration characteristic of her previous projects involving fieldwork.[27] Here, she brings earth samples in advance from other parts of Argentina to the new field sites to give to people, an anticipated and dislocated return, linking in a web, or meshwork, different people across different parts of Latin America. As the artist explains:

> In every journey I carry out a number of specific actions. I inform myself with the concept of process and directly lived experience, I solicit and I give earth samples and I convert myself in a nexus between regions, between the descendants of immigrants and the sons of the earth, between the old and the new continent, between zones of anonymity.[28]

Giant woollen clews (with wool brought by Pereda from Patagonia) become both the social medium and symbol for her engagement with people, as well as an element of restitution, in that the wool is donated and left to the community after the performance. In the 2008 performance *Flores para un desierto* (*Flowers for a Desert*), with the help of local people, she braids the thick wool threads into plaits, which can be rolled up and unrolled as large clews. The underlying idea is not simply to give the woollen clews in return for earth samples (much of Teresa Pereda's earlier work has been in this direction), and to collect stories, but also let the wool intervene and be appropriated in a relational manner in local life and the relations between artist-ethnographer and the people she is working with. The clew is then adorned with the colourful ribbons (Plate 4), which are used to mark llamas on 20 January in, what in Spanish is called the *floreo* (flowering) and in Aymara *wayñu*, and sometimes metaphorically referred to as a 'wedding' between animals to increase their fertility and number of future offspring.[29] The ceremony begins at 10.00 a.m. and first offerings (*ofrendas*) to the Pachamama are made (Plate 5). Pereda is invited by Erasmo and Eduardo Quispe (who are leading the ceremony), to participate, integrating the clew and the earth samples she brought from other parts of Argentina, as well as the shovel and the bag with which she will take earth samples from here. A white male llama is also sacrificed (Figure 1.1). Not only is the clew used to relate to the local people, and it is given to them as a gift, but it also has a transformative aspect in that it incorporates the work of appropriation, interferes in the cultural and natural landscapes, and connects both the artists, the people and their stories and materials, such as

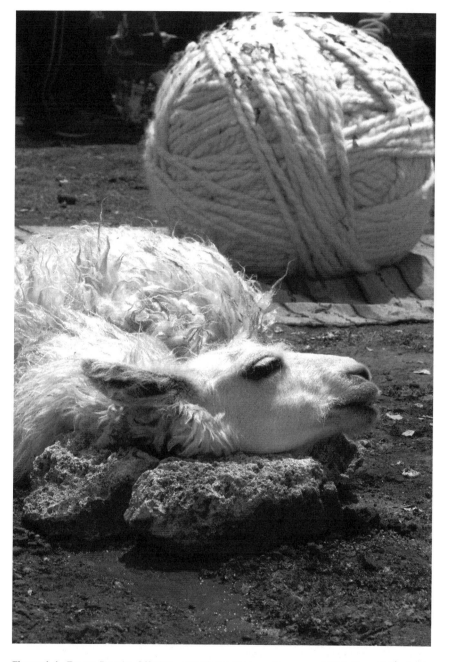

Figure 1.1. Teresa Pereda, *Offering – sacrifice* II photo-performance, 2008. From *Collecting in the Salt Pan: An appointment in Jaruma* series (2008) Salar de Uyuni, Bolivia, as part of the project *Gathering/Restitution: Appointments around America* (*Recolección/Restitución: Citas por América*). Courtesy of the artist.

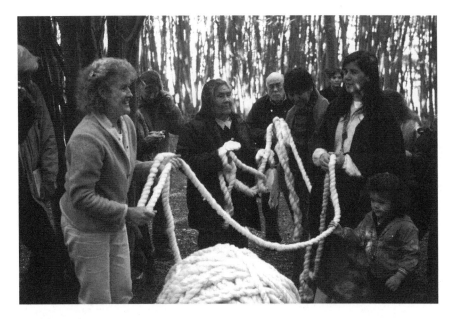

Figure 1.2. Teresa Pereda, *Weaving,* photo-performance, 2007. *Collecting in the Forest: An appointment in Yatana* series (2007) Bienal del Fin del Mundo, Tierra del Fuego, Argentina, as part of the project *Gathering/Restitution: Appointments around America (Recolección/Restitución: Citas por América).* Courtesy of the artist.

earth and wool. It is at once medium to and symbol of an exchange relationship and a more widely spun web of social and cultural relations. This idea of the web of social relations, as a textile or fabric, is also well captured in Pereda's performance 'Tejido' in Tierra del Fuego, the woollen clew is rolled through the forest and participants are invited to make a fabric or meshwork out of it, linking people and trees (Figure 1.2).[30] Such work then, while not directly referencing it, can be strongly linked to ideas of relational practice (Bourriaud), connected lines as meshwork (Ingold), and appropriation (Schneider).

In fact, we might also think of anthropological fieldwork, by comparison, as a kind of massively extended performance where a web of temporary social relations is spun between anthropologists and research subjects.

EXPERIMENTS WITH FIELDWORK

Experimentation is a key issue that runs throughout much of the discussion above, not just in terms of the kinds of literal experimentation that results in new forms of work and knowledge, but in the sense – perhaps literally the senses – that anthropology and contemporary art both move forward through experimentation. This is clearly somewhat problematic for anthropology in the way that, on the one hand, 'experiment' implies (certainly falsely in relation to fieldwork) a controlled laboratory

setting, and on the other, it is a label that is often used by anthropologists to effectively dismiss certain kinds of work, being produced by anthropologists as well as artists, which is deemed largely irrelevant because it is 'experimental'. Anthropology's iconophobia remains triumphant in such off-the-cuff relegation of works to the fringes. Experimentation, in the sense of formal experimentation with representational strategies and outputs, is clearly seen as absolutely central to the development of contemporary art – the situation is less clear within anthropology where there is much to militate against the taking of risks in the area of how to conduct ethnographic research and present the subsequent knowledge. This disciplinary and institutional inertia remains an obstacle to the development of a more experimental visual anthropology.

In most of anthropology research design follows the traditional PhD model with the formulation of a research proposal and a set of hypotheses, fieldwork, and the analysis of data and subsequent writing up for publication. Actual fieldwork, in relation to the original research proposal, allows for some flexibility but the overall process is geared to a finite outcome – that of publication. However, there are different ways to approach the production of knowledge, taking their cue from the notion of experiment as a 'knowledge-generating procedure'.[31] For instance, the Center for Experimental Ethnography at the University of California, Irvine, led by George Marcus, is investigating the possible relevance of the experimental design process in the applied arts for anthropological practices of experimental ethnography. Whilst mainstream anthropology in its institutionalized variety of university departments remains, on the whole, extremely reluctant to engage with more experimental, open-ended, research designs (which in part might be due to its academically restrictive, self-chosen elitism), it is by contrast in the arena of public culture and exhibition projects, which include anthropological practitioners (and occasionally also anthropology museums), where experimental work with open research design processes is now more often found.[32] These multi-disciplinary exhibition works, between artists, anthropologists, art critics/curators, draw both on recent trends of the so-called 'performative turn' in exhibition experimentation,[33] and on the new possibilities opened up by a whole host of 'relational' art practices,[34] the relations here being between social subjects, artists, artworld agents (critics, gallery owners, curators etc.) and members of the public, who through these relations bring the art work about. In other words, one might also think of such relations, as being – in a processual sense – the artwork. Without them it would cease to exist. This might go some way to explain the persuasiveness of claims by 'actor-network-theory'[35] to understand such processes, although one does not have to go necessarily the whole way and to admit agency to inanimate objects, which still might have to be mediated socially by human agents, after all.[36]

In such open-ended, experimental design arrangements 'knowledge is produced through experience rather than simply replicated',[37] and the aim is to 'emerge' knowledge rather than to simply find it, or it being embodied in a 'final product'.[38]

This new way of thinking about the intertwined processes of art and knowledge production has important implications for the relations between art and anthropology practices, and perhaps more wide-ranging epistemological relevance for the

anthropological research process itself. It is not just that art is one large 'unco-ordinated research programme'[39] but that the relations between practitioners, and their research partners become the agents and producers of knowledge.

One area, where artistic process provides an interesting way to rethink established working patterns, is with reference to fieldwork.

Traditionally, anthropological fieldwork has been conceived of as the slow, unfolding witnessing of events contemporaneous to being in the field. Practised in this fashion, it has been particularly ill-suited to deal with issues of spatial and temporal scale, being characterized, as George Marcus pointed out, by '... its sense of tempo, patience, slowness, in the presence of rapidly changing events; its anxieties about scale, about being pulled away from the Malinowskian scene of encounter.'[40] Despite calls for, and recent practices of 'multi-sited' ethnography, funding agencies are still reluctant to support more experimental research proposals by anthropologists – which remain marginal to the mainstream of the discipline. This is also surprising because potential collaborations with new multimedia arts would allow for a more reflective research practice encapsulating and problematizing, if not overcoming, the old and much-rehearsed dilemma of synchronous fieldwork versus diachronic field 'reality'. For instance, remote participants in the 'field' can now be linked in real time through multiple research techniques already employed by multi-media artists and performance scholars, such as Fabian Wagmister at the HyperMedia Studio and Center for Research in Engineering, Media and Performance (REMAP) at UCLA. These consist of and incorporate linked visual recordings and representation, sensing technologies, intelligent databases, distributed networks, and digital multimedia capabilities. Thus in one of their latest projects, REMAP researchers focus on how mobile phone user can use sensing technologies to provide new interactive maps of Los Angeles. It is but one step to think further and involve our research subjects in the field in interactive collaborations (mobile phone technology is now very widespread, or where it is not, it could be made available on even modest research budgets), a step not yet contemplated, despite much recent writing on the Internet and mobile sensing technology in anthropology.[41]

Anthropologist Juan Orrantia's visual work (Figure 1.3a–c) is an explicit attempt to use photography in an experimental way to access and represent the traces that memories of violent events leave in the present. Orrantia creatively combines his own image-making practices – using still photographic images, but also on occasion animating those images into short movies that use sound and image to explore resurgent memories (like the sound of outboard engines striking fear in those who recall the arrival of paramilitaries in high-speed motorboats) – with an equal concern for working collaboratively and sensitively with individuals to understand processes of remembering. If the object of anthropological study is the fleeting moment when the past resurfaces in the present then surely a variety of visual methodologies and outcomes are necessary to access people's views on that process and also to do representation of them any kind of justice. His recent work *Living in the Theatres of Memory* concerns the 'silence that is imprinted in the lives of people, creating a testimony of what it means to continue living with the haunting of events of terror'.[42]

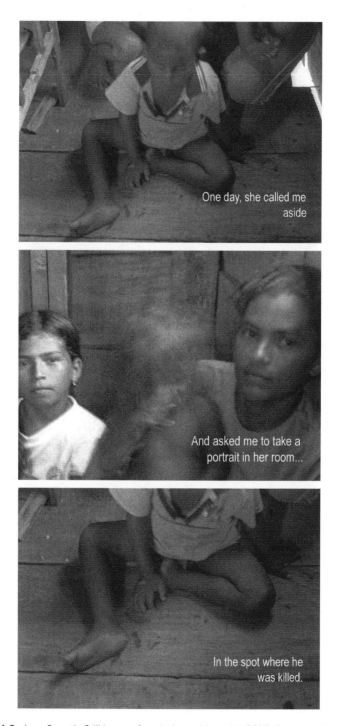

Figure 1.3. Juan Orrantia Still images from *Intimate Memories* 2008. Courtesy of the artist.

Orrantia is interested in the ways in which these memories of violence perpetrated by leftist guerrillas, right-wing paramilitaries and drug traffickers remain part of peoples' everyday lives in small villages on the coast of Colombia. Orrantia's writing is an elliptical and evocative exploration of the 'residues of terror':

> more than a defined experience, category or academic concept I engage memory as an inchoate experience that begins to form and take shape at moments, some of them unexpected, contingent to history and discourses but also to luck, emotion and even more violence. Memory is not a thing that we can simply delimit, but rather a fluid process of becoming that I approach here through instances when it comes about in momentary impulses, flashes, and fleeting images.[43]

This approach also suggest certain moments of connection with Ingold's concern for understanding the position of being in the world discussed above.

Another example of the value of experimentation in fieldwork and in representing the knowledges that emerge from the encounters involved in fieldwork is demonstrated in Andrew Irving's article 'Ethnography, Art and Death', in which he explores fertile new ground between disciplines.[44] As an anthropologist, Irving is concerned with understanding the experiences of AIDS/HIV patients in Uganda. One of his fieldwork methodologies involved connecting patients in groups of two, equipping them with a digital video camera and a digital audio recorder and asking them to effectively 'map' their experiences of HIV. The resulting testimonies and images are incredibly powerful at giving a sense of the dimensions of their experiences and – this is perhaps a very important 'and' in terms of anthropology's approach to the experimental – manages to tread a line with the obviously complex and fraught ethics of the situation. Indeed, Irving leaves out several photographs from the published article as a result of this ethical concern and instead includes the blank spaces within the pages of the *Journal of the Royal Anthropological Institute.* In one photograph we see a patch of otherwise empty waste ground full of weeds and rubbish, where one individual had attempted suicide. With the accompanying testimony the space becomes incredibly charged with a presence that animates it and also reveals the ways in which people's experiences of space is inscribed and re-inscribed through an ongoing process. According to Irving, the process was also something that allowed the participants to map positively their own relative position within the environment and the life they continue to lead, raising extremely productive issues of performative anthropology.

One of the well-known early attempts to define visual anthropology as a separate field within anthropology was Paul Hockings' seminal edited volume *Principles of Visual Anthropology.*[45] What emerged from this volume, and is in many senses still true of that sub-field, is a tri-partite division of visual anthropology into the study of other visual cultures, the use of visual media in carrying out anthropological research and disseminating the results, and what in the 1970s used to be called the study of 'non-verbal communication', which might now be subsumed within the recent anthropological resurgence of interest in the senses. The division of these three separate strands is in many ways still a feature of visual anthropology – one that perhaps needs

to be overcome. Many anthropological studies of the senses, despite generating a whole range of exciting new possibilities for further research and for representing anthropological knowledge, often fail to think through any of the implications that this research has for the kinds of methodologies and representational strategies employed by anthropologists, and in particular visual anthropologists. Bringing all three of these strands together – for example taking account of a particular cultural approach to vision while researching and producing visual material that takes into account other sensible worlds – would encourage the production of a range of experimental work. Such an approach clearly has its problems, but it would address the current inertia within the discipline in terms of tackling new and creative directions for work. In this sense it is more useful to consider 'visual anthropology' as something of a misnomer – as the art historian W. J. T. Mitchell points out in relation to discussions of visual media 'all media are, from the standpoint of sensory modality, "mixed media".'[46] Visual anthropology should be replaced by audio-visual anthropology, sensory anthropology, or some other term that more fully embraces the kinds of representational forms potentially involved. It might be more productive to consider the tripartite field – sound, image culture – as one relatively new postgraduate training course in visual anthropology does.[47]

EXPERIMENTAL FILM/EXPERIMENTAL MATERIALS

One of the ways to examine or draw out recent convergences between art and anthropology is to look at the increasingly blurred boundaries between the disciplines in the field of moving images. Much has been made recently of the blurring of boundaries between what were once disassociated media fields – 'experimental video', documentary film making, and short film. Contemporary artists are as likely to use the moving image to 'document' the world around them, as much as documentary film makers are concerned with experimenting with the formal qualities of film images and film structure.[48] This kind of documentary work clearly brings artists into areas of convergence with anthropology and anthropological concerns.

However, so far, experimentation in anthropology and artistic fields seems to have existed largely in parallel worlds without much contact between them. The point being that artists often anticipated later epistemological and pragmatic moves in anthropology, albeit for different purposes.[49] An instructive example is the work of video artist Juan Downey who, in his travelogue *Video Trans America* (1976), hands over the CCTV video camera to the Yanomamö[50] where they film and see themselves on the monitor (about a decade before these experiments were done more systematically in anthropology) (see Plate 6). He also produced installations with multiple television sets, and manipulated the image with a video synthesizer to evoke visual perceptions associated with séances and hallucinogenic drugs. Although Downey had met anthropologists Napoleon Chagnon and Jacques Lizot during his stay among the Yanomamö none of his work had any impact in anthropology, or even visual anthropology.[51]

The exhibition 'Yanomami, l'esprit de la forêt', held at the Fondation Cartier pour l'art contemporain in Paris in 2003, brought together a group of artists including

Gary Hill, Tony Oursler, Lothar Baumgarten, Claudia Andujar and Raymond Depardon amongst others – many of whom had been invited to spend time in a particular Yanomamö village in Brazil. Some, like the photographer Andujar, have had a long-term relationship with the Yanomamö. Andujar's black-and-white images are well known, and Baumgarten spent one-and-a-half years living with the Yanomamö, but video artists like Hill and Oursler, whose work for the exhibition investigates trance and hallucinogenic experiences, have only made brief visits. That notwithstanding, the works exhibited display a productive range of different visual strategies and representations of Yanomamö life that extend the long history of anthropological representations of these people in new and challenging directions (see Plate 7).

Another example of radical experimentation in the arts with relevance to anthropology is experimental or so-called structuralist celluloid film in the 1960s and 1970s. Here the main emphasis is not on the narrative structure of film but instead on the structurally given apparatus and conditioning material equipment of film making, which can be altered to make the viewer aware of the artifice of film making and viewing.

Structuralist film also problematizes the contemporaneity, and synchronic-diachronic relationship of filmic time in relation to the filmed event, and the position of the observer/camera. Thus experimental structuralist film does directly challenge dominant forms of single-camera recording and single-screen projection in mainstream feature and documentary film (including the majority of visual anthropology productions). One problem of the single camera (and, indeed, the single ethnographer) is the assumption of having by necessity only one position in the field, even when one moves around.

In his film *After Manet* (1976), Malcolm Le Grice deconstructed the assumptions linking the single observer to a single camera and a single screen (often taken to be synonymous with mainstream moving image production), by using four camera operators to film in real time an open-air picnic, and later projecting these simultaneously onto one screen (Figure 1.4).[52] It is revealing to compare these procedures with approaches in anthropology which tried to critically challenge the habitual suppression of different points of view, by deliberately incorporating them. For one, we can think of the experimental way Gregory Bateson's Naven[53] introduced different epistemological viewpoints. In more practical ways, there is also Marcel Griaule's proposal for a panoptic ethnography. James Clifford, summarizing a passage from Griaule's 1957 *Méthode de l'ethnographie*, explains how Griaule aimed to document a Dogon funeral ceremony by using contemporaneously different observers:

> He [Griaule] offers, characteristically, a map of the performance site and a set of tactics for its coverage, proceeding rather in the manner of a modern television crew reporting on an American political convention ... Observer number one is stationed atop a cliff not far from the village square with the job of photographing and noting the large-scale movements of the rite; number two is among the menstruating women to one side; three mixes with a band of torch bearers; four observes the group of musicians; five is on the roof tops 'charged with surveillance in the wings with their thousand indiscretions, and going frequently, along with number six, to

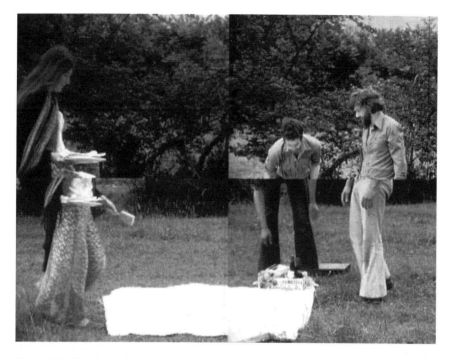

Figure 1.4. Malcolm Le Grice, *After Manet – le dejeuner sur l'herb*, 1975, 60 minutes, 16mm film projected on four screens. Film-maker Malcolm Le Grice (Performers Gill Eatherley, Annabel Nicolson, William Raban and Malcolm Le Grice). Courtesy of the artist.

the dead man's house in search of the latest news' ... Number seven observes the reactions of the women and children to the masked dances and ritual combats taking place at centre stage. All observers note the exact times of their observations so that a synthetic portrait of the ritual can be constructed.[54]

The direct implementation of such a project, precisely because of its panoptic pretension, remains highly problematic. However, with more recent inter-active hypermedia technology it is now theoretically possible to overcome the time-space bound separations to fieldworkers in more distant locales, or indeed of teams of fieldworkers, and their collaborators.

Ultimately a panoptic anthropology has to remain a utopian demand, and perhaps rightly so, as it is immediately redolent of a totalitarian, all comprehending, all encompassing view, which Foucault associated with the architectural history of the modern prison, where a truly panoptic viewpoint to all prisoners afforded the guards total control.[55]

Rane Willerslev and Olga Ulturgasheva creatively apply Sergei Eisenstein's concept of 'intellectual montage' to their ethnographic subject, the Siberian fur trade. They conclude:

While we recognize the 'multiplicity of perspectives' that defines the fur trade, we also acknowledge the impossibility of anticipating all of these viewpoints simultaneously. The Soviet montage-theorists aimed at such 'supervision' by putting together strips of film from every conceivable angle and distance, as well as employing numerous montage techniques to combine elements that have no inherent space-time connection.[56]

However, it is precisely the 'inherent space-time' connection which LeGrice's film *After Manet* preserves, and which is also part of the possibilities implicit in Griaule's multi-viewpoint scenario. Yet montage, or other experimental filmic devices, cannot just be applied for their own sake (be they in writing, film/video, or other representational genres), but in anthropology must be related to experiential time-space continua (even if they are fragmented in multi-sited research) of both research subjects and researchers.[57]

Linked to the question of materiality in film is the issue of materiality more generally in anthropological research in relation to the arts. For the last two decades there has been a burgeoning field of material culture studies, but it is only in recent years that materiality itself has become more theorized, namely in relation to research into fabrics, textiles, and more generally, intelligent materials. With what Susanne Küchler calls the 'material mind',[58] it is now possible to think about materials which have, if only partially, autonomous agency. She refers to smart or intelligent fabrics (such as those that are sensitive to and react to temperature difference, or ropes which can emit a warning signal before they break), all of which can perform operations that are traditionally attributed to the human mind, or specific mind-like apparatuses (computers and artificial intelligence, more generally), but not to matter as the Western tradition conceives it, and thereby, as Küchler says, carry 'our own mind beyond bodily confines.'[59] This has implications for theories of agency (e.g. Gell and Latour); it will also affect the crossovers between art and anthropology, as artists start to work with such materials, and anthropologists too, will not do only research on but with intelligent materials.

EXHIBITIONS

One of the indicators of precisely the kind of in-between qualities we are concerned with here revolves around the complicated issues associated with spaces of exhibition. The visual anthropologist Lucien Taylor – who runs the innovative Sensory Anthropology Lab at Harvard University (a collaboration between the Department of Anthropology and the Department of Visual and Environmental Studies) exhibits some of his recent film works from the series collectively known as *Sheeprushes* (2005) (see Plate 8) as single-screen projections in art gallery spaces (such as in 2007, as part of a show entitled 'Equal That Is, To the Real Itself' at the Marion Goodman Gallery in New York, a renowned dealer in contemporary art, along with work by the artists Steve McQueen amongst others). Other film works that are equally observational in style but perhaps have a more immediately recognizable narrative documentary structure (although they also push the boundaries of this field) are

exhibited at ethnographic film festivals. The reasons for this are complex – partly to do with durational aspects of film form as well as attention to colour detail and screening conditions, as much as any ideas of 'content' or 'style' – but they are symptomatic of wider problems with defining work in one way or another and with dealing with where certain types of work can be shown and encountered. It is also perhaps revealing of deeper problems with creativity and experimentation and one can point to numerous occasions when more experimental work produced by visual anthropologists or other visual practitioners is refused entry into ethnographic film festivals precisely because it is 'experimental' and therefore seen as outside the remit of visual anthropology. These are moments of effective border policing within anthropology. That more experimental work is yet to get much of a foothold is symptomatic of anthropology's iconophobia, an iconophobia that makes increasingly little sense as a category distinction in what is rapidly becoming an expanded field of digital production that embraces all kinds of practitioners and fields of enquiry.

That field has produced films like Gideon Koppel's recent *Sleep Furiously*, which had a limited cinematic release in the UK in 2009 (released on DVD by New Wave Films). The film defies easy categorization and sits between the realms of documentary film, art practice and experimental film – again the issue may well have much to do with spaces of exhibition than any inherent qualities in the work. Koppel insists that the film is not intended to be 'about' the community at Trefeurig – a small Welsh village where the filmmaker grew up; 'I didn't really set out to "represent" Trefeurig. In that sense I don't experience the film as a "documentary"'.[60]

Although observational in style, in places the film uses coloured panels accompanied by ambient sound in 'an original and distinctive grammar of seeing and hearing'.[61] As it goes about depicting in incredible detail the daily lives of the inhabitants of the village and their environment, it reveals Koppel's guiding principle to be a concern with senses of belonging and with the continual dialogue between internal and external landscape, as well as documenting pressing issues associated with rural change (Plate 9).

The film is a good example of the kind of work being produced in this in-between area, and others' such as Jeff Silva's film *Balkan Rhapsody*,[62] which uses many short fragments of observational film to create a deliberate collage of individual micromoments that add up to a picture of the effects of the conflict in the Balkans, and early films by the artist Rosalind Nashishibi,[63] reinforce the fact that anthropology never had a particularly strong claim to the observational style of film making as its own, and that exciting and experimental work in this field is currently being made by practitioners who are either from other fields or who are pushed towards exhibiting work outside of the spaces normally associated with anthropology.

INCOMPLETENESS

Surely, then, the whole structure and process of fieldwork and interaction with research subjects in anthropology needs rethinking, and this is where a lot can be learned from more open-ended, 'incomplete' procedures in the arts. 'As it now stands, the formal requirements push the expression of the alternative discussion of research

- how it really works - to the realm of the informal and the marginal and tend to make it a bit of the outlaw as well.[64] Taking his cue from the design process, as developed by designers and design theoreticians, Marcus proposes for anthropological research 'incompleteness as a norm', and acknowledges and encourages the 'complex role of collaborations in producing individual projects.'[65]

'Incompleteness', of course, has been a 'norm' in the arts for a long time, both with reference to the actual artworks, but specifically in relation to the artistic processes of creation. The visual arts, especially with their signature practices of experimentation from the early twentieth century onwards, provide a good foil with which to think of incompleteness as a 'positive norm of practice',[66] which is what Marcus postulates for future anthropology.[67]

In relation to movements as different as Futurism, Dada, Surrealism, Abstract Expressionism, Fluxus and happenings - to mention just a few - artists have stressed many times over the inherently open and processual character of the artwork, in fact its 'essential' incompleteness, thus emphasizing its transient character - to the point of destroying the artwork itself (as, for example, in Gustav Metzger's concept of auto-destructive art). Thus creative destructiveness, in its making as well as in its message, has been characteristic of much of twentieth-century art - an exhibition at the Centre Pompidou in 2005 was called appropriately, 'Big Bang. Destruction and Creation in the Art of the Twentieth Century'. A less radical version than Metzger's, and more commonly characteristic of the continuous processes of destruction and creation in much contemporary art, has been put forward by Claes Oldenburg, famous for his oversize sculptures of mundane objects in unfamiliar materials. Barbara Rose commented on Oldenburg's method:

'Composition is treated casually, informally, even arbitrarily, and chance - in the form of the action of gravity - is a determining factor.' Of his monuments (immense unrealized and possibly unrealizable projects to be erected in public squares and parks), Oldenburg writes: 'The thrown versions of the monuments originated in disgust with the subject, the way one would kick over or throw down a piece of sculpture that hadn't turned out well. Instead of destruction, I accepted as result a variation of form and position ... Such acceptance of chance and the arbitrary as part of the creative process is characteristic in general of post-Abstract Expressionist art.'[68]

To treat ethnography (and the concomitant processes of research and representation) as ruin and fragment, possible sites of intended and unintended, past and present destructions and reconstructions, from which new meanings can be engendered in processes of bricolage and assemblage, is a challenge that anthropology can take up, from, and in collaboration with, contemporary art. For anthropology, to have a debate on the incomplete, unfinished and not-yet-ready, is more than timely. Despite endless pondering on the status of fieldwork, field notes, and representation, there still has not been enough thorough discussion on how the fleeting experience of fieldwork can be captured and represented in other ways than by artificially crafted texts, that frequently enclose forcible completion.

Perhaps the anthropological enterprise is much of an open and ongoing 'archive', in the sense employed by French post-structuralists, such as Foucault and Derrida,

and it is at this juncture that it can meet with artistic practices, uncovering and adding to the archive.

The Internet, admittedly one such 'open' archive, is often perceived as offering more space for experimentation, yet many of the 'new' promises seemingly offered by the Internet and new media technologies, i.e. connectivity, relationality, virtuality, and their experimental and fictional capabilities, have been long explored, albeit in different media by artists – arguably, since the beginning of the twentieth century. The differences in terms of the potentials for 'connectivity', 'commentary' and experiments in 'composition' – the very terms found characteristic of contemporary and future fieldworks in anthropology,[69] are already ingrained in many twentieth-century artworks (as *projects*). What changes with the Internet is the generalized availability through technical templates (though still felt by many as normative and restricting) for, potentially, democratic access – beyond individual circles and those determined by the artworld.

FUTURE DIALOGUES

This book is then a further call for more experimentation in the fields of practice between art and anthropology.[70] Any future art-anthropology collaborations will have to deal with certain parameters coming from different disciplinary backgrounds, and certain eruptive fault lines, which, for instance, deal with the aforementioned issues of chromophobia / iconophobia, sensory research, ethics, experimentation, and (in)completeness around which we hope productive but contested and sometimes conflictive dialogues will develop.

There can be no normative *a priori* demands for such future dialogues. This is especially the case for projects where the planned collaborations might be between partners with widely different educational, cultural and economic backgrounds (for instance, outside 'First World' settings) – or, in other words, access to power and capital.

Dialogue is a fragile construct that cannot be normatively presumed and has to be delicately constructed for each instance of collaboration and in each phase of the project. It is only through a procedure of mutual respect and understanding that a hermeneutic field, however tenuous and uneven, can be built. This would include a certain 'relinquishment'[71] of one's own position, as well as an aspiration towards a truly 'dialogical aesthetics', based on 'listening' towards the other.[72]

In this way fruitful collaborations further develop in the spaces in between art and anthropology.

Farther Afield

Lucy R. Lippard

I was originally going to write about 'undermining *Overlay*' – a book I wrote in the late 1970s, inspired by a year on a farm in Devon, near Dartmoor, about contemporary art and the mostly megalithic art of 'prehistory', published in 1983.[1] It changed my way of thinking about art because it was the first time I'd had the guts to cross disciplinary barricades – outside of left politics, that is. Enthusiasm rather than knowledge or critical analysis was the fuel for *Overlay*. As a kid I always wanted to be an archaeologist – an idea I dropped like a hotcake when I saw students working *with toothbrushes* on a huge cliff in the Dordogne in the 1950s and realized I'd be as lousy at it as I am at any other kind of housekeeping. In *Overlay* I mined anthropology and archaeology for a cornucopia of visual and literary images that made me think about contemporary conceptual and public art in different ways. But being self-taught on the subject, I didn't ask enough questions, or the right ones.

Looking back, I see that I was acting like an artist – excited by unfamiliar material, itching to make something of it. In another sense, *Overlay* marked the beginning of the end of my artworld career, because since then I've drifted farther and farther away from anything that could possibly be called art criticism toward something vaguer and trendier called cultural criticism. In the process, politics has become less of a taboo, though naming names – of people, corporations, or wars – continues to be unfashionable both in high art and in anthropology to this day. In the early 1990s I belatedly discovered cultural geography and the 'cultural landscape'. The book I'm writing now is remaking me yet again into a wannabe historian or geographer with a *soupçon* of anthropology, since it's about practising what I preached in my 1997 book *The Lure of the Local*.[2] My fieldwork is prowling around the Galisteo Basin in northern New Mexico, where I live, listening to archaeologists (ever disappointed with how little they know about the stuff I want to know) and being a pest to the elder *hispano* community with my questions, trying to understand the limits of oral history when you want to live the rest of your life in the town you're studying. The only art in this book in progress is rock art – ancient petroglyphs and pictographs, though I wish there were local artists dealing directly with the current water and land issues we're wrestling with. If I were an anthropologist or an historian my field would be ordinary enough – the relationship between land and lives in a specific place and space over time – lots of time, about 1000 years.

Rather than rethinking *Overlay*, I'll just take the rap for my early feminist hopefulness, anthropological ignorance, and dangerous idealizations of early civilizations, and

go on to more recent material that looks less at the images and more at the structures shared by art and anthropology. *Overlay* was my personal permission to do fieldwork, to go outside, outside my own culture and training, in the great tradition of western-ers 'finding ourselves' beyond our boundaries, and dashing back home with the loot, to use as we please. If we're tourists, being in the field isn't work, so the trophies are not called data or resources, they're called souvenirs. If we're artists or writers, the trophies and/or souvenirs become raw material absorbed into careers that are totally *un*related to the sources' original meanings, no longer products of empirical reflec-tions of *anyone's* lived experience. Anthropology has, in fact, been a tourist guide into the spectacles and displays of culture, community, and alterity in mainstream art con-sciousness, coinciding with cultural work on the left, then diluting it into the imagery of a romanticized archaeology and a colonizing approach to other cultures. Eventually it helped those of us coming from outside the discipline to understand our tenden-cies to take only the frosting off the cake, without understanding the substance underneath, especially the social relations that engendered the visual anthropology we often find so compelling – and so disturbing. I can't disparage anyone's romance with that top layer of cultural anthropology and archaeology because I've been there too, but we art types should not get off the colonialist hook so easily.

Rather than historians and anthropologists, the models for my own neo-anthro work are mostly those artists who are going farther afield with fewer guidelines, and fewer precedents. So I will just muse on what everyone else has been musing on: art and anthro, anthro and art, can we tell them together? Can we tell them apart?

I'll illustrate these musings with a few imperfect, down-to-earth examples of art-ists who intersect with anthropology in their attempts to affect and intersect with culture. My interest lies in how each of these artists functions in society, how they choose their audiences, and the social effects – if any – such work has on the com-munity itself. But I'll focus here on their overlappings with anthropology's mandates as they betray the expectations of their home discipline, moving from art out into the world in various unexpected directions. Hulleah Tsinhnahjinnie is a Native American photographer, thus forced by history to confront anthropology whether she likes it or not. Suzanne Lacy is an innovator in an advanced form of political/civic/community art. Sabra Moore works quietly in her New Mexico community, bringing to bear strate-gies learned in the international artworld. And Abdelali Dahrouch is a twice uprooted Arab trying to make sense of his multiple identities in a global state of war.

The common ground between these artists and their anthropological counter-parts (on both sides) is ethics, or just plain responsibility. It finally comes down to who exploits whom for what and why. This is a subject that has been chewed over in the anthropological community for decades now but is still rarely addressed in the art community. While they are in vogue, artists who adopt a surface critique of anthropology, composted with post-colonial verbiage, can get away with murder – sometimes for better, sometimes for worse. I attribute this to the fact that art is gener-ally perceived as either above it all – out in the ether beyond the comprehension of ordinary people, or below it all – useless and frivolous, merely decorating the world. Anything goes.

So what makes anthropology so fascinating to socially concerned artists, even those who have been its historic victims, those who are now turning the tables? And how come artists are always borrowing from anthropology, but it's not a two-way street? Maybe because the freefall, contradictory, sometimes ritualized ways artists approach their subjects is more in sync with the cultures being studied than with those who do the serious studying? Artists and anthropologists, as *subjects*, share a sense of alienation from society and crave connections that their framework inherently denies them. On the other hand, artists share the *object's* predicament as well, in the sense that they have little control over what becomes of their cultural artifacts, little power to affect their social interpretations and no control over distribution. Of course the often indigenous objects of ethnography *in*voluntarily provide displays and spectacles of themselves or their objects, whereas artists ask for it, or are at least complicit.

Susan Hiller (whose background in anthropology has influenced her thought ever since she rejected it in favour of art) has written: 'Artists modify their culture while learning from it ...They are experts in their own cultures.'[3] This works for the best of them, but I wish it were more contagious. The rather utopian notion of 'reciprocal ethnography' has been widely embraced, but less widely carried through. Usually only one party is interested in knowing the other, or has the time and tools to dig beneath the surface. Mutual curiosity is relatively common, but you can't force reciprocity. Audience is still a major dilemma. Much art with anthropological affinities is not made for those *about whom* the art is made. There are admirable artists who enter a community, primarily to take something out, to raise a civic dialogue *with* but not *within* the community. But I admire still more those who are catalysts, who don't just explore but hang in, who stay and help expose and perhaps even help solve problems. That is a big difference. And it is the difference between artists with and without practical politics.

The quest for meaningful context, and for meaning itself, has led these artists towards anthropology, which, even when it's trapped in its own self-fulfilling prophecies, does offer significant contextual models. Because of its academic credentials (increasingly desirable in a theory-driven artworld), and despite its bad reputation among its subjects as Western civilization's weapon of choice against indigenous cultures, anthropology has been raided and embraced from every direction, visual art often first in line, sometimes adoringly, sometimes critically. We're all too familiar with the ways in which so-called primitive artifacts have inspired Western artists to move up an evolutionary aesthetic step. Going in the other direction, the one that interests me, it was really conceptual art in the mid 1960s that brought social disciplines into 'high' art on a more encompassing level, leaving objects behind and looking at cultural structures and processes. In the 1970s feminists confronted patriarchal culture by taking conceptual art into the personal realm. And in the 1980s and 1990s, postmodernists picked up the ball, rarely acknowledging who had passed it to them.

Sculptor Carl Andre once famously said that art is what we do, culture is what is done to us. If so, then artists are sacrificing something crucial when they cuddle up too close to anthropology. Artists can be accused of 'taking liberties' with received data; they don't have to stand up for their sources or sometimes even identify them.

There are footprints but no footnotes in art, although art history scurries along behind trying to pick up the trail. Artists have a social mandate to take risks. Yet unequal power makes unequal risks, and aesthetic daring must be balanced with responsibility (accountability) to the communities with whom the creators are creating.

Within the mainstream, art that approaches social anthropology or sociology *too* closely is usually dismissed as aesthetically unambitious, unless it's pretty enough to make it back over to the art side of the fence. So artists who borrow from anthropology and archaeology are usually quick to insist that the documentary or informational aspect of their work is secondary, that Art with a capital A is what it's all about. And why not? For all the blurring of disciplines, art and anthropology do indeed demand different means, have different ends. As Suzanne Lacy has written about the 'imperfect art' of working in public: 'Art is the passion to make something. If that urge to make finds its way back into public life, so much the better for all of us.' For artists committed inextricably to social justice and public good, she says, 'art is often unpredictable, rarely completely controllable. But when it works, it is both beautiful and important. Something real has taken place, and it is not always safe, not always entirely understandable.'[4]

Native American (Karuk) cultural historian Julian Lang sounds like an artist when he suggests how as a storyteller he relates the contradictions between modernity and ancient myths:

> I am not so much into entertaining, but just presenting a big fat myth and letting people think about it. In order for you, a non-Indian, to understand my culture, you are going to have to walk away ... thinking 'Jesus Christ, what was that?' Not in a negative sense, but it is just like – there are too many things in there. You can understand it on one hand, but on the other hand, it is too deep.'[5]

No group in the US has been more wounded by anthropologists, as well as mainstream artists who still appropriate their images, than Native Americans. Hulleah Tsinhnahjinnie, who is Creek, Seminole, and Diné (Navajo), has taken on a double task. First, and least visibly, she has become photographer to her own community and to the pan-Indian communities, taking documentary pictures and portraits for social organizations, publications, and events. Second, and more visibly, she has become a warrior challenging the historical representation of Native peoples. (Her work was seen also in London – typically at the Barbican, sponsored not by art historians but by anthropologists; she is even married to one!) Tsinhnahjinnie, who unashamedly calls herself a political artist, remembers the

> beautiful day when the scales fell from my eyes and I first encountered photographic sovereignty. A beautiful day when I decided I would take responsibility to reinterpret images of Native peoples ... No longer is the camera held by an outsider looking in, the camera is held with brown hands opening familiar worlds. We document ourselves with a humanizing eye, we create new visions with ease, and we can turn the camera and show how we see you.[6]

See Figure 2.1. Although she sees her role as 'informer and educator' between cultures, she and her friends resent non-Natives who are dependent on what they call 'the cultural tit' or, as Native photography critic Theresa Harlan put it, Indians don't want to be 'your cultural nursemaids, feeding you every time you cry because you don't understand.'[7] Tsinhnahjinnie sees herself living as a native in a settler culture

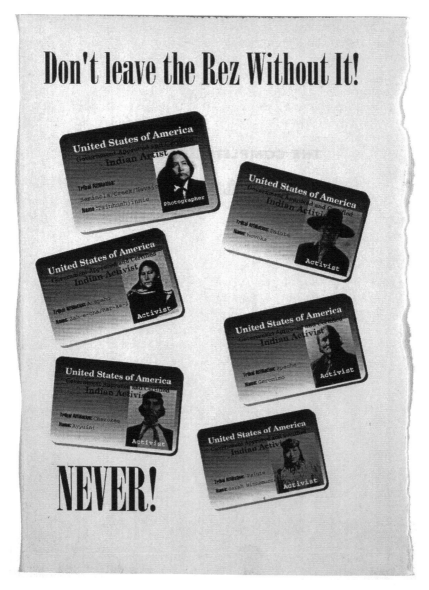

Figure 2.1. Hulleah J. Tsinhnahjinnie (Diné/Seminole/Muskogee) 'Don't leave the Rez Without It!' 1994. From the series *Photographic Memoirs of an Aboriginal Savant.* Unique digital print on aged book stock, 14" × 11". Courtesy of the artist.

on occupied land where the American dream creates environmental nightmares ...The act of existing has been nothing short of a wild west show. Designated an oddity because I am from this land called America. An oddity because I have a perfect tan. Odd because I love crossing the line, my Ts, the border, and my eyes ... I will never be American enough, because you have to be a foreigner to be a true American.[8]

In 1993 Tsinhnahjinnie made her first major attempt to communicate with non-Native audiences in an installation at the San Francisco Art Institute called 'Nobody's Pet Indian' (titled after Ward Churchill's article on Jimmie Durham's stance on the Native Arts and Crafts Board Act). Since then she has become a recalcitrant ambassador between Native communities and the dominant culture – a choice made by a good number of artists who are perceived as 'living in two worlds' – a notion many of them abhor. 'The reward', she says, 'is when your community comes to you and says that you've done well.'[9]

Anthropology is never too far in the background for any American Indian artist. Having discovered that an image is worth 1000 words – 'as long as they are in English'[10] – Tsinhnahjinnie published a fictional interview with herself by Alfred Kroeber to accompany her hard-hitting 1994 work, *Memoirs of an Aboriginal Savant.* 'Now is the time to pick up the weapon of thought. Now it is time', she declared. 'Realizing the impact of a written existence, which is considered more real than an oral existence – and rather than have an anthropologist interpret my existence – I have taken control of how I am presented ...The absence of an anthropologist makes it easier to exist.' ('Kroeber' protests, 'I thought we validated your existence.')[11]

The 'universality' presumed of high art is the opposite of real community-based works, which, as Ferdinand Lewis notes, are 'made for a particular moment, place and audience ... about how history has shaped a particular population's ability to live in a specific place at a given time ...While all art *includes* its audience (and critics) in a subjective experience, arts based civic dialogue also *implicates* them.'[12] True public engagement is rare in art, and that which produces groundbreaking art is rarer still.

Suzanne Lacy, who, like Josef Beuys, calls herself a 'social sculptor' manipulating 'the shape of interactions,'[13] is a pivotal figure who often achieves this synthesis. Lacy has had an interesting trajectory, exploring and expanding an avant-garde community-based art. While many artists begin in communities and then when they are noticed by the mainstream begin to distance themselves from home base in order to fulfil the obligations of success, Lacy has gone in the other direction, starting out as a personally oriented feminist performance artist (studying with Judy Chicago and Allan Kaprow) and later moving into increasingly broader functional situations, always collaborative, while struggling not to lose the art framework that is the underlying reason she does this at all.

Her projects often take years to complete, longer than many anthropologists stay in the field. Since the 1970s, she has worked all over the world in a huge variety of social situations, working with elderly women, with African-American quilters in Watts, with cancer wards, with battered women in prison, with neighbourhoods relocated by urban renewal. And if there are art types who don't know her work, that's tragic,

but it's also a mark of how effective she is on the unique ground she has chosen, and how far her field remains from museums and blockbuster internationalism. (Her 1995 book *Mapping the Terrain* surveyed the new ground for future art possibilities by showing what had happened and predicting to some extent what was going to happen, or where she would lead.)[14] Like many others, she advocates the practice of bringing the voiceless into the public sphere with dignity through their stories. But she goes much farther afield, developing increasingly adept strategies of dissent, community organizing, and political critique. Her work's ethical questions, as well as its hybridity of thought, media, and approaches, mimics the trajectory of civic life itself.[15]

Lacy's most important recent works have been done close to home, in a long-term series of pieces with kids and cops in Oakland, California, examining the complexity of the ways people move in and out of authority, challenging both governmental and corporate motivations. In informal but loosely staged discussions, the personal is leading inexorably into a municipal youth policy while maintaining its aesthetic integrity. Cumulatively, over the years, her several pieces with teenagers – *Teenage Living Room, The Roof Is on Fire, No Blood, No Foul,* and *Code 33* – add up to a pro-active community portrait. The apogee in each case is a grand collective performance in which aesthetics triumph for a couple of hours over social work and politics. Exploring political issues through lived experience, Lacy frames her visual images, and their beauty, so the meanings of what people say will remain central. Given her class background, she counts herself among them. 'I'm a working class artist', she says, but there lies the core dilemma. 'The people I work with share my values', she says, 'but don't share my esthetics.'[16]

In this context, I'll concentrate on a recent, less typical project – Lacy's ongoing collaboration begun in 2002 with a Colombian anthropologist, Pilar Riaño, and some 1,500 residents of the Medellin barrio of Antiochia. *La Piel de Memoria*, informed by Riaño's work on the intersection of culture and everyday violence in Bogota and Medellin, focuses on teenage violence and memory in the face of loss. Lacy and Riaño delve into the 'archaeology of grief' for the number of teenagers murdered in this neighbourhood . One young girl is quoted: 'One of the things I fear most is to remember'[17] (Figure 2.2).

The artist and the anthropologist worked through historical narrations evoked by objects borrowed from some 700 *barrio* households, which were incorporated into an installation on a bus called 'El Museo Arqueológico del Antioquia', which travelled through the *barrios*. Other phases were a celebration and street performance in which multiple parades of bicycles delivered letters containing a wish for the child of an unknown neighbour. A youth web site is also planned. The collaborators hope that the process of recovering memory within a collective context of mutual respect and listening can activate other social processes and lead to the reconstruction of a social fabric torn to ribbons by the years of lawlessness and drug trafficking in their communities.

Artists like Lacy are driven to go where anthropologists fear to tread. So-called scientists are supposed to observe and analyse, not to effect change, not to literally move people around, or ahead. At the same time, always on a tightrope between disciplines, Lacy challenges institutional systems to accommodate art, asking 'Can the radical

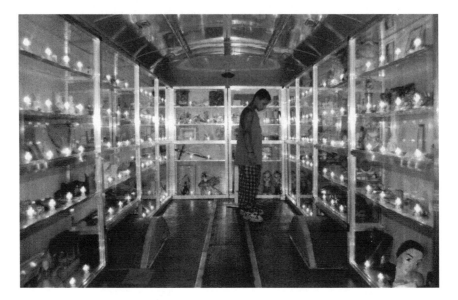

Figure 2.2. The Skin of Memory/La Piel del Memoria, Colombia, 1999. Artwork by Suzanne Lacy and Pilar Riaño-Alcalá. Photo by Carlos Sanchez. Courtesy of Suzanne Lacy.

nature of an activist artwork be embedded in places renowned for their intractability and resistance to change? Will we lose our artfulness and become instead managers and program designers?' (Or, she might have added, ethnographers?) 'It is our methodology that differs, in ways that continue to need articulating.'[18]

While Lacy's work will eventually be recognized more fully than it is today, Sabra Moore's will stay in its place. Raised a rural Texan, Moore worked in the Peace Corps in Africa and then spent some 30 years as a New York artist and activist, before she moved to rural, largely *hispano* northern New Mexico in the 1990s. She has long worked in collaborative forms, often in huge projects involving many women from different countries and cultures, which culminated in Xeroxed artists' books or exhibitions. Her sources are often her own and others' family stories.

Although a relative newcomer in New Mexico, Moore has become rooted in her community as an artist. She worked as a census taker in 2000 (a great art/anthropological strategy), headed the local recycling effort in her hometown of Abiquiu, tutors local schoolchildren, and for several years has directed a small local farmers' market in Española, a larger *hispano*, Anglo, and Indian town nearby. She has dynamically transformed these ordinary day jobs into art opportunities not only for herself but for other artists and for farmers, their children, and their infinitely extended families all over northern New Mexico. At the farmer's market, poetry and art contests have joined the biggest vegetable contests. In September 2003, Moore installed 'The Farm Show' in an historic house in Española. She asked a number of artists to interview the growers from the farmer's market and to make art from the results. She herself made the interviews into photo-text banners, solid oral histories translated into what

is still called art. Moore's own art and political commitment has led her into a unique kind of collaboration that will never be celebrated in the artworld even if the real community arts were ever to come into vogue. By teaming up local artists with local non-artists, she expands the artists' knowledge of the place and at the same time mutually expands local residents' knowledge of art and its possibilities when it enters life (Figure 2.3).

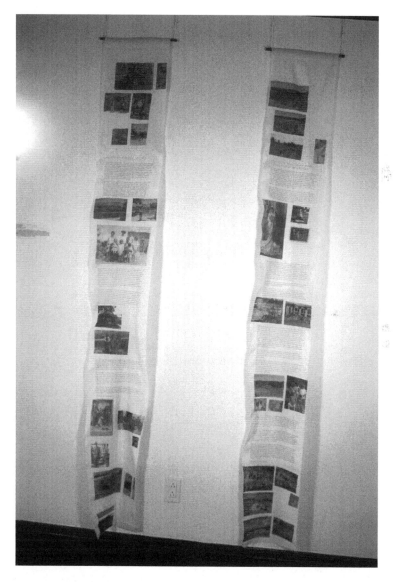

Figure 2.3. Sabra Moore, 2003, 10" × 96", laser transfer print on cloth. Banner on left: story and images of Ralph Trujillo, Chimayo, New Mexico. Banner on right: story and images of Tranquilino and Floraida Martinez, Penasco, New Mexico. Courtesy of Sabra Moore, 2003.

The biggest question for both artists and anthropologists should be, are you wanted here? By whom? Artists trying to make a living at the crossroads of community, culture and class need to speak several languages, to know how to change codes in midstream, to come into each situation with fresh eyes and mind, to navigate the shoals of historical enmities, to give up the role of final arbiter, especially about cultures not their own, and at the same time to take risks in order to move to a different level of collaboration. For years I have quoted a Lower East Side resident called Richard, who asked Tim Rollins and the Group Material artists' collective, when they worked on East 13th Street in lower Manhattan: 'You know, like I don't want to be nosy, and we all got our reasons for doing what we do with our lives, but I wonder – everybody here on the block wonders – *why are you here?*'[19] Every artist (and anthropologist) should be required to answer this question in depth before launching what threaten to be intrusive or invasive projects (often called 'interventions').

I'll end with a completely different kind of enterprise, political but not practical. Abdelali Dahrouch, who is Moroccan/French/American. He describes himself as an artist 'whose life has been and continues to be one of migration and exile, and whose physical realm is caught in time and space. The US of which I am a citizen – both Arab and American – is both home and a foreign land. I belong nowhere, but I am a part of everything.' Quoting Mahmoud Darwish, he says 'I am the Arab that never was.' And his work, he says, is 'an anthropology of the present'[20] (Figure 2.4).

Dahrouch's video installations *Desert Sin* (1995), created in response to the First Gulf War, and *Desert Sin Revisited* (2003), a revision incorporating Gulf War Two, are homeopathic critiques of the media coverage of the two events – the 'electronic

Figure 2.4. Abdelali Dahrouch, *Desert Sin Revisited*, Video Installation, 2003. Courtesy of the artist.

remains of a suspended moment in time.' These fragments of information from disen-
franchised spaces 'appear, faintly, through a luminous screen.'[21] Dahrouch condemns
senseless wars by means of a barren silence representing the pain of the Iraqi people
caught in the Bush/Blair/Hussein axis of evil. As Laura Kuo describes the newer work,
images of US government officials, weaponry, battles, Iraqi mothers, dead soldiers and
prisoners 'become ghostly shapes ... haunting and grotesque, undeniably seductive.'[22]

Though art theorists no longer fetishize hybridity quite to the extent they did in
the 1990s, diaspora, post-colonial discourse, emigration, immigration, and vulnerable
national boundaries have become a new kind of raw material. These artists work from
lived experience. The *avant garde*'s appropriation of globalization has been exacer-
bated by the cyber revolution. Dahrouch, and older models Yong Soon Min and Allan
de Souza, or Rasheed Araeen in the UK, might once have been considered 'outsiders'
in the West, objects of curiosity and inspiration for Western artists rather than peers in
a common enterprise (no longer called 'multiculturalism' since the decline in prestige
of identity politics). They now have a chance of being welcomed into the Western art-
world as subjects, challenging our sense of their realities, and of our own, shifting the
grounds on which artists from, say, England and Africa view each other. In the process,
the art mainstream has gradually constructed its own relationships with those once
relegated to the 'primitive' and the 'other'.[23] And although the co-dependency seems
pretty firmly internalized, these new strategies may make it less necessary to borrow
from anthropology.

To understand this changing field, one has to reject postmodernism's frequently
apolitical relativism. I cling to Gayatri Spivak's notion of a 'strategic essentialism', in
which she says it is 'crucial ... to allow for communities of identification, even if these
communities are multiple, discontinuous, and partly imaginary.'[24] Both art and anthro-
pology are rising to the occasion. It remains to be seen whether art like Dahrouch's,
Moore's, Lacy's, and Tsinhnahjinnie's facilitates a continuing co-dependency, a rap-
prochement with, or an eventual distancing from anthropology, as the two disciplines
return to their own strongholds or succumb to an arranged marriage.

The Artist as Shaman: The Work of Joseph Beuys and Marcus Coates

Victoria Walters

INTRODUCTION

In the opening sequence of his single-screen video installation *Radio Shaman* (2006) contemporary artist Marcus Coates stands patiently in the studio of a radio station in Stavanger, Norway, waiting to be interviewed. Over a smart suit, the artist wears the pelt and antler-adorned head of a deer as a headdress and the heads of two dead hares protrude from the centre of his jacket and under his right arm. Without a trace of amusement at this spectacle, the local DJ introduces Coates to the listeners as a performance artist and addresses him in English: 'What kind of a performance will you be doing in Stavanger these days?' Deadpan, the artist replies, 'Well, I work as a shaman and a shaman is traditionally someone who works with their community and helps solve problems that it's very difficult to find solutions for.'

Coates' adoption of the shaman's role has a series of key precedents in the history of Western art, but the most obvious is that of the twentieth-century German sculptor, Joseph Beuys. Beuys' interest in shamanism is perhaps best known from its echoes in his performative actions of the 1970s; however, it can be seen in the early stages of his artistic career, in drawings, watercolours and paintings dating from the early 1950s, continuing to feature in work completed not long before he died in 1986. In this essay I will reflect on both Beuys' and Coates' engagement with the ethnographic side of the shaman's role and discuss the way in which each could be said, in different ways and for different reasons, to 'adopt' or refer to it in their artworks. I am particularly interested, here, to explore how these artists undertake what could be seen as sensory fieldwork that informs their ritual performances and to look at ethical and artistic concerns raised by their respective engagements with what Mircea Eliade has described as 'the most archaic and widely distributed occult tradition'.[1]

SHAMANISM, A 'TECHNIQUE OF ECSTASY'

There is a tendency to use the term 'shaman' indiscriminately in relation to all healers and medicine men. However, as Eliade reminds us, 'Shamanism in the strict sense is pre-eminently a religious phenomenon of Siberia and Central Asia'.[2] Following the work of anthropologist Lévi-Strauss, the role of the shaman is widely understood to

be one of healing, and Tucker explains that it is because of their power of *self-healing* that shamans become respected in the community and play 'an essential role' in its 'psychic defence'.[3] Far from being mentally unstable, many people become shamans precisely because they have healed their own initiatory illness:

> It is not correct to say that shamans are, or must always be, neuropaths: on the contrary, a great many of them are perfectly sound in mind. Moreover, those who had previously been ill have *become shamans just because they succeeded in getting well*. Very often, when the vocation reveals itself in the course of an illness or an attack of epilepsy, the initiation is also a cure.[4]

Eliade notes that in addition to healing, the shaman plays a role in magico-religious rites such as the hunt[5] and Armstrong explains the related importance of animals to the shaman:

> Shamans operate only in hunting societies, and animals play an important role in their spirituality. During his training, a modern shaman sometimes lives with animals in the wild. He is supposed to meet an animal, who will instruct him in the secrets of ecstasy, teach him animal language, and become his constant companion. This is not regarded as a regression. In hunting societies, animals are not seen as inferior beings, but have superior wisdom.[6]

In an altered state of consciousness, usually initiated and sustained by repeated drumming, shamans seek guidance to combat sicknesses and resolve specific problems by 'journeying', either in this worldly realm, or to what are referred to as the 'upper' or 'lower' worlds. It is the shaman's capacity to operate in other realms of existence that leads Eliade to refer to shamanism as a 'technique of ecstasy'[7]. While journeying, shamans meet spirit guides, from whom they seek to elicit wisdom, which can then be used for healing on their 'return'. Guides appear in animal form and in some tribes the shaman mimics the cries of animals encountered. For the shaman, observations made in a non-rational state of consciousness are considered to be as valid as those noted in rational consciousness. Anthropologist and neo-shaman Michael Harner explains: 'In engaging in shamanic practice, one moves between what I term an Ordinary State of Consciousness (OSC) and a Shamanic State of Consciousness (SSC).'[8] Harner makes the important point that in a Shamanic State of Consciousness, the animals that appear to the shaman or the shaman's patient have a kind of reality. He points out:

> Observation with one's own senses is the basis for the empirical definition of reality; and there is no one yet, even in the sciences of ordinary reality, who has uncontestably proven that there is only one state of consciousness that is valid for firsthand observations. The myth of the SSC is ordinary reality; and the myth of the OSC is nonordinary reality.[9]

There is thus a sensory, empirical engagement with both seen and unseen worlds undertaken in both conscious and unconscious states at work here. This is clearly not

an approach to healing that a positivist would accept as valid and, as a result, shamanism has long confronted Western anthropologists with difficult questions about their own paradigms of understanding. Those very aspects that have made shamanism intriguing for the anthropologist have also proved of great interest to artists, whose work draws both on empirical observation in the OSC, to borrow Harner's term, and the well-spring of the unconscious mind. As a result, the figure of the shaman has featured heavily in the construction of notions of the modern artist. Art historian Esther Pasztory gives a useful overview:

> By the mid-twentieth century the concept of the shaman had been transformed into a metaphor for the artist; the artist is now identified as someone on the edge of madness who can ascend or descend into realms of unconsciousness unavailable to others and bring back gifts for the community in the forms of works of art. The shaman was seen as the 'first artist.' The concept of the shaman blended well with the idea of the extraordinary gifts of the genius. The contemporary artist is defined as a marginal person who risks his own sanity for the benefit of the group.[10]

The association of the shaman and the notion of the artist-genius has led many to argue that the metaphor of the artist as shaman perpetuates an artificial, romantic and primitivist stereotype. In order to assess Coates' and Beuys' self-identification with the shaman's role and the degree to which this has been influenced by a modernist notion of the artist 'genius', it seems helpful to compare both artists' positions with respect to this ancient tradition.

ECHOES AND PARALLELS

Literature on Beuys and Coates makes connections between both artists' personal ill health and their interest in shamanism; there are clear indications of self-identification with the shaman as wounded healer. Alec Finlay attributes Coates' interest in shamanism to the severe eczema which he suffered as a child: 'you, I think, draw on your shadow-time.'[11] Beuys experienced a number of psychic or near physical 'deaths' during his lifetime; Nisbet points to three traumas in Beuys' life which made a particular impact on the artist: a childhood depression and desire to commit suicide; a nervous breakdown in the artist's early thirties while staying with the Van Der Grinten brothers, documented in an interview with their mother[12] and, most famously, a near-fatal crash over the Crimea during the Second World War, from which Beuys famously claimed he was rescued by Tartars, who wrapped him in felt and fat to keep him warm.[13]

Coates, an ornithologist and naturalist, appears to have also derived his interest in the role of the shaman from an engagement with the natural world that had its beginnings in infancy. Growing up in suburbia, wildlife already had a mythic status for Coates, even in the conscious realm, 'wildlife was always this exotic thing because it was so limited.'[14] In an interview with Finlay subsequently represented as a poetic composition, Coates gives an account of a childhood of 'building camps, exploring the wild' with companions who described birds and animals to him which he had

never seen; 'British birds and animals took on/mythical status, fed by my older companions,/on whose every word I hung.'[15] Similarly, Beuys' childhood interest in the natural world and related myth could be seen as a necessary precursor to his later engagement with shamanism and its work with the empirical 'reality' of both conscious and unconscious worlds. Stachelhaus notes that the young Beuys:

> learned about plants, grasses, trees, herbs, mushrooms. He jotted down his observations in notebooks and kept a botanical collection in his parents' house. There he even maintained a small zoo and laboratory and was always hunting for mice, rats, flies, and spiders for it. He also caught fish and frogs.[16]

To differing extents, both Coates and Beuys frame their engagements with shamanism in relation to attempts to communicate with, and learn from, other animals. More specifically, Coates is interested in human attempts at 'becoming animal', a notion that stems from the work of Gilles Deleuze and can be seen in his observations about the portraiture of Francis Bacon:

> Sometimes an animal, for example a real dog, is treated as the shadow of its master, or conversely, the man's shadow itself assumes an autonomous and indeterminate animal existence. The shadow escapes from the body like an animal we had been sheltering. In place of formal correspondences, what Bacon's painting constitutes is a *zone of indiscernibility or undecidability* between man and animal.[17]

Deleuze's ideas resonate in Coates' work *Dawn Chorus*, a fourteen-screen video installation (2007) (Figure 3.1). Over a week, Coates and sound recordist Geoff Sample set up fourteen microphones to record birdsong during the dawn chorus. They then slowed the recordings down and Coates asked local people, often occupied in their daily tasks, to mimic the slowed sound. Subsequently, Coates and Sample sped up the tracks, and the resulting video portraits show their human subjects singing like a variety of birds, from a chaffinch to a wren. Something ineffable and animal hovers about their faces, their rapidly blinking eyes and chest movements uncannily redolent of the birds whose songs they emulate.[18]

The 'important role' of animals for the shaman and their 'superior wisdom' is powerfully evoked in what is perhaps Beuys' most famous work, the 1974 action *I Like America, America Likes Me* (Figure 3.2). The artist, wrapped in felt in order to insulate his body from society, was transported in an ambulance from Kennedy Airport in New York to the René Block Gallery to spend eight hours over three days with a live coyote. A wire grille was erected in the studio to demarcate the audience's space from the area that housed artist and coyote. Beuys brought a number of materials with him including the felt, straw to lie on, a triangle, a cane and a torch. His work with these items was careful and specific in the manner of a planned ritual, but Beuys displayed an openness to the coyote; the action was guided by the animal's pace and response to the objects. Despite their differences, in the action Beuys and the coyote find a way of interacting, living and communicating together, and there is a clear echo of the shaman's training here.

Figure 3.1. Marcus Coates, *Dawn Chorus, Stills Compilation*, 2007. Fourteen channel high definition video installation. Commissioned by Picture This and BALTIC Centre for Contemporary Art, funded by the Wellcome Trust. Courtesy of the artist and Workplace Gallery.

There is a clear engagement with anthropology in operation in both artists' work; Coates refers to his preparatory work with Geoff for *Dawn Chorus* as 'fieldwork', and when discussing *Local Birds* (2001), an earlier project where a similar sound technique was used, he comments: 'People said the film uncovered something fundamental about the singers' personalities – I think it emphasized the particularities of

Figure 3.2. Caroline Tisdall. Photograph of Joseph Beuys' action, *I Like America, America Likes Me* (1974). By kind permission of Caroline Tisdall. ©DACS, 2009.

their humanness.'[19] Anthropological questions are also central to Beuys' work, yet it is noteworthy that the German artist gives a hermeneutic inflection to the role of his art works in shedding light on the meaning of humanity. In an interview with Schellmann and Klüser of 1970, Beuys commented, 'Using the example of an animal you can get to an answer to the question: what is the human being, how is he meant?'[20]

A particular interest in the therapeutic aspect of the shaman's role is reflected in both Beuys' and Coates' practice. Coates describes his decision to engage in shamanic work as a means to use his skills in social contexts to help people, 'it struck me that I could use my animal 'becoming' skills as a purposeful tool on behalf of others.'[21] In the two-screen installation *Journey to the Lower World* (2004) (Figure 3.3), Coates offers to help a Liverpool-based residents' group whose block of flats is threatened with demolition by undertaking a shamanic journey to the 'lower world' on their behalf to ask for help from animal spirit guides and gain advice about their situation. There is a clear shamanic 'format' to Coates' performance; he closes the curtains of one of the flats in the block to shut out the daylight and turns to his audience, explaining what he is going to do. He then asks the residents to formulate a specific question and discusses this with them. After a number of preparatory acts, he undertakes a *Journey to the Lower World* on their behalf, holding their concerns in his mind as his intention. Circling around, he makes animal cries, amidst hoots of laughter and anxious looks from the residents. Once he has returned from his journey, Coates discusses and interprets what he has experienced with the audience and elicits their feedback.

Coates' explorations of the shaman's role are quite closely allied to descriptions of the shaman's work in an ethnographic sense, but are in no way presented as literal

Figure 3.3. Marcus Coates, *Journey to the Lower World (Coot)*, 2004. Funded by Film London. Photo by Nick David. Courtesy of the artist and Workplace Gallery.

interpretations. The artist makes his activities look deliberately amateurish, clearly establishing that he is actively appropriating other cultural traditions and that this should not be seen as an attempt at absolute authenticity. Coates draws both from core shamanism (anthropologist Harner's elaboration and teaching of the fundamental, cross-cultural principles and practices of shamans) and aspects of a Siberian Yakut shamanic ritual he has read about in the work of Waclaw Sieroszewski to create his 'performance'. At times the results are hilarious; instead of using the requisite broom to clear the energies of the room before the journey as in the Yakut ceremony, the artist has a quick hoover round. Despite its rough edges, Coates brings back a teaching from his engagement with the spirits and the artist's interpretation of it appears to have an effect on the group. As Wallinger puts it, 'The plausibility or otherwise of Coates as a shaman is a joke we share with the audience in the film. Faith doesn't reside in the slickness of representation.'[22] For Coates, the value of the journey is not in its objective authenticity, but its capacity to focus on, and stimulate discussion about, issues that are troubling the community. Finlay notes, 'although you are partly motivated by scepticism – of weekend shamans and cultural misappropriation – the project is not a parody, otherwise how could it be generous to its audience?'[23]

Beuys' work, too, reflects an interest in the therapeutic potential offered by an artistic concern with the shaman's role, and its engagement with dialogue is strikingly similar to that of Coates. Beuys explains, 'I am much more interested in a type of theory which provokes energy among people and leads them to a general discussion of their present problems. It is thus more a therapeutic methodology.'[24] However, Beuys' position seems less straightforward than that of the contemporary artist, addressing broader questions around human interactions with, and notions of, material substance. Despite his clear reference to the training of the shaman in *I Like America, America Likes Me*, Beuys was emphatic that his work did not seek to resurrect shamanic practice in a literal sense, even where he appeared to adopt the shaman's role. The artist explained:

> My intention is obviously not to return to such earlier cultures but to stress the idea of transformation and substance. That is precisely what the shaman does in order to bring about change and development: his nature is therapeutic ... while shamanism marks a point in the past, it also indicates a possibility for historical development ... So when I appear as a kind of shamanistic figure, or allude to it, I do it to stress my belief in other priorities and the need to come up with a completely different plan for working with substances.[25]

The shaman's role appears, then, to have been seen by Beuys as a means of emphasizing particular ideas around the historical evolution of the human being over time, the development of a new way of thinking about material as substance and a future notion of how the human being could work with this. Michael Tucker recognizes in Beuys' notion of 'substance' a completely different understanding to that of positivist science and *one intrinsically linked to the artist's decision to work through art*:

> What Beuys meant by the term 'substance' (or capital) was utterly different, growing out of a shamanistic perception of art (capital) as creative, animistic energy and

imagination: the ultimate root of any possibility of growth towards a non-totalitarian world of social and cosmic totality. As he said at the time of *How to explain pictures to a dead hare*: 'It's a question again of Which Reality? Is it the limited materialist understanding of *materia*, or is it *substance*? Substance for me is the greater issue and includes evolutionary power which leads ultimately to the real meaning of Materia, with its roots in MATER (mother – as in "mother earth"), as one pole of spirituality, while the other encompasses the whole process of development'.[26]

At a surface level, Coates' work displays a clearer ethnographic engagement with shamanism, however the nature of Beuys' work seems to reflect a deeper exploration of the methodology's potential to inform an artistic approach that could provide a counter-balance to Western paradigms of healing. Although there is a clear engagement with anthropology in Coates' practice, in postmodern mode, the contemporary artist seems reluctant to extrapolate a broader project from his observations, indicative perhaps, of the change of focus and strategy that Nicolas Bourriaud identifies in art of the 1990s, 'The issue no longer resides in broadening the boundaries of art, but in experiencing art's capacities of resistance within the overall social arena.'[27] Coates, working in the noughties, resists seeing his shamanic 'performances' even in terms of art, though the documentation of his journeys is presented as such: 'I didn't want to make "art" with them so much as provide them with some helpful information.'[28] This suggests a disaffection with the usefulness of seeing such work in terms of art at all, and would explain why the dead hares, which Coates holds in *Radio Shaman,* seem illustrative and full of pathos, as well as humour.

Beuys' actions exemplify a serious epistemological critique and move beyond the scope of a performance metaphor; the artist's comment with respect to his action *The Chief* (1963–4) is revealing in this respect: 'Such an action, and indeed every action, changes me radically; in a way it's a death, a real action and not an interpretation. Theme: how does one become a revolutionary? That's the problem.'[29] Responding to the shaman's engagement with visible and invisible substance, Beuys seems to work with both in his actions in order to develop a new epistemological position relating to the human being's capacity to transform; the artist's choice of the term 'action' rather than performance points to an emphasis on the fact that during these live works something palpable is being created. At the end of his account of the 1970 action *Celtic Kinloch Rannoch (Scottish Symphony)*, Alastair Mackintosh comments, 'Thus told it sounds like nothing; in fact it is electrifying.'[30] Beuys' work does not only appear transformative to the immediate audience present at the action, it *feels* palpably transformative both to them and to the spectator who encounters the work through photographic or video documentation.

A QUESTION OF ETHICS

To what degree do Coates' and Beuys' work raise ethical issues? Coates admits, 'lots of things worried me, such as questions of ethics, appropriating rites from another culture, setting myself up as a medium, my lack of training ...'[31] In preparation for *Journey to the Lower World*, the artist took a one-day core shamanism workshop in

Notting Hill. This may be seen as a form of participant observation, but it is fieldwork of questionable depth; the course is only an introduction and the artist makes it clear that he did very little additional research and training. Coates deliberately misappropriates, combining core shamanism with aspects of the Siberian Yakut shamanic ritual to create his own 'performance'. The deer headdress he wears during the session is absurdly literal; Peg Weiss explains that '[t]he feathered headdress was widespread across Siberia', but that where the headdress or cap of particular tribes represented the reindeer or stag, it was 'surmounted by iron "horns".'[32] The artist also displays a lackadaisical attitude to methods, which, it could be argued, suggests a lack of respect and could be seen as downright unwise given the psychodynamics of such a practice. Despite having read that 'this kind of "imitation" is considered dangerous in some shamanist cultures', Coates undertakes animal mimicry during his shamanic journey, simply because 'this is what I wanted to do, to see if I could test what my animal and bird voices could achieve.'[33]

Yet, as discussed earlier, the partial ineptitude of the performance is clearly part of its intent. The artist's work suggests that what might be unethical about any Western appropriation of shamanism is the pretence that there is any 'correct' way of approaching it and that it is ever free of the cultural baggage of the appropriator; Coates is drawing from a translation of shamanic principles and practice for a Western audience and an ethnographic description of a Yakut ceremony written by Sieroszewski, a Polish writer exiled to Siberia, who, Edward Manouelian argues, expressed a clear subversive political agenda through his anthropological accounts.[34] The artist wears his dual strategies of interest and scepticism firmly on his hooves, creating what Jonathan Griffin refers to as 'a constant itch in the understanding of his position.'[35] Yet the double-aspect of the work makes it very hard to query the ethics of Coates' practice without coming across as an overly worthy purist, a pedant with a taste for anthropology as science who does not fully understand the work's simultaneous credulity and critique, its wider concerns with communication and language and its discussion with Beuys' work. At the same time, it makes his work difficult to categorize with respect to notions of 'hard' or 'soft' primitivism; Coates seems to recreate indigenous rituals, however, he deliberately misappropriates them, and shows only a superficial interest in their cultural contexts.

Arnd Schneider has put forward the argument that it is important to look at artistic intentions, and that appropriation, rather than necessarily constituting a dubious and primitivistic act, may have a hermeneutic potential to engender transformation: 'appropriation should be re-evaluated as a hermeneutic procedure – an act of dialogical understanding – by which artists and anthropologists negotiate access to, and traffic in, cultural differences.'[36] Such a hermeneutic process appears to be at work in Beuys' practice. In the BBC4 documentary *Joseph Beuys and Me*, Caroline Tisdall notes that the emphasis of *I Like America, America Likes Me* was on the importance of dialogue and the notion that the ability to express thoughts and feelings through language is not exclusive to the human being:

This was a dialogue emphasising that human beings don't have the monopoly of language, feeling, instinct and just by watching that people would understand that

there were many other ways of talking, expressing, feeling, thinking in the world. I think that's a great message.[37]

Donald Kuspit points out that Beuys' work often engages in a dialogue with a figure that has been conceived of as having been 'a victim of destruction'.[38] As curator Sean Rainbird explains, Beuys 'went to meet only with the coyotes. So his whole contact was with the, if you like, the downtrodden, misunderstood, the "pest" animal of America'.[39] For Kuspit, this was a means to encourage the audience to see the humanity in the dehumanized victims of the Third Reich, to transform guilt into empathy and productive creativity, to revive people's sense of their own humanity, an issue which the artist saw as being of vital importance in post-Second World War Germany.[40] Stachelhaus describes Tisdall's broader interpretation that the work's focus related to 'man's tendency to project his own sense of inferiority onto an object of hate or a minority'[41] and this supports Kuspit's argument that Beuys' work not only leads to empathy with and understanding of the other, but also plays a vital role in *the psychic well-being and transformation of the self*.

Coates' work could also be seen in hermeneutic terms in Schneider's sense, as a practice engaged with the potential of appropriation to transform self and audience. In the works that refer to the shaman's role, Coates shows an intent to help the communities he journeys for, and he does return with findings for them to work with. He seems to be, to some degree, open to transform himself through an engagement with shamanic practice and professes an interest in what his engagement with the shaman's role says about the potential of all human beings: 'perhaps this stuff's in all of us, perhaps anyone can do it, perhaps it's about being human.'[42] However, I would suggest that there is still a limited openness to being transformed by difference in evidence. Though Coates displays a receptivity to the spirit guides he meets while journeying and clearly seeks to develop his understanding of the shaman's role, the superficial nature of his knowledge and his apparent resistance to extrapolating understandings from this methodology, which could inform his notion of art, seems to put a break on the radicalism of the work and its potential to transform artist, immediate and future audiences.

Schneider identifies Beuys as a 'hard primitivist', a term relating to those who 'become involved in the recreation of indigenous rituals, assume the indigenous on a more personal level, and show a greater interest in the cultural context.'[43] However, as with Coates, there is a degree of slippage here. There is a clear syncretism in works such as *I Like America, America Likes Me*. Beuys takes the alternative paradigm, which shamanism represents, and integrates it within a form of activity, a notion of artistic shaping, social sculpture, which is informed not only by an understanding of shamanism but a broad-ranging knowledge of Western and Eastern thought, constituting an artistic approach which could allow the practitioner to 'perceive sculptural things that are not perceptible with a normal instrument of perception.'[44] In Beuys' phrase, there is an explicit echo, not only of shamanism, but of Johann Wolfgang von Goethe's call for a notion of science based not only on rational observation, but other forms of human perception including intuition, and his argument that 'Every new object, clearly seen, opens up a new organ of perception in us.'[45]

It is noteworthy, in this respect, that some of the most moving aspects of Coates' work lend themselves to exactly this broader approach to observation. The single-screen video installation *Stoat* (1999) shows Coates' attempts to move around on stilts that he has made, which replicate the distance between the paws of a stoat. The artist's stumbling attempt has a moving humility and in the closing shot of the installation, we see his faltering passage start to take on a beautiful confidence as he steps out of view. Yet potential insights about perception available in this work, the way in which it could open up 'new organs of perception' in both artist and audience is not fully explored, as is the case in those works in which Coates adopts the shaman's role. This limits both the work's potential to transform and any possible investigation about what such processes might mean in terms of notions of substance.

CONCLUSION

Both Coates' and Beuys' work reflect a longer tradition of self-identification with the shaman's role within Western art – a means by which particular artists have sought to access a well-spring of therapeutic resources that can be brought to bear on the social contexts in which they operate. Notions of the artist-genius seem largely absent from the work of both artists, however, who seem more interested in investigating what the role of the shaman might indicate in terms of the potential, and often latent power, of all human beings. A comparison of the two artists' work points to the usefulness of a typology of appropriation, which, as Schneider suggests, integrates notions of 'hard' and 'soft' primitivism with the need to engage with artistic intent.[46] Coates' work in particular suggests the need for a model for understanding appropriation, which can allow for artistic critique, including that of the self, while retaining a degree of ethical questioning.

The work of both artists appears to be, to borrow Weiss's description of Kandinsky's oeuvre, 'neither strictly ethnographic nor paradigmatically artistic.'[47] Indeed, Beuys' practice reflects an engagement with shamanism as a methodology that seeks to inform an entirely new understanding of what art constitutes, and the artist's central intention is the stimulation of transformation and human creativity. It is interesting that Beuys' actions, which avoid an overly literal evocation of the shaman's work, have been the source of considerable derision by critics, particularly in the English-speaking world. The humour in the artist's actions is often obscured by this cultural anxiety, which would appear to relate to concern about the artist's wartime role as a Luftwaffe pilot and radio controller, the socio-political context in which the work was created and its related project of social sculpture, rather than to attempts by the artist to re-enact specific shamanic rituals. It may also be a direct response to the work's transformative power.

By contrast, Coates' performances appear to elicit more amusement than concern, but their serious implications are easy to overlook as a result. Kuspit argues that in his belief in the subjective, creative power of the self 'Beuys seems transitional between the modern and the postmodern. He is caught on the horns of the dilemma they represent.'[48] Placing Beuys alongside Coates, one might reconfigure Kuspit's analogy

thus: if Beuys' engagement with the shaman's role is reduced to a performance meta-phor and understood only in a literal sense, then the radical, future-oriented impulse behind it and its exploration of an expanded notion of substance are elided, and it is artists such as Coates who founder on the horns of this transitional dilemma as a result, treading a 'fine line between pathos and bathos'.[49] Unlike that of Beuys, the 'double' aspect of Coates' work appears not only as the cathartic position of the trickster, but as a reflection of the schizophrenia of his artistic predicament, as reflected in JJ Charlesworth's comment regarding *Journey to the Lower World*:

> The shaman of *Journey* may be a charlatan, because his act, the act of art making things better, seems too implausible – not because he has belief, but because he has not convinced us to believe in him. Yet this derelict form of character is one that we are nevertheless happy to maintain in the more contemporary guise of the socially committed artist. What or who exactly is Marcus, the artist, mimicking?[50]

Coates' anthropological and artistic work is humorous and engaging, and in adopting the shaman's role he raises the possibility of other ways of knowing. Yet arguably, the contemporary artist's practice also reminds us of the increased urgency of the resolution of dilemmas around notions of contemporary art. A serious dialogue around Beuys' anthropological approach in relation to contemporary debates in anthropology and art, particularly focused on issues of creativity and material, could play a vital role in this respect. Coates' shamanic performances shine a moving and funny spotlight on the human being's predicament and potential, but ultimately they point us in the direction of the vibrant beacon of Beuys' practice, and the twentieth-century artist's adoption of the shaman's role is of quite a different substance.

Hearing Faces, Seeing Voices: Sound Art, Experimentalism and the Ethnographic Gaze

John Wynne

The word itself, 'research', is probably one of the dirtiest words in the indigenous world's vocabulary.

Linda Tuhiwai Smith, *Decolonizing Methodologies: Research and Indigenous Peoples*

Anthropology may indeed be, for some artists, 'the compromise discourse of choice',[1] but it can also – potentially – provide valuable resources of critically evaluated knowledge and a continuously developing research framework by which to make art that deals critically with social realities. Of course there are dangers in artists colonizing one field of study after another, appropriating the useful bits without truly engaging with the ethos and ethics of other disciplines and taking up buzzwords and fashionable concepts in the most facile way, but if artists strive for responsible social engagement through their work, there is much to be learned by familiarizing ourselves with the issues and debates that occupy that group of disciplines known by the increasingly uncomfortable term, the social *sciences*.

It is sometimes problematic for artists who do fieldwork that, as Lucy Lippard describes in the context of the tourist, '... experience comes first and theory later, once we realise what we *should* be thinking.'[2] Thankfully, some sound artists, recordists and composers do take the time to *think* rather than blithely engage in the kind of sonic tourism and commodification of ethnicity that marks many endeavours.

But developing self-reflexive research and production practices both in the field and in the studio (or at the desk) is as important for artists as it is for ethnographers and anthropologists. The following passage from Rosanna Hertz's introduction to *Reflexivity and Voice* is frequently quoted by ethnographers and could equally be taken as advice for artists engaged in cross-cultural practice:

To be reflexive is to have an ongoing conversation about experience while simultaneously living in the moment. By extension, the reflexive ethnographer does not simply report 'facts' or 'truths' but actively constructs interpretations of his or her experiences in the field and then questions how those interpretations came about... . The outcome of reflexive social science is reflexive knowledge:

statements that provide insight on the workings of the social world *and* insight on how that knowledge came into existence. By bringing subject and object back into the same space (indeed even the same sentence), authors give their audiences the opportunity to evaluate them as 'situated actors' (i.e., active participants in the process of meaning creation).[3]

With the *sensory turn* in anthropology, the subjective experience of the senses – a primary element of artistic practice – is overtly recognized as an important aspect of fieldwork; with the *ethnographic turn* in contemporary art, much art practice involving fieldwork can similarly be mapped to varying locations on the 'experience/interpretation axis'.[4] In my own work, the interleaved and iterative processes of research, fieldwork and creative practice shares a great deal with ethnographic methodology as I strive for responsible engagement with other cultures and a praxis which is neither culturally insensitive nor insular. Yet the perceived need for sensitivity in cross-cultural work, reinforced by the kind of socio-political vigilance fostered by the social sciences, can also be stultifying. By implicitly challenging the position of anthropologists as 'privileged representers of difference',[5] artists submit themselves to 'the anthropological or ethnographic "court of judgement"',[6] sometimes a less than comfortable place to be. And an awareness of 'the indignity of speaking for others' can, and in some cases has, as Hal Foster points out, 'effected ... a censorious silence as much as an alternative speech'.[7] The challenge for both anthropologists and for artists whose work takes them to places where they don't *live* is to provide more than a shallow reflection of the received mythology of the *other*, the equivalent of Michael Taussig's half-serious description of ethnography as a process of 'telling other people's stories – badly.'[8]

Much of my practice over the last decade or so has led me into political and ethical minefields – working with speakers of endangered indigenous languages and with vulnerable heart and lung transplantees – where there is always a tension between, on the one hand, the need to respect the people with whom I work and to contextualize the recordings, information and images I collect and, on the other, my ambition to experiment with sound itself and to express the ideas and issues that interest me through work that is not purely documentary. I don't want to exploit difference and make work that draws on the exotic mystery of the *other*, to construct an essentializing mythology in the way that, in early ethnographic recording, 'particular performances were important only insofar as they could be used to reconstruct a paradigm for song, story, narrative, or myth in a given culture.'[9] But I do want to investigate the boundaries between documentary and abstraction by working with the raw materials gathered during my fieldwork in ways that are not always representational but nevertheless reveal something about the subject (Figure 4.1).

My exploration of what could be described as *composed documentary*[10] began in 1999 with *Upcountry*. This piece was originally conceived of as a sonic portrait of Kenyan master musician William Ingosi Mwoshi but moves beyond restrictive notions of portraiture to become as much about where he lives and my experience of it as about Ingosi himself. I sought ways of working with my sound recordings that would convey the subjectivity of my perspective without abandoning the context

from which the sounds arose. As John Miller Chernoff puts it in relation to the anthropologist, 'finding the proper level of abstraction to portray with fidelity both the relativity of his own viewpoint and the reality of the world he has witnessed necessarily involves an act of interpretation ...'[11] I do not set out to *obscure* the margins: the listener usually recognizes which side of the border they are on, but as my work oscillates between speech and sound and between sound and music, documentary and abstract elements inform each other so that the listener's experience is enriched through their interaction in ways that it wouldn't be through either conventional documentary or musical abstraction of recorded material alone. The apparent objectivity of documented reality is continuously questioned. As Katherine Norman describes it, *Upcountry* allows documentation and abstraction to 'disentangle, and even disagree'. She continues, 'You can be with Ingosi; you can be with Wynne. You can keep one person's world in mind whilst listening to the other's. And it isn't that difficult to accept both worlds ...A portrait that really sings is, after all, as much about the painter as the person in the chair. And observing the distance between the two is

Figure 4.1. Thamae Sobe (image from *Hearing Voices* installation). Photograph by Denise Hawrysio.

part of the whole experience.'[12] The result is a kind of intersubjectivity, a listening experience that reflects on the subjective experience both of artist and subject as well as implicating the listener in a more active and creative process. And of course there is the *intersubjective turn* in anthropology (some anthropologists must be getting dizzy with all this turning), a recognition of the self-reflecting nature of the endeavour to understand the *other* and the subsequent focus on field diaries, sketches and other materials generated in the field formerly dismissed as too subjective.

STUPIDITY, INTIMACY AND TECHNOLOGY

I approach new projects with an attitude of openness and a willingness to embrace my own ignorance, a recognition of my own *stupidity*. Foucault sought to 'recuperate stupidity' as a philosophical strategy, arguing that intelligence represents 'stupidity already vanquished'[13] and that the best way to move forward is to allow the world to pass through us and affect our thinking rather than to begin by assuming our own intelligence. The philosopher

> must be sufficiently 'ill humored' to persist in the confrontation with stupidity, to remain motionless to the point of stupefaction in order to approach it successfully and mime it, to let it slowly grow within himself ..., and to await, in the always-unpredictable conclusion to this elaborate preparation, the shock of difference.[14]

John Cage famously approached composition from a self-professed position of not knowing what he was doing. Of course this is essentially a metaphor for what he saw as the appropriate humility with which to approach the making of art, but it is also a suitable posture for those engaged in fieldwork and research-based practice. Linda Tuhiwai Smith writes 'If I have one consistent message for the students I teach and the researchers I train, it is that indigenous research is a humble and humbling activity.'[15] I became interested in click languages through following my ears and knew little about language endangerment or the circumstances or history of the Khoi and San peoples when I began the Botswana project; when I was in school as a child, Canadian history was almost exclusively about events after the arrival of Europeans so, having left Canada many years ago, I likewise knew little about the history or contemporary situation of aboriginal peoples in Canada before embarking on my project with speakers of the Gitxsan language in British Columbia. When I became artist-in-residence at one of the world's leading centres for heart and lung transplants I was largely unaware of the complex issues surrounding transplantation.

My research begins with listening – to the voices of the ostensible subjects of the work and those of academic/professional specialists (who are also *other* to me in significant ways), and to the environmental context of the fieldwork – asking sometimes naïve questions and building a perspective from the ground up. In the case of the *Transplant* project, photographer Tim Wainwright and I spent a great deal of time going through ethics committees, speaking to psychologists, medics, nurses and technical specialists and exploring the hospital itself both visually and sonically in addition working directly with fifty or so patients.

For the Khoisan and Gitxsan projects, the fieldwork was undertaken in collaboration with linguists with long-term involvement in those communities. This strategy gives me access to specialized knowledge before, during and after the fieldwork but it also distances me somewhat from the speakers themselves. This distance, however, allows me to listen more closely and to concentrate more on the technical processes in order to make recordings that could constitute significant contributions to the documentation of these languages and important archival material for the community as well as excellent raw materials for my own work and that of linguists. These projects involve a kind of double-layered fieldwork: I am, in one sense, observing/ recording the social scientists observing their subjects, allowing the social interaction and indeed the substance of the recordings to be determined largely by *their* working methods. By contrast, the *Transplant* project is described by anthropologist Tom Rice as 'an intimate form of ethnographic documentary, so intimate in fact that it can make uncomfortable, even shocking viewing/listening. Importantly, the installation brings its audience into such proximity with patients that we become, like the patients themselves, captive – unable to escape a confrontation with the reality of illness.'[16]

As Schneider and Wright point out, 'Both artists and anthropologists play with distance and intimacy – an intimacy that is the currency of fieldwork – and both now overtly place themselves between their audiences and the world.'[17] Whilst we generally steered away from sensationalism and overtly emotional content in the *Transplant* project, the degree of intimacy in that work would feel less appropriate in my endangered languages projects. In the case of *Upcountry*, there was a huge cultural and economic gap between Ingosi and myself. Despite being recognized as one of Kenya's finest neo-traditional musicians he lives in considerable poverty on a *shamba* (smallholding) with no electricity or running water. But we are both artists and there is often a sense of affinity between creative practitioners stretching across cultures, which I think comes across in the piece, particularly when it premiered in London followed by a performance by Ingosi himself. The political and social history of the Khoi and San peoples in Southern Africa is unfortunately comparable to that of the most oppressed indigenous groups around the world. Since their traditional lifestyle has been made virtually impossible by the fencing off of land for cattle owned primarily by the Bantu-speaking majority in Botswana, the earmarking of vast areas of the Kalahari as game reserves, and the demands of the diamond mining industry to which Botswana largely owes its modest wealth, most have endured marginalized lives, including forced evictions and near slave-labour conditions in jobs that have little or no connection to their indigenous culture. Poverty, alcoholism and AIDS are rife and their social and economic marginalization further erodes the status of their various cultures and languages. It was partly in recognition of the gulf between their circumstances and mine that I chose to use photographs in which their faces are obscured by the recording equipment. Although there are similar, if less severe, problems with poverty and alcoholism on the Kispiox reserve in Canada and other significant differences between myself and the members of that community, I also found considerable cultural ground shared with some people with whom we worked, particularly those of my own generation. The complexity of this relationship inevitably informs the outcome of that project.

In the installations emerging from the Khoisan, Gitxsan and *Transplant* projects, I combine sound and still image in new ways: flat speaker technology allows me to *personalize* the sound because each large photograph *is* a loudspeaker, the actual source of each of up to 24 independent channels of sound. In this sense, the work offers an alternative to what Susan Stewart refers to as 'the silence of the photograph' and its 'promise of visual intimacy at the expense of the other senses'.[18] The photographs are *animated* by sound, but at the same time the actual images in *Hearing Voices*, my click-language installation, deny visual intimacy and make it clear that we neither hear nor see with complete objectivity. The images from which the sound emerges – photographs taken by visual artist Denise Hawrysio during the recording sessions and subsequently digitally manipulated – are composed to simultaneously reveal the process, symbolize my own presence and disrupt, frustrate, or at least problematize, the ethnographic gaze, the '"ethnotopia" of limitless observation'.[19] They question the easy association of the photographic image with *presence* and disrupt what Barthes describes as the 'antiphon of "Look," "See," "Here it is"'[20] common to all photography. The photographic composition suggests the '"facelessness" such people have suffered in world dialogues'[21] and highlights the power relations that are of particular relevance to technological mediation in cross cultural work. As David Toop puts it:

> The portraiture integrated into the playback system of this installation counters the shift towards a detachment from human agency, yet also engages with the mediating effects of recording technology. Faces are obscured; voices are extended, or filtered, until their meaning is abstracted. These faces, and voices, are both highlighted by the wider world of digital communications, and with conscious irony, absorbed by its power.[22]

There is also tension in my work between the inherent, inescapable temporal movement of sound and the full stop of photography, Barthes' 'flat death'. In *Transplant* the symbolic death of the photograph is given further resonance through the parallel symbolism of organ transplantation and its offer to defeat physical mortality.

Practitioners experimenting with alternative approaches to ethnographic fieldwork now sometimes 'explicitly aim to give voice to researchers and researched, as multiple selves of the field.'[23] In this work, my own voice is implicit in the way the recordings and the images are manipulated, framed and presented. It is, in some respects, an attempt to achieve what Hal Foster advocates: 'a parallactic work that attempts to frame the framer as he or she frames the other. This is one way to negotiate the contradictory status of otherness as given and constructed, real and fantasmatic ...'[24] The recording equipment is my symbolic presence within the frame and the technology itself represents the developed North; it stands between the viewer and the subject and means different things depending on which side of it one finds oneself.

It would be difficult to deny a degree of *voyeurism/ecouteurism* in my work, but within *Hearing Voices* there is also a critical awareness of recording as a symbol of power and of the economic inequity which inescapably frames my relationship with the subjects. The somewhat anxious repetition, throughout the history of ethnographic recording, of images of subjects listening to themselves may, on the surface,

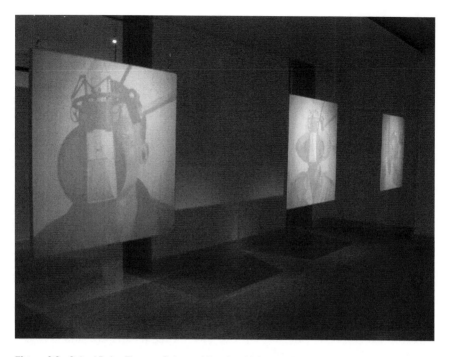

Figure 4.2. Cukuri Dako, Thamae Sobe and Gosaitse Kabatlhophane (*Hearing Voices* installation detail). Photography by Denise Hawrysio.

demonstrate *their* fascination with *our* technology. But a current of condescension lingers whereby the *civilized* viewer inevitably feels superior to the *primitive* folk who may never have heard themselves reproduced artificially. For Taussig, 'the more important question lies with the white man's fascination with their fascination with these mimetically capacious machines.'[25] In the developed world, recording devices are, in a very real and very far-reaching sense, the 'technological substance of civilized identity-formation'.[26] This internalization of technology amongst those in the North is confirmed by my experience that people are sometimes more intimidated by microphones and recorders than those in remote areas who are less accustomed to seeing and using them. Perhaps a more intimate knowledge of their power and their ability to distort the truth leads to a greater suspicion of those who wield them (Figure 4.2). The *Hearing Voices* images are deliberately low in contrast and high in brightness: Joram |Useb, a representative of the Working Group of Indigenous Minorities in Southern Africa who opened the exhibition at the National Art Gallery of Namibia, noted that the faded printing of the images was a fitting analogy for what is happening to Khoisan languages and cultures. The composition and printing of the images also imply a questioning of visual dominance in the gallery context, encouraging the audience to concentrate on the sound and reflecting the importance of the *aural* in oral cultures.

Hearing Voices signals the impossibility of reproducing objective reality and high-lights the microphone as a 'non-neutral interface'.[27] Unlike early ethnographers, for whom 'purging the messy means by which information was acquired' was perceived as necessary for maintaining the apparent objectivity and authority of their work, photography is used here to underscore the 'inevitable artificiality of the encoun-ter',[28] to question the assumption that, in Heidegger's words, 'technology comes to presence ... in the realm where revealing and unconcealment take place, where *alétheia*, truth, happens,'[29] and to convey a sense of simultaneous movement towards and away from the subjects. We hear their voices as though our ear was centimetres from their mouths, but we cannot forget the technology that is allowing this intimacy. Jonathan Sterne notes that doctors have historically learned to forget that other means of hearing the *other* while maintaining physical distance, the stethoscope: 'In classic technological deterministic fashion, the tool stands in for a whole process from which it erases itself. Mediate auscultation was thus a "license to forget," a kind of reification. The forgetting associated with technology was the forgetting that all learners do as they achieve mastery ...'[30] The stethoscope and the microphone alike become tools of social mediation, allowing intimate listening while at the same time establishing a bodily distance between doctor and patient, documenter and docu-mented – a distance that in effect 'renders social difference spatial'.[31]

Recording technology, while helping to preserve oral history in non-literate cultures, can also be instrumental in its demise. In the traditional culture of many indigenous communities, specific individuals were given the task of remembering im-portant stories or significant and potentially disputed agreements between individu-als such as those concerning territorial rights. Writing and, later, recording devices, began to make these civic positions redundant, providing another 'licence to forget'. The rise of renewed cultural awareness and pride amongst native communities in Canada in the 1970s coincided with the availability of cheap cassette recorders and many families and clans recorded the voices of their elders. Once committed to tape, the stories – and sometimes the tapes themselves – were often forgotten. Recording technologies can thus obviate the need for embodied knowledge – 'knowledge literally stored in the body'[32] – and so accelerate the very changes in the social and personal spheres they may seemingly offer to ameliorate.

As well as signifying the social and economic gap between artist or social scientist and the *other*, recording technology also mediates emotional relations. Indeed, re-cording can replace emotional interaction, as Jean Wainwright notes:

Warhol acquired his first tape recorder (a reel to reel) in the mid 1950s.
 In the summer of 1965 he engineered a deal with Norelco to acquire one of their cassette audio recorders. This acquisition began his relationships with faithful machines that were both surrogates and mediators. He referred to the tape recorder as his 'wife' and quipped that 'when I say 'we' I mean my tape recorder and me.' He declared that his tape recorder finished whatever emotional life he had; an interesting problem 'was an interesting tape'. Terrified by death, driven by curiosity about how people lived their lives, Warhol stockpiled a knowledge system, an anthropological and sociological portrait of 'lived lives'.[33]

It could be argued that the current ubiquity of digital recording devices in the North, and increasingly in *developing* countries, is having a similar effect on people's experience of the world: instead of just *seeing*, instead of being *in the moment,* many of us are busy stockpiling images that we assume will record the moment for posterity but most of which are later deleted, forgotten or lost, so that rather than enhancing our memory, the camera becomes a tool for its diminishment and a barrier to direct experience. I certainly hear differently if I am actively recording sound, but the barrier that the microphone and headphones constitute also, paradoxically, allows me to hear in far greater detail.

The authenticity of ethnography and documentary has often been signalled by their apparent naturalism. Keyan Tomaselli observes that 'overtly ethnographic films tend to lack technical sophistication and competent craft skills'[34] and unsteady handheld camerawork and poor sound quality in some documentary films only add to their apparent realism and validity. Unfortunately, anthropologists and linguists often spend a great deal of time and money doing fieldwork, only to return with recordings that may suit their particular narrowly defined academic needs but are less useful as cultural and linguistic documentation for communities and academic archives. This is largely due to a lack of technical knowledge combined with the difficulty of working alone in less-than-ideal conditions, but also sometimes because of a desire to capture things *naturally*. Historically, 'ethnographic film is film which endeavours to interpret the behaviour of people of one culture by using shots of people doing precisely what they would have been doing if the cameras were not present.'[35] In contrast to this illusory practice, my working method in these projects has been relatively intrusive. I use a large, high-quality studio microphone placed a few centimetres from the mouth and a popshield to prevent overloading the mic. As a result, those being recorded are unavoidably aware of participating in a process of constructing meaning rather than behaving as though they were being captured as part of some unmediated reality. But, again paradoxically, this approach doesn't necessarily result in a lack of intimacy or excess self-consciousness.

Transplant patients spend long periods of time in a highly technologized environment: they often live in a 'spaghetti junction' of wires and tubes,[36] constantly probed, monitored and kept alive by bleeping, bubbling machines. Indeed many have devices such as ventricular assist devices (VADs, otherwise known as artificial hearts) inside them or nearby, noisily performing the functions of their failing organs twenty-four hours a day. So in some sense the equipment Tim and I brought to their bedside was just more *gear* – at least it would relieve the boredom and wasn't going to hurt. We used the process of setting up the equipment as an opportunity to expose and demystify it and, as Tim puts it, 'register the beginning of the communication process.'[37] But heart and lung transplant patients are, like people living on meagre government handouts in a squatter camp beside the Trans Kalahari Highway, in a very vulnerable situation. As David Toop explains it:

> As with photography, the ethics of interviewing a person in this condition is a delicate matter, not simply because of vulnerability or privacy, and the close intimacy that draws out expressions of deep fears and all the other emotions we

would expect, but because each person has become somewhat voiceless and helpless within the net of noise.

Physically and psychically they are invaded by its alarums, excursions and invasions. The secret internal sounds of the body have become louder than the voice. To be confronted in this state with an instrument of power (the microphone) that is notorious for its capacity to draw out, extract, and like a scalpel, open up, is to submit to the reverse process.[38]

Although we made it clear that we were there to get materials for a work of art, we did not attempt to steer patients towards specific utterances to suit our own purposes.

The direction of the project was in some ways determined by the participants: we were there to listen, and because we had no medical or psychological agenda and no emotional ties to the participants, patients were remarkably open and saw it as an opportunity for their voices to be heard, both for their own sake and for prospective transplant recipients and their families. With us, they didn't need to play the dangerous game of positioning themselves as sick enough to need a transplant but well enough and emotionally stable enough to survive it, and the hospital psychiatrist commented early on that patients often revealed more to us than to her.

Sometimes, a responsible approach to subjects entails recognizing that they know what they are doing/saying, and respecting the trust they have given by participating. When I wrote to a project participant on the Kispiox reserve to double-check that there would be no objections to my publishing one of the photographs from our session with her and her brother in this book, she replied that if they didn't want me to use the photographs they wouldn't have let us take them. By contrast, the ethics unit at the university which held the purse-strings was so concerned about the precise wording of the consent forms that by the time an agreement was reached the fieldwork had been completed, ironically without formal written consent. For people with a history of oral culture, sometimes their word is enough. After all, treaties were written documents, too.

EXPERIMENTALISM AND ETHICS

Basic research is when I'm doing what I don't know what I'm doing.[39]

Wernher von Braun

Although this statement may recall Cage's approach to composition as an activity in which he didn't know what he was doing, von Braun's biography alerts us to what can lie behind such an apparently apolitical stance. While he claimed to be more interested in space travel than in the military applications of rocket technology, he was a member of the Nazi Party and his work was instrumental to the development of Hitler's 'vengeance weapons', which were manufactured at the Mittelwork forced labour factory and later targeted on London. After the war, he worked for the US military, developing, amongst other projects, the rocket used for America's first live nuclear ballistic missile test.[40]

Research and experimentation are seldom without ethical implications, and indigenous communities are sensitive about being scrutinized by outsiders, particularly in the shadow of supposedly neutral fields of study such as anthropometry.

They are 'not only beginning to fight back against the invasion of their communities by academic, corporate and populist researchers, but to think about, and carry out research, on their own concerns.'[41] Australian aboriginals, the San peoples of the Kalahari (otherwise known by the less politically sensitive term 'Bushmen'), and some Native American groups have each been referred to by various observers as the most studied cultures in the world. 'The Navajos used to joke that a traditional family included the nuclear group, plus one grandpa ... a couple of aunties, and at least one anthropologist.'[42] There is resentment about this amongst some in these communities, but there are also many who still value the work of linguists and others who study and document their language and culture, who recognize the potential for such work to strengthen and preserve these and who see the work of outsiders as potentially complementary to that of community researchers and activists.

People can be understandably touchy when outsiders tell them that their language is dying, and there are examples of linguists being banned from working in communities as a result of their lack of sensitivity to such feelings. And in one notorious case, knowledge about traditional place names and territories acquired by a linguist working in the Fraser Valley in British Columbia was abused when he testified against the native community on behalf of Canadian National Railway, who wanted to double their track through First Nations territory against the wishes of the community.

In another case, knowledge gained by an anthropologist working with the Coast Tsimshian community somehow came into the hands of white commercial interests and the following season some very rich traditional abalone harvesting sites were virtually wiped out. It only takes one such instance for fieldworkers from any discipline to be viewed with caution or even hostility. Thankfully, the linguists who have worked with the Gitxsan language in the past have a good reputation in the community and we had no shortage of willing participants. We experienced only one directly negative reaction to our work, from a woman who said she was tired of people studying her culture and wished the money could be used to provide dentists rather than linguists. We were also aware that some people flatly refuse to work with any researchers because of the perceived possibility of commercial exploitation.

Experimentalism has been a key element in much art practice for at least a century and is also important in anthropology's attempts to adapt to changing relationships with its research subjects and to interrogate its position as a social *science* by looking at the practice of artists. Nevertheless, 'experimentation and creativity are differently conceived, and differently valued on either side of the border.'[43] Too much experimentation amongst anthropologists has historically 'proved unacceptable to the boundary-keeping institutional and professional rules of order in the academy' and the results consequently seen as 'idiosyncratic and certainly marginal'.[44] Artists are, of course, less constrained, but the experimental artist with an ethnological bent ought to be wary of the association of experimentation with the tropes of exploration and discovery. John Corbett writes:

This notion of discovery or exploration helps undergird the idea that the composer is engaging in a value-free, experimental endeavour, even as it allows us to suggest the colonialist impulse submerged in its rhetoric. It is assumed that the discoverer-composer, out on the open seas of aural possibility, surely will bring back ideas and practices from distant lands, perhaps ones that can enhance the quality of Western musical life. Musical experimentation becomes metaphorical microcolonialism.[45]

Nevertheless, such criticism should not stop the artist from moving into unfamiliar territory – 'unless, of course, s/he somehow lays claim to that territory'.[46] For artists, anthropologists and linguists to ignore cultures and languages that are under threat would be to take the path of least resistance by adopting the attitude of the overwhelming majority in the dominant culture(s). But as to whether it is possible for the relationship between artist/researcher and *other* to be symbiotic rather than parasitical, there is clearly room for disagreement, and it is difficult to oppose self-described 'universal Cherokee artist' Jimmie Durham's critique of non-native artists working with indigenous subject matter. When he saw Lothar Baumgarten's *The Tongue of the Cherokee* in the Carnegie Museum in the mid-1980s Durham 'felt appropriated and sort of cancelled', and in response made an installation that included works titled *Not Lothar Baumgarten's Cherokee* and *Not Joseph Beuys' Coyote*. The latter piece, which refers to Beuys's 1974 gallery performance with a live coyote, is 'a skull-on-pole figure with one horn arm and one large rearview mirror arm (the better to see who is catching up from the past).'[47] But such an exchange is surely valuable.

Although her priority is to promote the development of indigenous researchers, Maori writer Linda Tuhiwai Smith acknowledges that 'at some points there is, there has to be, dialogue across the boundaries of oppositions.'[48] Similarly, Audre Lorde has written of the 'creative function of difference in our lives. Difference must be not merely tolerated, but seen as a fund of necessary polarities between which our creativity can spark like a dialectic.'[49] Although there is another, less politically charged, sphere of my work to which I return (often with some relief) between the projects under discussion here, I see language endangerment as a critically important subject as well as an area rich in interesting sounds. The linguistic diversity of the world is under threat: of the approximately 6,000 languages in the world, it is variously estimated that between 50 and 90 per cent will be gone by the end of this century. Both the Kalahari Desert and the west coast of Canada are fragile and dwindling 'pockets of residual diversity'[50] where there are numerous distinct indigenous languages considered by linguists to be *moribund*. Some languages, like Upriver Halkomelem, have only a few very elderly speakers, but rather than focus on the arguably more exotic subject of a language that could cease to exist with the passing of one or two elders, I chose to work with a language whose decline can still – potentially – be slowed down, and which still has enough so-called *competent* speakers to help make the archives richer and more valuable to both academics and the community. Once Gitxsanimaax is gone – and few, even within the community, would dispute that it will be gone as a living language by the middle of the twenty-first century[51] – the unique knowledge and ways of thinking it embodies will be gone with it, apart from what remains in memory and in archives.

I came to the subject of language endangerment through my attraction to the *sound* of vocal clicks in the languages of Southern Africa, and my practice is based on experimenting with sonic material. These projects deal with the linguistic, communicative, social, political and personal dimensions of language, but I am also interested in using the voice – and contextual environmental sounds – as material for rhythmic experimentation and timbral and spectro-morphological investigation. I deconstruct, stretch, filter, and distil speech, listening 'inside and outside the material'[52] to find ways of working with it that allow others to hear more than documentary-style reproduction would allow. As Barry Truax and others have pointed out, techniques such as granular synthesis allow one to examine sounds on a micro level, so that when you *zoom out* again, there is a qualitative change in what you hear. By leading the listener back and forth across the boundaries between speech and sound, sound and music, my work constructs an experience that explores 'the various levels of meaning that can be derived from human communications.' Voice is the means by which the self is performed to others: 'Verbal language is ... used by almost all of us, so taken for granted, yet language is a complex act in which the message carried by speech is just one aspect of a convergence of cultural context, abstract sonic material, and human body functioning that encompasses breath and brain, gesture and noise.'[53]

In my composed documentaries for radio, environmental sounds are also at times manipulated and new ways of listening become possible in the transitions between representational and more abstract or musical sound material. But the voice always returns and its detail is always clearly in focus. In *Hearts, Lungs and Minds,* a half-hour piece commissioned by BBC Radio 3:

> The disorientating impression of envelopment in a confused web of sound is very strong, but this is repeatedly pulled back to specifics by recordings of the patients themselves. Feelings of fragility are pervasive and clearly audible in these bedside recordings: every tremor and lapse; the halting and wheezing of breath; ... the pain of what is said; the grain of how it is said.[54]

Patients' voices are not manipulated in any of the finished work emerging from the *Transplant* project, but in some of the work resulting from my collaborative fieldwork with linguists, where subjectivity and mediation are more significant elements and where the language is a central theme, the words themselves also become abstracted. In *Hearing Voices,* the click-languages are broken down to the basic constituents common to all language, vowels and consonants (clicks), and these become the fabric of the composed elements of the work. The Gitxsan language is marked by a prevalence of voiceless fricatives and other nearly inaudible breathy sounds, which offered an interesting and unanticipated contrast to the astounding percussive energy of the distinctive clicks of the Khoi and San languages and these sounds were used in abstraction to some degree in that project. Of course, translating my subjects' words into something between language and music is itself a process permeated with issues of power – a site of 'asymmetrical relations',[55] as Michaela Wolf describes the process of language translation. Sarat Maharaj writes:

How do we deal with difference without fixing it as a version of ourselves? How do we deal with difference without entirely reducing it to the terms and categories of our own language? It is not able to face the fact that it has demolished the other in some way. This act of violation at the heart of language, at the heart of conceiving the other leads me to look for para-linguistic ways of engaging the other.[56]

Sound art may offer one such para-linguistic strategy, a way of expressing cross-cultural experiences that language itself cannot achieve.

The difference that is untranslatable is not a fixed and essential thing; it is itself a product of translation and is itself always in motion. I think the only way in which people who are different can come to constitute a common conversation is by recognizing the inadequacy of each of our positions as well as what is not translatable.[57]

Manipulation and abstraction of acoustic source material can, rather than obscuring the actuality from which it was derived, convey meanings and reveal characteristics hidden from the senses in the context of real-time experience or even when listening to untreated recordings.

TRAGEDY, HUMOUR AND THE MUSEUM

What? Post-colonial? Have they left?[58]

Bobbi Sykes

The consequences of colonialism for indigenous communities around the world have been – and continue to be – devastating. But the degree of devastation varies, and many of these communities also continue to develop and strengthen an identity that is different from the cultures that surround them, even if some of what outsiders view as the essence of that difference has changed and continues to change. Like a healthy language, a strong culture can adopt elements from other cultures without necessarily undermining its own foundations. Gitxsanimaax shows many of the signs of a dying language (the fact that it is rarely spoken at home by/to children, the rising average age of competent speakers); it will be a dark day when the Gitxsan language is no longer spoken, and some of the things that disappear with it will be irretrievable, but this will certainly not be the end of Gitxsan culture. The pathos with which academics and others often view indigenous culture is undoubtedly one-dimensional: it is a 'partial, Eurocentric view, and so satisfyingly tragic!'[59] 'There is sadness here', wrote one gallery visitor of *Hearing Voices,* so perhaps my own work is not entirely exempt from accusations of 'imperialist nostalgia'. But material conditions for the Khoi and San peoples are far worse than those of the Gitxsan community: the people I met in the Kalahari Desert didn't have much to laugh about. By contrast, and despite the absurd historical prejudice that Native North Americans constitute 'a sombre-eyed, dark-faced ebb and flow of indistinguishable taciturnity',[60] there was a great deal of laughter during our fieldwork on the Kispiox reserve, and this is reflected

in the finished work. Some contemporary Native writers in Canada are 'confronting the white search for the "true" (that is, the vanishing) Indian with thoroughly hybrid real Indians instead.'[61] When I arrived at the National Art Gallery of Namibia to show *Hearing Voices*, one member of the board expressed her relief that the images did not portray the kind of culturally frozen stereotypes favoured by eco-tourist brochures, but rather showed members of a living – if beleaguered – indigenous community.

For both artists and anthropologists, it is in the gap between fieldwork and the final outputs of their projects that the playfulness and humour that often exist in the relationship between researcher and subject in the field can sometimes be lost as we think and analyse and process. In an essay entitled *How To Be as Funny as an Indian*, Ian Ferguson writes, 'My sister was once asked, by a ... well-intentioned White Person, the ... eternal question: "What do you people want?" "What we want," she said, "is for you people to lighten up."'[62]

My Gitxsan work premiered as part of an exhibition titled *Border Zones: New Art Across Cultures*[63] at the Museum of Anthropology in Vancouver, which includes a mix of indigenous and transnational artists. This is a tricky context. The museum sits on traditional Musqueam territory and such institutions have been justifiably criticized by aboriginal groups around the world for removing cultural artefacts from their community context and displaying them, sometimes in inappropriate ways, for others to gawk at. And although the education system in Canada has become more enlightened since my childhood, Karen Froman points out that 'the vast majority of teachers currently employed in the public school system have no training in native studies, and fall back on the stereotypes and the old methods of teaching. Aboriginal people are still museum pieces.'[64] In drawing parallels between ethnography and pornography, Bill Nichols describes the complexity of our relationship to the exotic: 'We are caught within oscillations of the familiar and the strange. We acquire a fascination *with* this oscillation per se, which leads to a deferment of the completion of knowledge in favour of the perpetuation of the preconditions for this fascination'[65] (Figure 4.3). My work seeks to encourage visitors to think about why they come to such places by interrogating the voyeurism of exotica and by challenging practices of representation and concepts of *otherness* through drawing attention to its own *othering*. Like *Hearing Voices, Anspvaxw* creates tension through its paradoxical simultaneous movement towards and away from its subjects and through the potentially conflicting

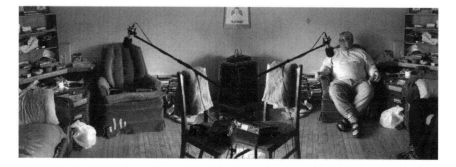

Figure 4.3. Bob Wilson (image from *Anspayaxw* installation). Photography by Denise Hawrysio.

requirements of documentation/explication and privacy/respect. It aims to create a contemplative space in which the audience can think about the issues that underlie the work and in which my presence as an artist co-exists with the *otherness* of the subject rather than either subsuming it or presenting it under the guise of objectivity.

Thankfully, the MoA recognizes its own position as a site of cultural contestation and has, for some time, been engaged in 'a critical re-thinking of the relationships among cultural institutions, originating communities, knowledge systems, and collections of art and ethnology.'[66] The museum's relationships with Native communities are a matter of ongoing negotiation. Tahltan artist Peter Morin opened a conference there in 2005 with a moving and thought-provoking performance called *I grieve too much*. The performance, which was relayed via CCTV from where it took place in the *visual storage* area to the auditorium in which conference attendees sat a few metres away, addressed the institutional display of native artefacts. Sitting blindfolded in front of one of the museum's display/storage cabinets containing items made by his aunts, he told the story of Essie Parrish, one of the last traditional 'sucking doctors' from the Pomo Nation in California. Some in her community felt that Essie's early death was caused by her allowing anthropologist Lowell Bean to record her performing a healing ceremony, which was later, against her wishes, shown widely across the country. *The Sucking Doctor* became a *classic* piece of ethnographic film, but for the Pomo community it became yet another betrayal by the establishment. Peter used the museum objects for a ceremony dedicated to his aunts, to Essie, and to the members of his home community who had been arrested on the day of his performance while protesting against the beginning of test drilling by Shell Canada on land held sacred by the Tahltan. Peter later wrote:

> These objects are our master works. When they were taken from our communities, our sense of accomplishment was severed. When these objects were taken, along with our children who were taken away to residential schools, our trust in the future dimmed.
>
> I wanted this performance to be broadcast to the theatre because I wanted to convey the experience of having your relationship to the objects mediated through glass, and through the informational panels in the museum. This is what I had been experiencing as an aboriginal person in the museum. I heard the objects singing and this singing was so close but beyond my reach. And I felt that these ways of knowledge in the museum were causing continued harm, because I felt harmed when I was there in the museum like my body was under attack from this extreme view that was presented as an authority on the aboriginal body.[67]

At the end of the performance, Peter put on headphones and began to sing. The singing was oddly evocative: was it strange because that's what happens when you sing with headphones on and can't hear your own voice or was it strange because it was a ceremonial song from a tradition we weren't familiar with? Eventually it became clear that the song was *I've Seen Fire and I've Seen Rain*. The museum is, for Morin, a site of trauma, but the story it tells is not, as the term *post-colonial* suggests to some, 'finished business'.[68] His performance conveyed a great deal about historical

perspective, tradition and appropriation, but it did so without didacticism and with delicate humour, making critical use of that contrary movement in exotica between the strange and the familiar.

There is much in Peter's description of this work that resonates with both *Hearing Voices* and with *Anspayaxw*: a desire to make visible the 'vanishing mediators'[69] often at work in the museum context, the tension of hearing something that is close but unreachable, the questioning of the ethnographic gaze. I have tried to position my work between the usual approach of art museums or galleries which, as Lippard says, present ethnographic material, if they show it at all, decontextualized and with too little information, and the ethnographic museum, with its old-fashioned, educational approach and too much information for the average viewer, 'sometimes to the detriment of aesthetics'[70] and, I might add, of the dignity of the subjects. I want to do more than just *play* with other people's words, but equally I don't want to perpetuate false and reductive models of cultural identity of the kind on which exotica thrives. Through my work, I attempt to explore what Steven Feld describes as 'strategies and possibilities for valuing indigeneity as something more than essentialized otherness ...'[71]

In the Thick of It: Notes on Observation and Context
Christopher Wright

The work of the artist Cameron Jamie has been referred to as 'backyard anthropol-
ogy' for the way it documents aspects of popular culture such as amateur backyard
wrestling, Halloween decorations in the suburban US, and the annual Krampus ritual
in Austria.[1] Jamie's exhibitions often include various forms of documentation of these
events – single-screen videos, photographs, related artefacts (such as the masks worn
in the Krampus ritual) as well as his drawings and paintings. As the art critic Ralph
Rugoff says, Jamie's work 'seems to overlap with the concerns and methodologies
of visual anthropology'[2] but his 'amateur' status is also highlighted – perhaps as a
way of distancing him from the concerns of 'professional anthropologists' while still
allowing him to invoke their methodologies. For Rugoff this amateur status is what
allows Jamie to explore areas of popular culture that are off-limits for professional
anthropologists or just outside of their remit. Although Rugoff is wrong on this point
because there are anthropological studies of popular forms, the positioning is of
interest – perhaps it allows a perception of Jamie as having a different set of concerns
than his professional counterparts, or of not having to adhere to what are perceived
as rigid disciplinary norms within anthropology. This is a key moment of differentia-
tion between the two disciplines, but also revealing of the kinds of perceptions and
misperceptions involved with the kinds of work produced in between the two
fields. Rugoff argues that, in his exhibitions, Jamie often 'presents the results of his
"fieldwork" as a "participant-observer" in visual form'. But the 'conceptual distance'
that, according to Rugoff, is maintained by anthropologists undertaking participant
observation, is the opposite of Jamie's aim of immersing the viewer in various
kinds of sensual experience. These oppositions – amateur/professional; distance/
immersion – are of interest to me here as, although they are to some extent based on
misconceptions about art and anthropology, they are useful to think through in terms
of encouraging new forms of visual work in anthropology – which is my concern as
someone who has taught visual anthropology for a number of years.

Jamie is originally from the suburbs of the San Fernando Valley in California,
although he is now based mostly in Paris, and he has for many years produced work
that documents subcultures in various ways. Having left his home in Northridge in
the valley in 1994 after an earthquake destroyed his house and studio (and a lot of his
work), Jamie allegedly returns there every year to make small-scale performances that

often have only one, or even no, witnesses. Sometimes Jamie gives the 'testimonials' of the single witness of these events to a professional illustrator – Erik Weilhaert – to turn into ink drawings that are then exhibited as part of the process of documentation. Some of these – which form part of an ongoing work called *The Goat Project* (2000–) – reveal the processes of separation from the original performance. The three-stage process, performance, eyewitness account, and subsequent illustration, mirrors some of the dilemmas also faced by anthropologists concerned with documenting ritual performances.

In his exhibitions Jamie sometimes tries to reverse this gradual movement away from the original event – for one exhibition of images from the *Goat Project,* in a darkened De Vleeshal, a Gothic hall in Middleburg in the Netherlands, visitors had to climb a 'concrete mountain' on their own with only a lamp to light their way and after descending in the gloom on the other side they finally found the ink drawings hung round the necks of Gothic statues. Here Jamie effectively reintroduces an element of performance, to see the images you have to immerse yourself in an event, the 'performativity transferred from artist to viewer'.[3] Again, this has much to say to the, very limited, ways in which anthropologists think about how to represent performance in their own work, and also about the different kinds of 'contracts' that artists, performers, and anthropologists engage in with their respective audiences. It also raises a series of issues and productive questions about the relation of documentation to the original performance – think of Ute Klophaus's black-and-white photographs of many of Joseph Beuys' performances and happenings – they are often what is remembered, rather than the event itself, which was possibly only witnessed by a small group of people. They become the iconic images that stand for all the complexity and experiential qualities of the actual performance.

The work of Jamie's that I am interested in exploring further in this light is a 2002 single-screen video work called *Kranky Klaus.* When the work was exhibited in the UK under the auspices of ArtAngel, who commissioned the piece as part of a trilogy of films, it was shown on a giant screen in large venues accompanied by a loud 'grunge' soundtrack courtesy of the cult band The Melvins. The trilogy of films also included *BB*, about the amateur wrestling scene in the mid-west US, and *Spook House*, about the homemade Halloween tableaux created by people in the suburbs of Detroit. The live music (which is also a prominent feature of the film's soundtrack, even when it is shown without the band being present) makes viewing the film an even more powerfully immersive experience than it already is. The music is a very important element of the whole experience of *Kranky Klaus*, and of course I can do very little in the way of even gesturing towards the performative aspects of the film here. There is also, of course, the pressing question of whether audiences going to see the Melvins perform live, as much as to watch a film by Cameron Jamie, would have been actually distracted by the combination of the two. However, there is clearly a fundamental question for all those – whether artists or anthropologists – trying to represent or document aspects of performance that involves the process of translation. There are issues surrounding the degrees of separation from the original event and the ways in which this is achieved or overcome, and this is what is often one of the key issues at stake in any differentiations between artist and anthropologist.

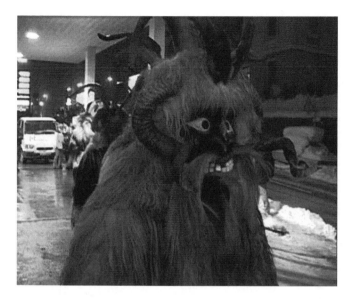

Figure 5.1. The Krampuses on the petrol station forecourt. Still from *Kranky Klaus*, Cameron Jamie, 2002. Image courtesy of ArtAngel, UK.

Kranky Klaus opens with a group of masked figures – the masks carved wooden grotesque faces with horns – dressed in suits of long fur and each having two huge cow-bells on their backs dancing in a petrol station forecourt. There is no introductory text panel, only the title, *Kranky Klaus,* and there is only one brief section of subtitling into English towards the end of the film. Throughout the film we follow the masked figures – the Krampuses – as they make their way through a series of encounters, first with shopkeepers, one of whom laughs and jokes as he is wrestled to the ground by the Krampuses, another who is clearly upset and wants to keep them away from her shop. The Krampuses sometimes take off their masks and parade in front of the audiences they have just physically assaulted. The Krampuses drink in a bar and all sing along to Ram Jam's song *Black Betty* – the bar has images from pornographic magazines stuck to the walls. We are given no context for these events and are encouraged to react to them as participants through the use of a hand-held camera and the fact that Jamie (the cameraman) is often in the middle of the action and so images are often blurred and out of focus as he is thrown to the floor. We see the Krampuses confront a group of nervous looking children in a hotel lobby and assault dinner guests in the same hotel and, towards the end of the film we see one particular encounter – an encounter that is subtitled into English – between the Krampuses and a group of teenage girls in the kitchen of a house. This is a scene we have seen brief snatches of before – many of the events are prefigured in various ways – and one of the girls is clearly upset and in tears as a result of the actions of the Krampuses. Her friends attempt to console her and there is a real sense of tension as the girl and one of the Krampuses confront each other. Throughout the film there

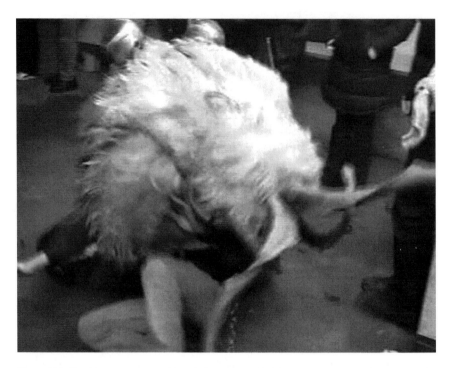

Figure 5.2. The Krampuses assaulting their audience. Still from *Kranky Klaus*, Cameron Jamie, 2002. Image courtesy of ArtAngel, UK.

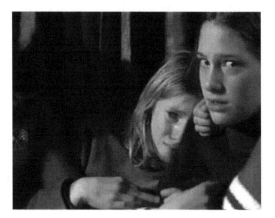

Figure 5.3. Teenage girls. Still from *Kranky Klaus*, Cameron Jamie, 2002. Image courtesy of ArtAngel, UK.

is an intense soundtrack – the bells attached to the Krampuses make a continual din and the music from the Melvins is an incredibly strong presence, even if it is not in the form of a live performance and is part of the film's soundtrack.

For me, as a visual anthropologist, *Kranky Klaus* works very well as a film about ritual for several reasons. Jamie is concerned with immersing the viewer – that is his specific form of contract with the audience – he wants you to have an experience, he is interested in your affective responses. This concern with the immersive and with the experience of the image already leaves behind a great deal of what passes for visual anthropology with its overriding concern for information and explanation – which is often at the expense of experience, or even seen in direct opposition to any ideas of experience. If this is one of the factors that distinguishes Jamie as an 'amateur ethnographer' then I wish that more visual anthropologists would take a similarly amateur approach, or at least a more overtly experimental one. This quality of immersing you as a viewer is frequently in direct contrast to the aims of much visual anthropology. There is often a positive valorization of certain kinds of distancing, the underlying notion being that it is from this vantage point that the context becomes apparent, and it is this idea of context that is seen to be the overriding explanatory tool in understanding ritual within anthropological terms.

But why is there this opposition between experience and context? Why would an artist attempt to immerse you, and an anthropologist attempt to largely extricate you from that experience? It has often felt to me like much of the practical work produced within visual anthropology is actually trying to work against the properties of the medium it uses – trying to make films act like texts.[4] Film seems particularly good at immersing you as a viewer – so do visual anthropologist's who use it to represent anthropological forms of understanding have to struggle against some of its qualities of film – even to the extent of frequently denying them?

Anthropologists have a long history of focusing their research and fieldwork endeavours on an understanding of ritual, and it has certainly been a key trope in anthropological filmmaking. Certainly for visual anthropologists, ritual performance seems to offer a kind of ready-made narrative – neatly sidestepping any difficult issues about the anthropological imposition of a narrative. Leaving aside complex questions around what constitutes the context for ritual action, these performances seemingly offer a clear narrative development – a preparatory stage, the performance, and its aftermath – which is not imposed by the anthropologist. Most of the written and visual anthropological approaches to ritual are concerned with contextualizing it; they clearly suggest that the way to understand ritual is to understand its context. That is where its meaning lies – in its relations to other aspects of social life and structure or religious belief that are somehow prefigured in the ritual itself. This reflective trope – in which society and ritual mirror each other in some way, or in which ritual is the structural working-out of social complexities – is central to many anthropological explications of ritual performances. My concern is with how this process of contextualization can in some instances amount to a betrayal of the actual performance itself.

Context is also frequently used by anthropologists as a way of differentiating between their own work as professionals and the endeavours of others looking at

similar issues from outside the discipline, especially the work of artists. To suggest that the work of a particular artist, however interesting, is somehow lacking in any kind of anthropological understanding because it fails to contextualize its subject matter, is a far too frequent a strategy. It is a means of effectively policing boundaries and a mechanism for easily dismissing work as irrelevant or outside the purview of professional anthropology, and therefore incapable of raising any productive, or difficult, questions for the discipline. For many anthropologists, art simply does not provide context, whereas anthropology does – it is what anthropologists are good at. This is a similar process of differentiation and self-definition to Rugoff's insistence that Jamie is an 'amateur' ethnographer. Anthropological ideas about context and about meaning being dependent on context have a long history within the discipline, and there has been much argument around the inadequacy of context as the sole source of explanatory meaning, although this continues to be a given within the discipline.[5] Context is a key element that I want to think through in relation to Jamie's work and to *Kranky Klaus* in particular. I want to suggest that what are at stake here are two different kinds of approaches to understanding performance – contextual and immersive.

When it comes to performance the anthropological focus tends to centre on issues of context, as though context was necessarily the only way of explaining or approaching performance. This focus often happens at the expense of qualities of immersion and experience. For many artists the desired effect is precisely immersion and performance was seen as a way of reintroducing a range of (essentially anthropological) elements into audience experiences of the work. What seems clear to me is that it is not beneficial to either side to continue insisting on many of the kinds of oppositions outlined above. Anthropologists need to focus on the immersive aspects of representing ritual performance, and artists need to think about their documenting practices in a broader way that takes into account issues of context.

I would suggest that anthropologists, particularly visual ones, who argue that experience is always necessarily subordinate to context, need to open themselves to other possibilities for documenting and representing ritual performance. Strategies of representation that do not work against the immersive and experiential qualities of the mediums involved and insist that context is the only way of understanding – as though experience was not equally a form of understanding. Anthropologists can sometimes seem to be a bit detached, and despite an increasing academic interest in the bodily senses and the senses cross-culturally – the rise of so-called 'sensuous anthropology'[6] – the notion that understanding only happens through 'standing back' and having a distanced contextualizing view of something is still dominant in many instances. Despite increasing numbers of anthropologists who do want to take significant account of the role of the senses, both in their fieldwork and in their subsequent representations, both written and visual – there remains a great deal of reluctance to experiment with the wide range of possibilities for achieving these ends. Anthropologists need to be encouraged to make that leap.

It is perhaps all too easy to imagine an anthropological version of *Kranky Klaus* in which the film would start with scenes of the pine-clad valley and a caption telling us the name of the village in Austria – this would be followed by a voiceover narrative, or an interview with a local informant, informing us that 'every year before Christmas a ritual takes place in which ...' In this sanitized version, we would be provided with

the context before any of the events of the ritual itself had themselves unfolded. That is the standard formula for far too many (although not all) anthropological documentaries - we are essentially given the context up front so we can make *sense* of the performance, as though that is the only possible way to access or approach performance from an anthropological perspective. But in the case of *Kranky Klaus* if you as a member of the viewing audience were provided with all that context then I am convinced that your experience of the film and your understanding of the ritual would be impoverished - you would miss something central to the event. You would not be searching for understanding, and if that was the case then the tension that is central to the event itself would be missing. Of course going to see the work of an 'artist' accompanied by a live band at a large venue is certainly a different kind of context, and there is much to be said about the issues surrounding the spaces in which one encounters both art and anthropology as in many ways defining framing devices, but in this case the kinds of anthropological contextualization that would be second nature (and one would hope open to investigation precisely because of that role as second nature) works to obscure some forms of understanding of the ritual.

Jamie is the opposite of any notion of a detached observer - he wants to be engaged, immersed - immersed as a filmmaker and as a participant. In this light *Kranky Klaus* is a useful model for a kind of engaged visual anthropology that has the immersion of the audience as its explicit intention. It is not that context is unimportant - far from it - and I am certainly not making a case against contextual models of understanding, but fully explicating context is perhaps not the best use of visual material and sound - the creative potential of film - in this particular case. It might also be the case for a lot of approaches to ritual performance in visual anthropology. Once this leap of faith in attending to the immersive potentials of film and other media has been made, a whole range of creative possibilities present themselves - the use of film, or photography and ambient sounds in relation to anthropological approaches to memory, etc. This is the area that I want to encourage visual anthropologists to explore. As a film maker, Jamie is in the thick of the action - he is at times on the floor. I can imagine an anthropologist attempting to set up a tripod, or at least just standing back well out of the way of the action and in an attempt to get the 'whole scene'. It is precisely any notion of encompassing the 'whole scene' that is at stake here.

From the perspective of a new audience - and perhaps one from outside central Europe - *Kranky Klaus* certainly has a sense of uncertainty to it, and this uncertainty is central to the performance it documents. The young men wearing the large horned Krampus masks take them off - everyone knows who they are - this is something that happens annually in this village - a kind of public secret. The Krampuses take their predetermined route - presents and gifts are handed out, but people are also sometimes the subject of rough handling, even violence. The violence and the heavily misogynist overtones of much of the behaviour involved in the event as a whole are certainly problematic areas that are not tackled by Jamie. We also see shots of a Confederate flag and other memorabilia of the American West, which equally has a whole range of possible negative overtones. These problematic concerns might be tackled through precisely the kinds of contextualization I am effectively arguing against here, and I do not want to suggest that they should in any way be elided, but rather that the ways in which anthropological films about rituals are always

contextualized in particular ways often has negative effects in other areas – particularly those related to the experience of film.

The violent or beneficent behaviour of the Krampuses is supposedly related to the part they play in a kind of social policing on a local level – one of their roles is to punish those who have been in some way 'badly' behaved during the previous year. Obviously, their roles are complex and have many layers but I want to focus on the way that as a participant in the performance you don't know if the Krampuses are going to punish you up or not. Do they know that you did something bad during the year that you tried to hide? Essentially, you don't ever quite know if you're going to get roughed up or not. Clearly, some of the teenage girls shown in the later stages of the film are crying – they are seriously upset – where others are laughing, and we see a similar mixture of fear and attraction on the faces of children watching the Krampuses and having to sing a song in order to get their rewards.

When you watch this film you smile and laugh, but also feel uncomfortable and even upset at points. That laughter and sense of nervousness, that sense of palpable fear, is central to your being immersed in the film. It is also central to understanding that performance. Really this is something simple – in leaving the context out in this case Jamie has made a film that says something much more central and immediate about the performance itself than perhaps an anthropologist would who is likely to have felt compelled to have included the context from the outset. An anthropological version, although it would most likely have provided far more in the way of context, would, in doing so, have in many ways detached you from the event rather than seeking to immerse you in it. In attempting to find out more about the ritual I have of course resorted to textual explanations of its context – these are clearly important to an understanding of it and the complex issues that surround it – but so is the understanding that comes from visceral immersion in the event as it unfolds on the screen. This is perhaps an issue of narrative unfolding – to include much more contextual material would certainly be possible and effective at the end of the film, but at the beginning it would distract you from experiencing some of the tension of the event. There are clearly much wider issues here about the relation of different forms of documentation and expository genres to understanding, and indeed to the kinds of understanding involved in art and anthropology, but my point is that a lack of context is productive here.

For me *Kranky Klaus* suggests ways in which visual anthropologists should be open to thinking about documenting and representing performance – ways that treat visual material and what the visual can do very differently from the currently accepted models. I feel that anthropology has sometimes missed what is central to performance by striving solely to provide a context for it – and doing so through a form and a medium that is not always suited to it. It is not that context is unimportant, but there can be a different place for that context, and it is often included at the expense of immersion and the kinds of understanding that immersion offers. In this case I think it has allowed Jamie to effectively translate some of the central experience of the Krampus ritual performance into a form that is accessible to us and certainly has more impact? As such his work should serve as a model for a renewed creativity in visual anthropology.

Fieldwork as Artistic Practice

Tatsuo Inagaki

I have been exploring the possibilities of art in public spaces and places from a belief that art should be actively engaged with society. In developing my practice, I found the conventional practices of site-specific art, art in community and public art highly problematic. They seemed to exist in many instances without consideration for the particularity of a region, the people from the region, or the relationship between the two. They seemed to be presented like museum pieces rather than works for the people living in the region. So I wanted to find a way to produce works and projects for a region and its people. In order to produce such work, I needed to build closer relationships with those people. As I researched various methods and developed my own practice, I found that fieldwork was a very effective method to get to know a region and its local people's way of life. In particular, the fieldwork approach used by anthropologists became the model for my fieldwork. Unlike commonplace social surveys in the form of questionnaires and the like, this approach provides in-depth information and gives a better understanding of the region through field investigations.

FROM 'FIELDWORK' TO 'MUSEUM'

My art projects have involved collaboration with local residents during all stages of fieldwork and production. In their final presentation form, many of my works employ the methodology of 'museums' and the 'captions' used in museums. The incorporation of such methodologies in my work transforms each of the remembered incidents collected in my interviews into important and cherished events for those involved in the project and for the audience.

For example, I conduct a series of interviews with local residents, asking about their lives and their relationships with the place. I then present the results of these interviews in the form of a 'Museum' (e.g. the 'Grizedale Museum', 'Moya Museum', 'Daikanyama Museum' and 'Tappie Museum'). I also get local residents to recount stories about memorable experiences that happened in the area. I create 'captions' (plaques) containing these stories and install them at the places where they actually happened (e.g. at 'My Place' in Antalya; also in Grizedale, Moya, Muritz National Park and Le Vent des Forêts). By touring around these museums and captions, visitors can trace the lives of particular individuals in the area. Such life stories articulate the

relationships among the region's people and places, the characteristics and histories of its towns, and so forth.

SITES FOR COMMUNICATION

Anthropologists begin fieldwork with individuals and then generalize the results into the form of ethnography or essays, so as to articulate the similarities and differences with other cultures. By contrast, although I also begin fieldwork for my art projects with individuals, I return the results to the individuals. In my practice, therefore, the position of individuals in a region is articulated, and the relationships between the region and its individuals are fully elucidated. The results of my fieldwork research are presented in the region itself, in an attempt to produce feedback about the effect on communication among the local residents. I consult with the local residents concerning the final form of the presentation, so as to tailor it to the form most appropriate for the region. Hence, my work is not what is termed 'community art', despite its involvement of the surrounding community. I try to construct personal relationships with all of the participants in my projects by learning their names, habits, personal histories and connections with the region.

My practice aims to explore the possibilities of art by re-examining the issue of one-to-one communication – not mass communication – beyond the bounds of conventional art practice. Although I often use 'museum' or 'captions' as vehicles to facilitate my projects, my practice is not a so-called 'institutional critique'. I offer my 'museums' and plaques to regions and their people as sites for communication.

In my projects, the relationships between people and their region are re-discovered through individual perspectives, and represented in a manner which local people can easily understand. This encourages them to build more intimate relationships with their region.

I hope that such projects can create places where people can connect with each other and exchange all sorts of ideas. I believe that art has the potential to create such places and opportunities for interpersonal communication.

APPENDIX 1: PROJECT PROCESS

My projects to date have basically been conducted according to the process set forth below:

1. Interviews with Local Residents

I usually conduct fieldwork research on a specific group of people in a local community. The composition of the group is determined according to the particular needs of the community that emerge from my research.

2. Planning

On the basis of this fieldwork research, I plan project details and related events such as workshops. These plans take account of the locals' everyday lives and the needs of the region. The project is modified and/or expanded so as to feed ideas back into the region.

3. Creation of a Site for Communication

A site for communication is created in collaboration with local residents, taking account of their various needs and circumstances. The site often takes the form of a 'Museum'.

4. Sharing the Site

Visitors to the 'Museum' will be led by the experiences it offers to appreciate the different facets and interpersonal connections of the individual interviewees, or perhaps to understand real individuals. Thus, an organic site is presented that explores new possibilities for museums and art from the viewpoint of one-to-one communication.

5. Workshops and Lectures

In addition to the 'Museum', I usually conduct a series of workshops and lectures about the region for the local residents. These activities generate further understanding of the relationship between the region and its people.

6. Documentation

Large amounts of valuable information and records about the region are accumulated in the course of a project. From these materials I create archives in the forms of catalogues and websites.

APPENDIX 2: PROJECT EXAMPLES

'Childhood Museum'

1 May–30 June 2004
Localismos, Mexico City, Mexico

Localismos was a project held in the historical centre of Mexico City. The district was facing a number of social problems, such as depopulation, and the project aimed to revitalize the area through artistic practice and inviting twenty contemporary artists from various countries. For this project, I collected some childhood photographs from the local people living in the region, and asked them about their memories of these photographs. Based on the interviews, I created 'Childhood Museum' in a disused school building. The Museum presented a series of enlarged childhood photographs accompanied by texts from the interviews. It thus became a place where the visitors would recall the time these photographs were taken as well as their own childhood.

Figure 6.1. Tatsuo Inagaki, *Childhood Museum*, 1 May–30 June 2004, Mexico City, Mexico.

'My Place in Kaleiçi, Antalya'

19 October–22 November 2003
Cultural Heritage and Contemporary Art, Antalya, Turkey

I took part in an international exhibition *Cultural Heritage and Contemporary Art* held in the historical district of Kaleiçi in Antalya, Turkey. I was interested in the way its people live their lives, including what they think about the meaning of living in Kaleiçi ('old city'), inscribed as it is with the vestiges of various eras. I saw my task as being to deepen my understanding of them and see what kind of information I could draw from them. I therefore interviewed local people about their memories of the area and memorable incidents that had happened in their lives, and then produced plaques based on these interviews to be installed at the sites associated with each incident.

'Grizedale Museum'

16 June–16 September 2002
Grizedale Arts, Artist-in-Residence Programme
Grizedale Visitor Centre, Grizedale, United Kingdom

I was invited to an artist-in-residence programme in Grizedale in the Lake District, England. I realized a project about the region and the people.

First, I conducted in-depth fieldwork research into Grizedale, and interviewed five groups of people who live and work in the vicinity, asking about their life, relation-

Figure 6.2. Tatsuo Inagaki, *My Place in Kaleiçi, Antalya*, 19 October– 22 November, 2003, Antalya, Turkey.

ships with the place, and memorable things that had happened in the area. The results of my fieldwork, including the interviews, were ultimately presented to the public inside the Grizedale Visitor Centre, in the form of 'Grizedale Museum' accompanied by texts, images, and some commemorative objects.

Figure 6.3. Tatsuo Inagaki, *Grizedale Museum*, 16 June–16 September, Grizedale, United Kingdom.

This 'Museum' has functioned as a place where Grizedale's local people and visitors from elsewhere gather, relax, talk about their ideas and memories, and contemplate their relationships with their hometown and loved ones. *Grizedale Museum* has become a permanent installation at the Visitor Centre, and attracted many visitors to date. It is also used for their educational programmes including a workshop for children.

'Tappie Museum'

21 July–21 August 2001
Presented in the L.A. International Art Biennial
18th Street Arts Complex, Santa Monica, CA, USA

'Tappie Museum' was a project dedicated to documenting the life of 'Tappie', an 83-year-old ordinary American citizen and long-time resident of Santa Monica. Funded by the Asian Cultural Council and the Japan Foundation (Tokyo/LA), I was appointed to the artist-in-residence programme at the 18th Street Arts Complex in Santa Monica to produce work in collaboration with local residents and artists.

In the interviews Tappie recounted various stories of his life with his unique sense of humour. The stories included his birth in China in 1918, his immigration to America in his childhood, the beginning of his life in Santa Monica, incidents during

the Second World War, his wife whom he met during a trip to Mexico, his other family members including his children and grandchildren, and his operation for lung cancer. Among the commemorative objects displayed in the Museum are toys and dolls from the time when his children were infants, together with some old photographs of Santa Monica.

By touring the Museum, visitors are able to survey the life of this unique individual, who, however, is not a celebrity but just an 'ordinary person'. Through his life story, the relationships among people and place in the region, and their relation to local history, are articulated. This project was the first in which I created a museum dedicated solely to one local individual.

'MY PLACE'

30 June – 15 July 1999
Le Vent des Forêts 1999
Meuse, France

I participated in the *Le Vent des Forêts* project, held in France for two weeks starting on 30 June 1999. Le Vent des Forêts, which means 'the wind of the forests', is a forested area shared by six surrounding villages that forms an important part of village life. The project is run jointly by these six villages, and a great number of works with the forest as their theme have been installed there.

My project was based on interviews with twelve people living in these six villages. I asked them for their personal stories relating to the forest and put up plaques at the places associated with each story.

These personal stories tell us the life of people in these villages, especially their relationship with the forest. The twelve story plaques also serve as monuments to reawaken people's memories. This project was the first in which I produced plaques from interviews.

Affinities: Fieldwork in Anthropology Today and the Ethnographic in Artwork
George E. Marcus

Practitioners of anthropology and the arts have encountered each other on a number of occasions over the history of the various modernities and modernisms of the twentieth century. Their most recent encounter, in which the ethnographic fieldwork itself has been interrogated, has a strong point of origin in the so-called Writing Culture critiques of the 1980s.[1] As part of a widespread moment of interdisciplinary ferment, this very effective collaboration of scholars, positioned by training at very different edges of the arts, humanities and social sciences, offered a revealing critical examination of the textual production of authoritative knowledge about others and cultures. In so doing, it has encouraged, on the one side, a hope and an impetus for highly focused cross-over collaborations as a *modus operandi* of intellectual work, and on the other side, that such work might make ethnography and the fieldwork that produces it, something quite different from its forms within the empiricist tradition out of which it emerged. This was a tradition committed to a documentary function and naturalist representation propelled by disciplined participation of and observation in the life-worlds of others as formal subjects. In this chapter, I want to examine some of the current ironies, tensions and possibilities to which this moment has given rise in the relationship between anthropologists and artists and in their mutual attraction to a certain experience of investigation that places intellectual pursuits directly into contact with the ways of the world.

Anthropologists, to their credit, were open to this critique of writing and were relieved that it was hermetically textual and did not touch the near-religious fellowship of their fieldwork itself – the core of a craft expressing and regulating their professional culture. But it had a profound effect on fieldwork nonetheless – not so much on how it was done methodologically and experientially (it actually reinforced what I call the classic *Malinowskian mise-en-scène*, which has created problems in the present that I will also discuss) – but about how it was regarded and conceived as well as expanding the intellectual communities in which fieldwork became an attractive object of interest and potential appropriation.[2] To the considerable ambivalence of anthropologists, the practices that distinctively defined them, and made them a guild in the social sciences, became fashionable in artworlds and among humanists. Thus, the classic tropes of fieldwork were re-mythologized in a way consistent with the critical sensibilities and theories of the time, and not just for anthropologists but for other intellectual communities who saw it as useful to their own projects. In a

sense, anthropology has been dealing with this combined revitalization and appropriation of its classic method ever since. Anthropologists have been both contemptuous of, and flattered by, the mimicry. Beyond this, they have not yet assessed what this flow in the traffic between anthropology and the arts might mean beneficially for the as yet poorly articulated contemporary conditions of doing fieldwork that are finally reshaping the powerful Malinowskian imaginary of fieldwork that has stood in for method in anthropology.

The shared intellectual tool and doctrine that defined the Writing Culture collaboration and then proliferated as a signature style in theoretical discourse, interpretative writing and artworks, was the exercise of an acute and sometimes unrelenting critical reflexivity. This was intended at first to unmask and transgress a hegemonic regime of naturalistic modes of narration and representation, and then to encourage different kinds of relationships and normative communities of knowledge production in the act of research or art-making itself. Critical reflexivity suited the revolutionary/reform impulses of left/liberal intellectual life in the decidedly conservative times of the 1980s and 1990s. In the post-Cold War confusions of New World Order hopes and nightmares, these longstanding impulses now lack any contemporary social compass altogether, and the exercise of critical reflexivity is less in the service of normative political visions than the means to discover what critique might be within new social arrangements whose cultural and political contours are not yet clear.

The use of this tool has fared quite differently in the domains where it has been self-consciously deployed. In productions of artworks and performances, it has been a powerful, open-ended means of introducing the purpose of social and cultural critique into various media. In the name of breaking with all forms of naturalist representation and performance (anti-naturalism being a longstanding battle-cry in modernist art criticism and production) it has broken boundaries, questioned effects, and extended art into realms where it had not gone before. In anthropology, critical reflexivity was the means of making visible and then gesturing beyond the tropes of ethnographic writing, but rather than breaking with the *mise-en-scène* of fieldwork as the chronotope where all of this writing is imagined (perhaps in the world of the 1980s there was not the impetus or the necessity to break with this chronotope that there is now) it ended by reinforcing it and being entrapped by it. Critical reflexivity led mostly to genres of auto-ethnography of varying emphasis and quality in which the Malinowskian scene of fieldwork was made and remade according to the conditions of producing anthropological knowledge across boundaries of cultural difference and translation. However, this reflexivity failed to generate new strategies, forms and norms of practice to encounter the more complex, parallel and fragmented worlds that many fieldwork projects must now negotiate.

Finally, then, critical reflexivity in its anthropological form could not breach the historically embedded purpose in ethnography of documentation and realist or naturalist interpretation arising from it. Relations in fieldwork might be conceived differently, and the old empiricist naturalism of ethnographic representation might have been thoroughly undermined by the practice of reflexivity, but the genre form itself remains resolutely associated with a documentary function. In my opinion this holding on to realist purpose is not such a bad or damning thing, and it is perhaps an

inevitable dimension of intellectual work, especially in an ethnographic form. Long ago Raymond Williams,[3] inspired by Brechtian theatre, and the possibility of what he termed subjunctive critical strategies in performance, contested those who attack realism as a bourgeois form yet propose no particular alternative to it except a different kind of criticism.

Only momentarily flirting with avant-gardist circles of expression and reception during the 1980s fashion of postmodernism, anthropology, in its strength, appeal, and effectiveness, depends on retaining realist expression in novel and critical forms. The tradition of fieldwork is up to this, but only in new configurations. Artists, to whom fieldwork in its critically reflexive mode has appealed, have seen this potential within its anthropological tradition of practice. In my opinion, anthropologists themselves have not, or have not seen it as clearly. In this difference there remains, I believe, the direction for further stimulating discussions and collaborations between artists and anthropologists concerning their mutual attraction to the practice of fieldwork.

By the mid 1990s, the working artist's appropriation of ethnographic methods, under the stimulus of the Writing Culture critiques – couched in the more generic appeal of identity politics that followed these critiques – was subjected to a shrewd critical commentary in a brief essay by Hal Foster, 'Artist as Ethnographer?' included in a volume that Fred Myers and I edited.[4] Foster claimed that the cultural or ethnic other had replaced the working class as those in whose name the artist struggles. What had been the site of ethnographic fieldwork becomes the site of artistic transformation and also a potential site of political transformation. The classic Malinowskian *mise-en-scène* of anthropology defines a place of marginality and alterity, which, for the identity politics following the Writing Culture critique, became the figural and actual locale of the subversion of dominant culture. In this cultural politics of marginality enacted by the work of art, Foster sees the kind of ideological patronage of which Walter Benjamin had warned.

Foster also foresaw that the coming struggles over culture would not be located in marginal spaces, or enclaves – the geographies of subaltern peoples and places that classic ethnography had mapped – but rather in a field of immanence defined by the operation of a globalizing multinational capitalism in which older geopolitical models of centre and periphery would no longer hold. 'The artist as ethnographic fieldworker today may seek to work with sited communities', says Foster, 'with the best motives of political engagement and institutional transgression, only in part to have this work recoded by its sponsors as social outreach, economic development, public relations … or art.'[5] Such work serves the purposes of its art sponsor, Foster says; the show becomes the spectacle where cultural capital collects.

While I agree with much of what Foster argues, I want to take three exceptions to his critique.

1. In delivering his critique of artists as ethnographers Foster seems to assume the perspective and voice of what would be the traditional anthropologist with a hint of resentment: these artists are just playing at the serious pursuit of ethnography in the interests of accumulating their symbolic capital in the experimental ethos of artistic endeavour. Perhaps this is truer of site-specific installation art, but such

a generic charge of bad faith or naiveté is not warranted. One must allow for the fact that the fieldwork deployed in certain art projects is well thought out and adequate for its purposes in a sophisticated way. This suggests that once fieldwork/ethnography proliferates as an ideal practice within wider communities, as occurred in the Writing Culture critiques, then its virtues cannot be solely owned by anthropology – or at least a charitable appropriation of it is the wise orientation to adopt.[6] Further, in the case of some areas of art, such as theatre and film, it is important to acknowledge that there have long been investigative and preparatory practices that, while similar to anthropological fieldwork in their forms, have an independent genealogy in terms of how they fit into artistic practices.[7] It is from these cases of artistic production, once they are identified, and understood and respected as parallel but separate from the fashionable (or even earnest) mimicry of anthropological practices, that anthropologists can learn something cogent for the instabilities in applying the traditional model of fieldwork to their current projects.[8]

2. It is the standard of the traditional modality of anthropological fieldwork – what I have called the Malinowskian *mise-en-scène* – to which Foster holds the artistic mimicry of fieldwork accountable. Indeed, it is this traditional modality that artists have found attractive to appropriate, as Foster has explained in detail. For artists, fieldwork in anthropology is a stable practice – however flawed by its deep association with the production of a distinct form of documentary naturalism. Still, it is a space, especially as reimagined through the Writing Culture critiques, in which interesting art could be made. But within contemporary anthropology (anthropology that is markedly different from even the 1990s in some of its newer topical interests), fieldwork as a signature practice is increasingly unstable. Fieldwork itself – its spatial boundaries and temporal limits, its forms, what one wants from subjects, how it is constructed, designed and thought about in training – rather than the ethnographic text and its form – is currently the object of experimentation in anthropological pedagogy and practice. Especially so for student ethnographers as they develop new topics in circumstances quite different from those of their teachers and forebears.[9] There is certainly a widely felt but as yet poorly articulated sense – especially among students – that the ethos of fieldwork and the modes of inculcating it in professional culture do not meet the realities of enacting it in present circumstances of inquiry. In this sense, the emergent critique of fieldwork in anthropology is about where the critique of ethnographic texts was before its articulation in the Writing Culture initiative of the 1980s.

On the side of anthropology at least, the question is what value can the example of the artworld's experimental appropriation of fieldwork, albeit in its classic form, have for anthropologists in their own current predicament of reimagining that traditional modality? I would like to think that there is much at this juncture of reinvention that anthropology can learn from certain artistic domains where what looks like fieldwork has been incorporated within more complex practices of investigation. An examination of these art practices is of great relevance to anthropology as it faces up to the further decline of its distinctive documentary function and becomes involved in projects for which the classic modality of fieldwork is

unsatisfying. I believe that new techniques, or at least new aesthetics of technique, even of a formal sort, are needed to amend the Malinowskian *mise-en-scène*; the sorts of techniques that are already used by certain arts that have shown an affinity with and desire for aspects of the craft of ethnography itself within their own processes. But which arts?

3. I would agree that the appropriation of ethnographic fieldwork by site-specific installation art, to which it seems well suited, is vulnerable in the way Foster caricatured in his critique. However, where I have found similar appropriations or practices parallel to ethnographic fieldwork, behind the scenes, so to speak, is in theatre and film, which are not so vulnerable to the sort of critique that Foster made of site-specific art with ethnographic pretensions. While the conduct of what looks like ethnographic fieldwork in the preparatory phases of film or theatre production might be just as short term (and apparently superficial from the angle of anthropological self-esteem and sensibility in the classic mode), it is not as easily assimilated as the cultural capital of more powerful and sponsoring institutions. Rather, what is ethnographic investigation in the complex collective actions that result in a theatrical or film production is deeply embedded within these processes – so much so that what looks like a moment or phase of anthropological fieldwork in such efforts should perhaps be rethought, expanded, or extended in terms of the powerful concept of fieldwork that regulates the professional culture of anthropology. Working through what looks like fieldwork in the crafts of theatre and film, by applying a meta-ethnographic perspective to them,[10] would offer anthropology both a fresh channel to continue discussions and collaborations with art and also provide an appropriate model of alternative practice in order to address the current challenges to the traditional modality of fieldwork. The point is not to turn anthropological fieldwork into a form of theatre – more than it already is – but to use the experience and techniques of the latter to reinvent the boundaries and functions of fieldwork in anthropology.

In the later 1990s I became involved in co-sponsoring, in Houston, a series of installations by a group of Cuban and Venezuelan artists. One of these, the 'Market from Here', was based on the themes of the Writing Culture critique, the nature of fieldwork and the anthropologist's reflexivity. It was created by the Cuban artist and critic, Abdel Hernandez, and a leading scenographer of the Venezuelan theatre, Fernando Calzadilla. The installation was created from months of collaborative fieldwork in the Catia urban market of Caracas, and was moved from its original setting and rebuilt in the sculpture court of Rice University. I admired Calzadilla's part in this project, especially the translation of his fieldwork into the design of the installation.[11] Subsequently, I have maintained active exchanges with Calzadilla and my interest in his work has shifted to his work as a designer of theatrical productions in Venezuela and elsewhere. Calzadilla's deep theoretical and practical knowledge of all the elements involved in producing theatre, only enhanced the level of our discussions about scenography.

In connection with my thinking about the predicaments of the traditional fieldwork modality in anthropology and the need to reinvent it for the research projects

that younger anthropologists are now taking on, I found aspects of my discussion with Calzadilla over the last three years very relevant. His account of how fieldwork fits into his craft and the larger picture of producing theatre was satisfying to me in a way that many recent accounts of fieldwork in anthropology have not been. After a discussion of what it is about the Malinowskian *mise-en-scène* that requires a reinvention of its norms and forms, I want to return to my exchanges with Calzadilla to focus briefly on one particular example that we discussed of preparing the stage for a production of a García Lorca play in Caracas in 1994.

I now want give my sense of what in recent years has made the traditional regulative ideals of fieldwork unstable in the work of anthropology, and a subject for reinvention or reimagination. The problem has to do with the failure of the reigning lore of professional craft by which fieldwork has long been regulated, thought about, and idealized to articulate certain dimensions that were always there in the Malinowskian *mise-en-scène*, but are more important than ever now. The craft is inadequate, finally, especially for student ethnographers in the kinds of research that they are increasingly undertaking. Based on old governing tropes, it is not clear what fieldwork is to be undertaken experientially in these projects and what kinds of data it is supposed to generate. Part of the destabilization has to do with the conditions that are reshaping research projects and demanding different emphases from the old ethos in its vision and imaginings of what fieldwork is. This is hardly worthy of the term crisis, as in the 1980s' 'crisis of representation', but like the diffusely articulated reflexively critical tendencies before the critique of writing in the 1980s, there is now a comparable situation with fieldwork – the Malinowskian *mise-en-scène* is by no means an empty term or guide, but it only roughly covers the forms and norms it actually takes when applied and practised now.

In evoking the state of the lore of craft by which fieldwork has been constituted in the professional culture of anthropology and the key role it has played in initiating students into career defining fieldwork projects, I have deliberately used the term *mise-en-scène* to refer to the imaginary that mediates and regulates the expression of method in anthropology. Fieldwork has been a vividly theatrical or filmic object of thought in anthropology with a distinctive visual style from its very inception and ideological consolidation by Malinowski as the key symbol, initiatory rite, and method of anthropology. Early in the essay in the *Argonauts of the Western Pacific* in which fieldwork is evoked and its practices inculcated, Malinowski intones: 'Imagine yourself, suddenly set down surrounded by all your gear, alone on a tropical beach close to a native village, while the launch or dinghy which has brought you sails away out of sight.'[12] Anthropologists have always thought about each other's fieldwork, especially in teaching it as method through examples to professional initiates, in elaborately visualized tableaus, scenarios, and stories. Such a dramaturgical regime of method is at its most effective when the experience of fieldwork actually corresponds, roughly at least, to the imaginary that anthropologists deploy to frame what they report to each other from their own experiences. There is a great premium placed on ethnography that is able to set scenes that can be entered through concretely visualized and situated thought experiments. I would just remark here that there is thus a particular affinity or appropriateness for thinking though the craft of scenography, as Calzadilla

practices it, as a form of ethnography, which, in anthropology, involves a highly visualized mode of communicating stories, details, and data.

Another distinctive, if not peculiar, aspect of the professional lore about fieldwork in anthropology is that it is highly specific and deeply entwined with for the early phases of fieldwork experience with the image (as per Malinowski) of 'first contact' and heightened otherness in mind. The initiate's experience of fieldwork is how the imaginary is slanted, even when it expresses the experience of seasoned fieldworkers. But what of the continuing research of an anthropologist who has been working in a particular site for a decade, or even decades? Is there any model of method in anthropology for what fieldwork is like for the virtuoso? Is it even recognizable as fieldwork according to the Malinwoskian *mise-en-scène*? My point is that the later work of mature ethnographers usually operates free of the tropes of earlier work. I would argue that initiatory fieldwork in certain arenas in which many younger anthropologists are working today requires something of the more diffuse and open idea of what fieldwork can be than seems to be characteristic of virtuoso fieldwork. So this is a problem of pedagogy. Students enter anthropology inspired by complex social and cultural theories as well as the examples of mature second and third works of senior anthropologists that they admire and want to emulate, and then are faced with a still powerful culture of method that insists that they do something less ambitious. My point here is to suggest that there are aspects of the craft of scenography, which incorporate fieldwork of the Malinowskian sort, that are useful to think through in considering an alternative imaginary for fieldwork that might take account of the aporia of what fieldwork is in mature work. Norms of fieldwork are in need of release from the emphatic and vivid 'being there-ness' of the classic imaginary of fieldwork.

Turning now to the actual challenges to the traditional fieldwork imaginary, what in the world (today) has led to fieldwork's entanglements in multiple and heterogeneous sites of investigation and in complicitous forms of collaboration[13] that have changed markedly what anthropologists want from 'natives' as subjects and have deeply compromised claims to authoritative knowledge even of the revised sorts reinstantiated by the reflexive critiques of the 1980s? The conventional understanding of these developments has lain in certain presumptions about the nature of postmodernity that circulated widely in the arenas of interdisciplinary ferment of the 1990s and 2000s, namely that as cultures and settled populations have fragmented, have become mobile and transnational as well as more cosmopolitan (or at least more invaded or intervened on!) locally, so fieldwork has literally had to follow, when it could, these processes in space. Furthermore, the weight of political and ethical critique of the traditional fieldwork relationship that generated ethnographic data as revealed by the scrupulous reflexive probing of the postmodern gaze broke the modicum of innocence and naiveté necessary to sustain the distance in the ethnographer's relationship to subjects. Complicity with subjects – a state of ambiguity and improper seeming alliance – now pervades the *mise-en-scène* of fieldwork, signalling a loss of innocence in the wake of postmodern exposures. Herein both the intensity of focus and the integrity of relationship that have shaped the Malinowskian scene have been challenged.

I am sympathetic to this conventional understanding of the challenges to the traditional composure of fieldwork, but they do not arise simply from the complexities of a postmodern or now globalizing world. After all, many anthropologists can easily continue doing the same old thing and many do, and in many situations, it is even valuable to do so. But my take on what generates multi-sitedness and complicit relations in fieldwork projects today has more to do with the self-esteem of anthropology in the decline of its distinctive documentary function amid many more competing and overlapping forms of representation comparable to its own. In effect, every ethnography project enters sites of fieldwork through zones of collateral, counterpart knowledges, which it cannot ignore in finding its way to the preferred scenes of ordinary everyday life with which it is traditionally comfortable. This condition alone makes fieldwork multi-sited in nature, and heterogeneously so, as well as complicit with certain subjects. The fundamental problem here is confronting the politics of knowledge that any fieldwork project involves and the ethnographer's trying to gain position in relation to this politics by making this arena itself part of the design of fieldwork investigation.

Thus, since the 1980s, any critical anthropology worthy of the name not only tries to speak truth to power – power as conceptualized and theorized, truth as subaltern and understood within the closely observed everyday lives of ordinary subjects – but also tries to understand power and its agencies in the same ethnographically committed terms and in the same boundaries of fieldwork in which the subaltern is included. Ethnography, understanding itself, in Bourdieu's terms, as a dominated segment within the dominant, suggests an alternative modality relevant to the circumstances of contemporary fieldwork in which incorporating a second-order perspective on often overlapping, kindred official, expert, and academic discourses as counterparts to the ethnographer's own requires an essential and complicating reinvention of the traditional *mise-en-scène*. This reinvention is what accounts most cogently for making much of contemporary fieldwork multi-sited and political. It also makes it both slightly alienated and slightly paranoid in ways that are both inevitable and productive.[14]

The keenly reflexive critical anthropology after the 1980s is well suited to this incorporation of cultures of the rational as a strategic part of its sites of fieldwork. Indeed, if there was one great success of the 1980s' critiques it was to create an anthropology of present knowledges and their distributions in a way that was thoroughly new and original. In a sense, all anthropology since has been most effectively an intimate critique of diffused Western knowledge practices in the name of specific communities of subjects misrepresented, excluded from, seduced, or victimized by such practices. The emerging innovation of contemporary fieldwork is to treat such power/knowledges as equal subjects of fieldwork in their complex and obscured connections to the scenes of everyday life as the cultivated and favoured milieu of classic ethnography. But to be effective, such fieldwork has to do something more with this complex field of engagements than just distanced description and interpretation, however reflexive. At the moment, a pervasive, sometimes cloying, discourse and rhetoric of moral redemption holds this vacant place of an alternative, fully imagined and worked out alternative function for ethnography. Eventually this rhetoric might be replaced by more active techniques that are styled between ideas

of experimentation and ideas of activism. This interstitial space is where I consider that concepts and crafts of staging, design, and performance from the worlds of film and theatre might be stimulating.

Anthropology, in the midst of this transition in its sense of what fieldwork should do and is capable of, is thus much in need of exemplars of practices that move and produce knowledge forms in such reconfigured spaces of investigation. It is these, which certain artistic practices, such as scenography, that have found an affinity with the classic fieldwork modality, can offer back to anthropology at this juncture, and in so doing further develop as well the longstanding affinity between art and anthropology keyed to a mutual interest in fieldwork.

So, contemporary critical ethnography orients itself through the imaginaries of expert others and works through found zones of powerful official or expert knowledge, making practices in order to find more traditional subjects for itself. But what does it want of the complicit collaborations it makes with counterpart subjects in these domains? And what does it make of the scene of ethnography? This is distinctly not about an ethnography of elite cultures but rather about access to a construction of an imaginary for fieldwork that can only be shaped by complicitous alliance with makers of visionary or anticipatory knowledge who are already in the scene or within the bounds of the field. The imaginaries of knowledge makers who have preceded the ethnographer are what the dreams of contemporary fieldwork are made of. But what are the practices/aesthetics of technique that go along with such complicitous, multi-sited fieldwork investigations? For this we return in conclusion to the humble, exquisitely subtle craft of the scenographer.

Here is an example culled from my exchanges with Fernando Calzadilla: his account of how he prepared the set design for a 1994 production in Caracas of García Lorca's *La Casa de Bernarda Alba*.[15] As Calzadilla states:

> The basic principles of the production were about discovery, unveiling, avoiding artificiality to show the narratives that compose our collective imaginary; to transform quotidian events into exciting acts; to support the player for everything starts with her, and to avoid a naturalistic proposition that would function simply as décor. There was no adaptation from the original text: it was García Lorca to the last comma ... From day one, those of us directly involved in the production intuitively knew that the play should be located in a Venezuelan town.

Consequently Calzadilla and his wife spent three months in two communities with a 400-year-old tradition of closed, rural, conservative life. His account of his time in these towns reads very much like the initial experience of fieldwork in the Malinowskian *mise-en-scène*. Given the time pressures in theatrical production this was an unusually long time to do this sort of preparatory fieldwork, which, as such, is not that uncommon an activity in Venezuelan dramaturgy. In this, Calzadilla potentially corresponds to Hal Foster's critique of the brevity and superficiality of the practice of fieldwork with which he charges site-specific artists. But in Calzadilla's case the fieldwork, of this emblematically traditional sort can only be assessed by its transformations in design craft of staging the Lorca play. From day one the fieldwork had its

rationale in the complex performance text of Lorca's play and the role of scenography within it. The submergence of a bounded traditional fieldwork experience within a larger multi-sited design is instructive. The idea of design could shift the norms and forms of fieldwork in line with where it is moving circumstantially. In mature work or any multi-sited work, fieldwork only moves forward as critique by staging.

Simply and materially, Calzadilla's fieldwork produced objects and artifacts with which to design the staging and look of the production. But more subtly it is a certain sensibility derived from fieldwork – and not the ability to represent others – that travels or moves to another location of intellectual work. In the case of scenography, this creates a uniquely local space-time for the performance of the Lorca play in Caracas. This is fieldwork, as I intimated earlier, adequate for the scenographer's purposes, perhaps not for the very traditional anthropological ones, but nonetheless one that involves a distinctive sense of ethics, function and purpose. What is recognizable as anthropological fieldwork here is organically embedded in a broader process of design. Calzadilla goes on to describe his key creative effect in the staging of this play:

> I was in a delicate situation, walking on a tight rope between reality and illusion, and I had to provide the hic and nunc of the performance. I needed to create a space where these elements would become significant and not a sample case of our good job as fieldworkers. I took the risk, supported by the rest of the team, of laying bare the house's structure; removing all the walls for a play whose central theme is confinement and oppression. What we did with this move was to create a fiction within the reality of the performance so that our fieldwork experience did not translate directly but was mediated by an unreal space that focused attention on the drama by contrast, and not on the objects. Had we presented the objects in a naturalistic environment, they would have turned into curiosity cabinet items, adornment. The overwhelming presence of the real object in a naturalistic space would have highlighted the fictional aspect of the embodied characters rather than support the actresses in their performance – an objectification of the person, specifically critical in a case of an all female cast. What we needed was to highlight the reality of the event, the reality of the performers, and the drama they were going to enact. Translating fieldwork experience onto the stage to create a space where the actors could perform the myth (in this case, Lorca's text), meant giving them enough material to stand and relate to the characteristics, physical and otherwise, of the particular space.

What Calzadilla makes clear is that fieldwork's most substantive contribution to the production is not in what the audience can literally see, but in constituting what he calls the internal narratives of the production, unbeknownst to the audience, which originate within the 'raw materials' provided by the fieldwork. Calzadilla says:

> They might seem totally inconsequential to the performance but I know from talking with the actresses and from the audience response that they were not. The play was awarded best lighting and set design and several actresses won acting prizes for their work in Bernarda. I remember how an actress identified her

character so strongly with the space I provided her that she continued adding stuff in making the space hers.

Calzadilla goes on to give exquisite details of how the staging created a working and visceral imaginary for the production – for example, he describes what the effects on the emotive quality of movement were by his decision to build a real tile floor on the set – something that the audience could not even see, but which shaped a milieu by the feeling of bare feet on tiles.

Of course anthropological ethnography is not scenography, but given the sorts of predicaments that the fieldwork paradigm currently faces in anthropology, I think the craft of scenography as practised by Calzadilla, among others, can provide inspirations, rather than merely nice analogies, for its reinvention.

1. Calzadilla de-essentializes the tropes of classic fieldwork while practising and incorporating them in a broader process of investigation and intellectual work. This is what inevitably happens in contemporary multi-sited fieldwork – the bounds of the Malinowskian *mise-en-scène* are exceeded – without the result being conceived or named. The movement between contexts of work and the changing functions of investigation in Calzadilla is something that is regularly experienced in contemporary fieldwork projects. Fieldwork in anthropology needs, for its imaginary, a different chronotope of practice, and, for many, aspects of scenography are a good model.

2. Since new fieldwork projects exceed single sites and solely documentary purposes, a concept of design as it is used in crafts like scenography (and there are many such artistic modes of practice that employ the idea of design) might offer an idea of process that could be used in anthropology to affect the crucial situation of pedagogy in the training of students for their first ethnographic projects. Anthropologists like their means of inculcating fieldwork in professional culture through the lore of craft, but the evocation of design might give them more and different things to talk about. The concept and example of design would do the conceptually applied work of incorporating the Malinowskian *mise-en-scène* into a regime of alternative sets of expectations from fieldwork.

3. Calzadilla's process places an emphasis on the idea and reality of collaborations – of various sorts and with various requirements. Indeed the work process of scenographer is a skein of progressive collaborations from the inception of any project. The idea of collaboration at the core of the production of ethnographic knowledge was critically highlighted by the 1980s critiques but, as an emphasis, it subsequently settled into a particular genre style of writing ethnography. In the multi-sited space, collaborations and complicities define the politics of knowledge that also shape the design of inquiry. What Calzadilla knows from fieldwork, as only the initiating collaboration, moves through a complex series of further collaborations which are never other than prominent in the account of his work and its results. Contemporary ethnography seems to operate in a very similar way in fact, but not yet in the norms or forms that it narrates to itself professionally. This, of course, creates new problems for asserting the expertise of authority, the ethics

of making relationships in a complex field of collaborations. But to consider this regime of collaborations as usual is something that anthropology should aspire to.

In bringing this essay to a close, it seems to me that the discussions between anthropologists and artists of their mutual interest in fieldwork can proceed further at this juncture by working through, on the one hand, the destabilization of the traditional modality of fieldwork in anthropology, which is occurring inexorably, and on the other hand, the manifest practices of fieldwork in the various configurations of a multitude of specific art practices. In particular, what seems right to me now, at least for anthropology in its current predicaments with method, is to try to learn something from the humbler but more subtle crafts, like the scenography engaged with here, behind and within the scenes of the performance events of theatre and film.

Show and Tell: Weaving a Basket of Knowledge

Amiria Salmond and Rosanna Raymond

Rosanna Raymond

LEAVES AND SONG

Open the door
and call on the winds
to blow the dust from my eyes

Shake your leaves and lament
we can anoint each other with the past
and readdress my lost adornment

Breathe with me ... exhale with perpetual emotion
sing me a song, to take away this cold

Possess me with your caress,
stroke by stroke, we can invoke an affinity

Come to me ... share some air,
let it quaver and reach far inside you

Give me your skin to hang from
impressed with your essence, I will shine

Blow me ... I will release gods into the air
and call for my loved ones

Cling to me, and be fluent with your grasp
wrap your lips around me, let them slide

Give up your grieving ...
but don't deny those tears
let them fall in tribulation

These plaintiff moments
will lull the pain
as you leave me behind

A ... I ... E

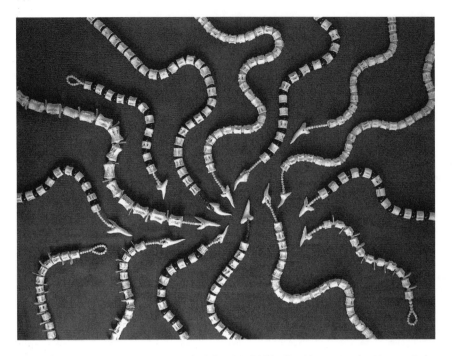

Figure 8.1. Rosanna Raymond, *Flight of Poutini*, 2002. Shark's teeth, shark's vertebrae, greenstone and mother-of-pearl beads, collection of the artist. Photograph by Kerry Brown.

Amiria Salmond

This paper grew out of a series of what are tempted to call 'discussions' between Rosanna and I over the course of about two years. To call them discussions would be misleading though, as our engagements actually took a variety of forms – me watching Rosanna perform her poetry at an exhibition launch, both of us singing at Westminster Abbey with Ngati Ranana, the London Maori Club; Rosanna selling me some of the jewellery she makes; me visiting Rosanna's house and eating with her and her family; Rosanna coming to Cambridge to study collections at the Museum of Archaeology and Anthropology, and staying with me; or just sitting down together to do some weaving. Of course all these meetings were permeated by discussion, which has played an important role in the relationship, but to reduce them to 'talk' wouldn't do justice to a collaboration that has encompassed graphic, musical, and performance modes.

Rosanna Raymond

Some of my first vivid memories are of family days spent at the Auckland War Memorial Museum. As I grew older I still visited the museum – I had travelled the

world by now and had lived away from Auckland for over 10 years. I was drawn to the *tapa* cloth, hair, bone, stone, wood, feathers, shells, weaving. I would stare at the *taonga*; they stirred my imagination to life before colonization. I had a thousand questions they could answer, but in the glass cabinets they were rendered silent. So I would read the books and descriptions of these curious artefacts of dying cultures, catalogued and neatly arranged in a natural order passed down from Darwin, and assorted 'Enlightened ones' but these many books sung me no songs or showed me no dances; my visits became punctuated with a sense of frustration that I did not know how to address until I started to live and work within my community again and then these objects came to life and became *taonga*, treasured ancestral possessions.

Amiria Salmond

Marilyn Strathern has described how the epistemological preoccupations of modernist anthropology have led to a 'division of labour' between social/cultural anthropologists and those concerned with material culture of the kind that finds its way to museums. Instead of segregating objects and context, she suggests, 'we should extend our concept of artefact to performance and to event'.[1] Perhaps the problem is less a preoccupation with the nature of knowledge *per se*, however, than a focus on particular *ways* of knowing and communicating meaning that are categorically distinct from their objects. Such formulations are embedded in our understandings of language, and derive from the assumption that the seat of the intellect is in the human linguistic capacity. 'Understood as a realm of discourse,' Tim Ingold notes, '... culture is conceived to hover over the material world but not to permeate it.'[2] Meaning is laid over objects or imputed into them, but an object/performance/event cannot *be* its meaning,[3] an assumption that is axiomatic to the type of linguistic theory often picked up on in anthropology (although of course not all theories of language subscribe to this view).

Rosanna Raymond

Auckland in the late 1980s was a hotbed of Polynesian empowerment through the arts, music and fashion, a new wave of urban Polynesians were finding new avenues to create their own visual landscape, telling new stories and creating new histories. I was part of this movement.[4] In my circle of friends were artists, activists, carvers, musicians, performers, university students, we would debate issues of cultural appropriation, colonialism, authenticity, and the continuum of our cultural heritage. Museums and the people who worked in them came to represent aspects of colonialism and appropriation, they were killing our *taonga* by burying it in boxes, silencing them, they had taken them away from us, yet I still visited, as the collections had a powerful effect on me.

Academics started to creep into my peripheral vision at festivals and art galleries. My first impression of the world of academia and anthropology was problematic and

based on the experiences I had with various academic articles written and analysed *from a distance*, by 'professionals' with 'impartial views'. I found some very staid views on what Polynesian culture should be, not about what it has developed into. Debates on hybridity, the effects of diaspora and the institutionalized telling of histories challenge the legitimacy of our culture and how it has been maintained.

Amiria Salmond

Strathern notes that the disciplinary apartheid she identified has led anthropologists to conceive of themselves 'as experts in the elucidation of social/cultural "contexts"';[5] systems or frameworks used to make sense of social life. In this scheme, instead of taking things for themselves, the primary task of anthropologists is to slot ethnographic 'data' (in the form of objects, performances and events, among other things) into the social and historical systems (i.e. 'society' or 'culture') that give them meaning. One effect of this procedure, she noted, is that the system itself becomes the object of study, and artefacts (like Rosanna and her work) are reduced to mere illustration. 'For if one sets up social context as the frame of reference in relation to which meanings are to be elucidated', Strathern wrote, 'then explicating that frame of reference obviates or renders the illustrations superfluous: they are become exemplars or reflections of meanings which are produced elsewhere.'[6]

Rosanna Raymond

Reading about myself labelled as 'hybrid' and having my 'authenticity' questioned by people outside my community left me feeling disempowered. I was often frustrated at the many mistakes and misrepresentations that appeared in articles, especially by people who had spent very little or no time with us or within our community – often our involvement in projects as practitioners was welcomed, but our analysis of what we were doing was not considered as important unless validated by an 'expert'. It left me feeling apprehensive about the world of academia and its experts but, since then, a more balanced relationship has developed with anthropology, academia and institutions, and it has become part of my work and creative process.

In late 1999 I moved to London with my husband and children. Moving out of the Pacific has affected how and why I work in so many different ways, good and bad. New modes of work and materials, an indifferent artworld in a global market – these were some of the problems that I first experienced.

Living in a new environment with different cultural beliefs and many other cultures and histories has enabled me to view my work differently, yet I found that I have kept the fundamental *kaupapa* (ideals or beliefs) within the work. My cultural heritage gives me inspiration even in the setting of London town, with scarcely a star or shimmering water sunset to be seen. The past has been the way to my future, and has helped me adapt to living in new circumstances even when distance and diaspora have become an issue.

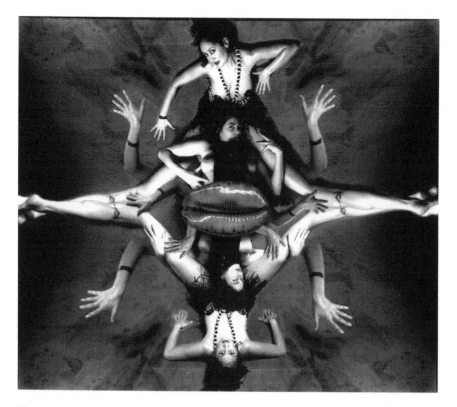

Figure 8.2. Rosanna Raymond, *Flower in the Sky*, 2001. Digitally manipulated photograph. Digital manipulation by Delete Graphics, collection of the artist, photograph by Kerry Brown.

Amiria Salmond

One of the strengths of fieldwork has always been the 'total immersion' experience of placing oneself bodily within (often) unfamiliar social situations. Through fieldwork, anthropologists and others have explored multiple modes of engagement, learning to make things, observing and participating in performances and entering into relations of exchange.[7] Such collaborations have long provided crucial ways of forging relationships and gaining insights, which in many ways cannot be separated out from the ethnographic process as a whole.

Rosanna Raymond

The celebration of my cultural heritage is fused into my work as an artist, even if it is perceived as invented, revivalist, inauthentic, corrupt, traditionally based, or contemporary. Whatever label you want to put on it, this is not how I and other 'hybrid' Polynesian artists view our role in producing art that speaks and relates to living in

Polynesia today, in a modern urban environment. It is not about using the culture as 'a resource for hybrid art production', but about keeping it part of my life, relevant to how I live in the twenty-first century. I cannot produce artworks, write poems, and create costumes without the knowledge of my cultural heritage, and the experience of living it. Producing art works is my way of putting my culture into the future – not in the 'things past' boxes – making it relevant to me as a 'modern Pacific person'.

Amiria Salmond

As a student in New Zealand, I was taught the techniques of Maori cloak weaving by Maureen Lander and Hinemoa Harrison, both expert in the art.[8] First we visited a museum to study artefacts made using the processes we were to learn, drawing them in an attempt to work out how they were put together. Drawing forced me to analyse relationships between the different threads that formed the *kaupapa* or body of the cloak, and to hypothesize as to how they had been positioned. Back at university, we then learned to strip *muka* fibre from flax leaves, roll a two-ply cord and *whatu* the strings together through finger weaving to make a *tauira*, a sampler made like the body of a cloak.

For me the practice of weaving also illuminated aspects of Maori kinship. The *aho* or weft thread twined around the *whenu* or warps is also the *aho tipuna*, the line that

Figure 8.3. *Whakapapa* (base plait) of a kit bag, artist unknown, photograph by Amiria Salmond.

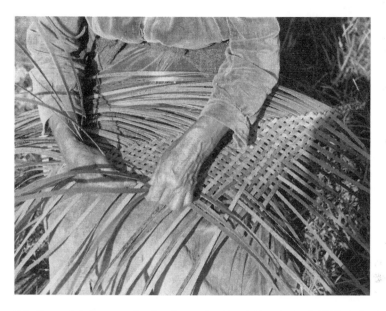

Figure 8.4. Hoana Pokaihau weaving flax, Otaua, Northland, New Zealand, 1939. Collection of University of Cambridge Museum of Archaeology and Archaeology (P.4680.ACH.1), photograph by Werner Kissling.

links the *papa* or generational layers in series of kin relations. A *whariki takapau*, the sleeping mat that was used to give birth upon, is built up in sections, or *papa*. The *aho* or main threads go from one *papa* to another, binding the pattern together. *Tukutuku* are woven panels lining the interior of the communal meetinghouse, often made by two weavers who pass the threads through to each other from either side, building up the pattern. *Tuku* is a term of exchange, signifying the release of something important into the keeping of another, with the expectation of an ongoing relationship. To *whiri* is to plait, and *whiriwhiri* is to deliberate, discuss or debate. In light of these insights I began experimenting with *raranga* or plaitwork, and learned how the plait at the base of a woven *kete* or kitbag is called the *whakapapa* – the same term used to translate 'genealogy' – which literally means 'to make layers'. My knowledge of weaving thus threw into relief aspects of the ways in which relations between people in Maori come into being.[9]

Rosanna Raymond

I see working with institutions as a vehicle to help bridge the gaps that have emerged in the process of housing, collecting and writing about indigenous peoples over the past two centuries.[10] I see the future of collections and museums becoming an arena for cultural exchange, going outside the boundary of the space into everyday life.

An old Maori whakatauki *or proverb*

Na taku rourou, na tou rourou, ka ora ai te manuhiri
With my woven food basket and yours, the visitors are fed.

Tracing Histories
Mohini Chandra and Rebecca Empson

Mohini Chandra's Fijian-Indian relatives live in different places around the world. They circulate family photographs as a means by which to maintain a connectedness with each other over great distances and generations. As family members move to different locations, they use different technologies to maintain relationships and chart shifting experiences. Chandra draws on and reconfigures her relatives' images, and other forms of self-representation to create artworks that provide a way for her to explore her own identity within a post-colonial context. Instead of thinking of relatedness and identity as an accomplished fact, for both Chandra and her relatives, relations are a site of production that are continually crafted within different processes of representation and re-representation. Following her presentation at the 'Fieldworks' conference, artist Mohini Chandra and anthropologist Rebecca Empson met to discuss Chandra's work and its relationship to themes in anthropology. The following are extracts from this discussion, which took place at Mohini's flat in London in the summer of 2004 and subsequent conversations, which took place up until 2009.

Rebecca: Your first degree was in sociology and your artwork has been described as a type of 'personal, self-reflexive, anthropology'[1] that reveals the evocative means by which your Fiji-Indian relatives record their experiences of movement and departure and your own attempt to place yourself within their mapping systems. Do you think that your departure from sociology has left a trace in your current work?

Mohini: My background in sociology reflected a very early interest in global power relations and politics that emerged through colonialism and was still developing in terms of post-colonial situations. I also became very interested in photography at this time so I was trying to explore this visual medium alongside issues that I was very passionate about. Although I had never really practised as a sociologist, because I went into art practice quite soon afterwards, I think that my work engages in a number of humanities disciplines, such as new forms of geography, history, and anthropology. It is important to mention that I believe my practice engages with such disciplines in the mode of various critical dialogues and conversations. I know that these disciplines have become increasingly self-reflexive and critical over recent years, and I suspect that some of the debates that have emerged from post-coloniality, in particular, in relation to history and anthropology have been really telling, as have practices of artists who have engaged in those critical debates and have actually played a big part

in entering into a dialogue with some areas of anthropology, particularly in relation to issues of self-reflexivity, for example. However, what is interesting is that as an artist, unlike an anthropologist in the classical sense (i.e. as an outsider coming in to study the natives), I don't feel that I need to go out and find a community to study; it is just there, it is part of me and it is part of who I am and what I do. I am simply exploring something which is of my background and if that is interesting anthropologically, or new anthropologically, then it is only because people like me haven't been involved in that process before. Furthermore, it is probably fair to say that complex communities like the diaspora community that I am engaged with (and part of), have not been included very much in anthropological 'fieldwork' because anthropologists tend to look for the most authentic and 'indigenous'. To talk about complex diaspora stories is an emergent discourse as those who have experienced this have also increasingly found, or claimed, the means to express their experiences through visual and other art forms.

Rebecca: There is a parallel between your focus on the mobility (or migration) of Fiji-Indian identity, and the migration of your own ideas between different intellectual communities. The mobility of your relatives' images is often due to the ways in which they use local technologies to disseminate them to different locations. How is this variability related to the movement between disciplines in your own work?

Mohini: For me this really emerged through debates around identity and post-colonial theory, which I had access to through studying at art college. Obviously, I had encountered these kind of ideas in sociology but when I actually came to look at these debates in terms of representation and photography, particularly in relation to disciplines such as anthropology, which emerged through various forms of colonial encounter, that is in a sense when the kind of critique that I could make really fell into place, specifically in terms of the visual. That is where an art education, which often uses a lot of ideas from the critical components of cultural theory, is a really interesting entrée into all of those disciplines and discourses. If you are trained as an anthropologist, then you are already in a position where you have to critique your own discipline constantly but you are implicated within in. Whereas, in a sense, coming from outside of all these disciplines this gave me a sceptical curiosity.

I think the complexity of this relationship was something that began to emerge at the 'Fieldworks' conference. However, it was interpreted as a desire by artists to borrow from anthropologists and anthropologists to borrow from artists, which seems to me to be a slightly simplistic reading. From my perspective, I cannot really speak for what anthropologists want to do in relation to art, but I think art is a bit of a challenge to anthropologists. It is not really a case of anthropologist envy! On the other hand, the range of artistic practices discussed at the conference was indicative of a desire not to simply dismiss the discourse, but rather to engage with it. I think the more interesting artistic practices, in relation to anthropology, are actually dealing with anthropology in a highly critical way, engaging with the problematics of the historical discipline of anthropology, playfully reinterpreting methodologies, practices, and concepts.

In answer to your question it is probably fair to say that the material I work with – that is diaspora and family photographs – are not easily characterized, being interpreted within an art context as personal documents and within anthropology as vernacular artefacts. They are also indicative, as you suggest, of highly mobile and perhaps 'subaltern' experiences, which is hard to document or express, it is a fluid state of being. So yes, it is probably true that all of these factors influence the highly interdisciplinary and contingent nature of my work.

Rebecca: Is this mobility and interdisciplinarity only possible for artists who step outside the traditional constraints of Euro-American art institutions?

Mohini: I think it is interesting that, at this point in time, we have a generation of artists who may have cultural roots in one community, may be living in Britain or America but have a range of global connections. These artists have a really multi-disciplinary, multi-faceted view of life. For these people, 'interpreting' from one culture to another is not really an issue, it is kind of natural and it is not a one-way process. That is the state in which they exist, it is not an extraordinary thing that they do and they are not in effect studying 'another' culture. But I think that if artists do go and 'plunder' from another culture or experience, simply to aestheticize or to 'authenticate' their own work, they run the risk of simplifying complex situations – it is a very difficult issue.

It has not actually been usual at all in art to make relationships of collaboration and assistance from different communities explicit. However, I do think that it is possible that through a critical engagement with discourses such as anthropology that artists have realized: 'actually it may be problematic when we appropriate elements from others as we see fit.' Therefore, if you want to engage with those discourses in a critical way as an artist, you can perhaps learn how not to appropriate from other cultures inappropriately!

Rebecca: It is clear that your work is created out of an engagement with your relatives' and your own identity performances. This is very much like the kind of anthropological practice that Taussig and Marcus called for in the Fieldworks conference. They suggested that anthropologists expose the kind of collaborations and complicities that are at the heart of anthropological field encounters in their writings. They called for anthropologists to focus on practices of theatre and cinematography, in terms of the preparatory stages of these practices such as stage and set design, in order to re-examine the methodological framework of fieldwork and its visibility in anthropological writing.

Mohini: I think the analogy made with cinema and theatre indicates the potential of looking at a situation in all of its multifaceted, implied, and perhaps hidden ways, as well as to the ways in which people perform or present themselves to us. However what should not be forgotten, of course, is the position of the audience, the one who looks on, and that includes the artist as well as the anthropologist. So, in this situation you might make that relationship explicit and imply or allude to the way in which you have worked, or the relationship you have with those 'participants'.

Figure 9.1. Studio (Nadi) still from DVD projection, 2003/2004. Fiji Studios.

Figure 9.2. *VoiceOver*, ebook with soundfile, Proboscis, www.diffusion.org.uk, 2002.

The reference to 'performative' ways of working, such as theatre and cinema, was also directly relevant to me in that I have been looking at the ways in which various forms of identity are 'performed' through photography. Fiji-Indians have been making these photographs, these performances, since the 1950s or even earlier when they took over European studios in Fiji and began to appropriate photography in the construction of their own (often idealized) identity. In my most recent series of video works entitled 'Fiji Studios' (2003/4) I have attempted to explore this by recording the processes in which such photographs are made. Most importantly, these videos also focus on the long moments when the studios are empty – awaiting their next client, in a state of expectation. The potential of the stage-like set for me implies something about the expectant pause before a performance while the photographic moment, the interaction between photographer client and their collective imagination, has something of the Bollywood cinema about it. I am also working on a series of paintings of studio 'sitters' in Fiji and Bollywood stars from the 1950s. The 'mixed-upness' of these portraits or performances is essential to our reading of these still studio moments, one aspect of their critical cultural context.

Rebecca: The gallery space also becomes this 'contact zone', an uneasy space of anticipation. As a place of collaboration and contestation for your artwork, the gallery can be seen as similar to the photographic studios featured in your relatives' performances. Do you feel that this sense of performance extends to the audiences who view your installations? For instance, I really like 'Travels in a New World 1' (1994) where

the objects in the room are reminiscent of islands. When viewers walk around the room they anchor themselves on these different shores not quite knowing what is on these different islands. There is no fixed trajectory or right way to move around the space. As each viewer walks around the studio they create different passages, different trajectories around the objects.

Mohini: Yes, and there was tea on the floor so everyone left a mark of where they had been. So, although it was a very personal piece, it certainly was a kind of performance that involved the audience. That was the first work I did where I attempted to allude to a colonial indenture history and to my own memories of going to a place like Fiji as a family member but also as a tourist. Since the earliest days of European engagement with Fiji it has been seen as a kind of paradise, albeit a slightly troubled paradise. For the Indians in Fiji their experience of Fiji has, however, been less than 'edenic'. There was a kind of edgy complexity to that work, whereby I wasn't really sure of my own place as a child going into that situation and I wanted the viewer to feel that sense of being unsettled, of not quite knowing what they were looking at and not quite knowing or understanding something very complex.

Rebecca: Your relatives make themselves visible to each other through different media, but in your work their images are, in a sense, invisible. Can you tell me a bit about your relationship with the visibly performed Fiji-Indian identities and how this is reinterpreted within your work?

Mohini: When I talk about the people I work with I don't really see them as another group. It is just an extension of myself, and my relationship with my family. In this way my work could also be seen as an extension of diaspora photographic practices. However, I have to remember that the context in which I show the work is very different to the context in which families would look at their own photographs. In many of my works I have tried to deal with this issue by 'implying' the photograph rather than actually showing it or making it explicit. In the 'Album Pacifica' series (1997/2001) for example, I showed photographs of the 'backs' of family photographs, while in the 'Travels in a New World 2' video installation (1997) family members discuss a remembered photograph which they were all included in many years ago. Such works allude to the 'invisibility' of these communities, but they also allude to the ways in which photography and other media are used by people to stay in touch with each other. In 'Voice Over' (2002) a web-based book (www.diffusion.org.uk, 'Liquid Geography' series), I used sounds and photographs of an original tape that my father had made of various relatives around the world speaking. He was going to take this tape back to Fiji to play to his parents. This tape is a kind of letter that has been passed around through many different hands before it was returned to Fiji.

However, it is mainly the audience's relationship with media such as photography that comes under scrutiny in my work, rather than any specific family photograph. By creating spaces in which audiences have to use their imaginations to conjure up the photograph, the work becomes a way for me to evoke the diaspora experience. In so doing I use my own specific experience as a template but I do not necessarily tie it to

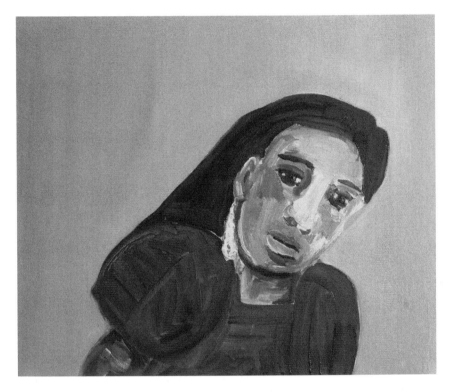

Figure 9.3. *Actress Kamini Kaushal,* 2009 (oil on linen) 25 × 30 cm.

that particular experience. In this way, my work explores the ways in which histories are told. I don't want to control the readings of the work. Instead, I want to create a space for different meanings, particularly as I'm talking about a historical experience that is multi-layered, complex and can't be pinned down.

Rebecca: Similarly, maybe, there are always multiple readings of a particular anthropological text, which is a performance of sorts, or a re-performance of events, experiences, and emotions. An artwork allows people to take different routes, to make different interpretations as they engage with the work. Do you think that it is easier to allow for these multiple interpretations and layered meanings in an artwork rather than in a text?

Mohini: I think for myself, what I am trying to do is create maps and as you know maps can be read in many different ways depending on where you want to go. They contain essential information but at the end of the day it is up to the viewer where they want to take that.

Collaborative Migrations: Contemporary Art in/as Anthropology

Steven Feld, in conversation with Virginia Ryan

Arnd Schneider's 'Three Modes of Experimentation with Art and Anthropology' voices concern about 'the general reluctance that exists within anthropology, including its sub-discipline of visual anthropology, to engage beyond a narrative textual paradigm with visual work in the contemporary arts'.[1] He calls for 'a new engagement with visual forms of research and representation beyond the sub-disciplinary confines of visual anthropology'[2] and asks about 'new possibilities of experimentation in visual research and representation which so far have rarely been contemplated by anthropology'.[3] This article responds to Schneider's concerns by discussing three experimental collaborations. Each was initiated in visual projects by artist Virginia Ryan, who then invited anthropologist and sound/visual artist Steven Feld to join through anthropological response in written, acoustic, and visual media. Each project speaks distinctly to issues Schneider raises about ways experimentation in art might simultaneously and reflexively experiment with anthropology.

At the same time, the three projects described also push up against Schneider's focus on 'the visual in its entirety'[4] by describing works that variously and multiply combine visual media (sculpture, painting, photography, video), acoustic media (ambience, music, sound art), and text, as well as experimental modes of publication, installation, exhibit, and symposia. These projects, like others analysed by Schneider, are also sites where art appropriates anthropology, but equally projects where anthropology reflexively and reciprocally appropriates art.[5] While in agreement with Schneider's call for more progressive and searching forms of experimentation across the fields, these projects offer an amplified call for multi-media experiments and collaborations where mixed materials, performances, and installation can engage the complexity of ways artists and anthropologists think about the contemporary world.

CREATING COLLABORATION

In the three cases described here, collaborative multi-media experimentation is presented in both exhibition and publication,[6] and the projects speak to modes of witnessing and issues of concern to both contemporary artists and anthropologists: post-colonial identities; race and representation; the sensuous materiality of history; place and memory; nostalgia and loss; environmental degradation and reclamation.

These collaborations begin in the practice of Virginia Ryan, an Australian-born and Italy-based visual artist who works in photographic, painting, and sculptural media. She has resided, produced work and exhibited in Australia, Egypt, Italy, Brazil, Scotland, ex-Yugoslavia, and Ghana. Her work has often concerned displacement, migrations, memory, loss, and involves multiple engagements with local artists, communities, and artworlds in the places where she has resided. She is a founder and former co-director of the Foundation for Contemporary Art-Ghana, and in Ghana met Steven Feld, a US-based anthropologist who has principally done ethnographic research in Papua New Guinea.[7] A musician, sound artist, photographer, and filmmaker, Feld has produced anthropological work in textual, sound, and visual media, and publishes equally in print, radio, exhibit, and CD/DVD formats.[8]

From 2006–8, Ryan and Feld collaborated on three Ghana-based projects, *Exposures, Castaways*, and *Topgraphies of the Dark*. Each project was initiated by Ryan as stand-alone visual work for exhibit in Ghana and Europe. With Feld's participation each project moved into the realm of a collaborative publication and expanded exhibition. Although Feld continued with music and film projects in Ghana after Ryan closed her Accra studio in 2008, he has also continued to collaborate with Ryan, through sound installation, on *The Hand, The Eye, The Voice*, her current multi-sited and multi-year project with women sewers and embroiders in six locations in Italy.[9]

EXPOSURES: A WHITE WOMAN IN WEST AFRICA

From 2001–5 Virginia Ryan staged several hundred photographs of herself in diverse situations in Accra, Ghana, and surrounding locales in West Africa, where she was living and working as an artist, administrator, and member of a diplomatic mission. The photographs are of Ryan with African and non-African interlocutors, hosts, and co-workers in diverse public situations, and a few private ones. The images inquire into and create an artistic conversation about the experience of being white in West Africa, of a European woman being the exposed object of a non-European gaze.

Ryan showed Feld an informal selection of these images in Accra in 2004, and asked for an off-the-cuff anthropological response to them. Feld responded by telling Ryan about anthropological projects that experimented with reflexivity and self-representation in contexts of encounter,[10] and in particular discussed with her the anthropologist and filmmaker Jean Rouch's notion of 'reverse anthropology', a term that provocatively catalyses the clash of politics and aesthetics in situations where those more typically positioned as representers come to be represented.[11]

What then evolved was a series of co-editing conversations, where Ryan and Feld selected and paired sixty of the collected photographs, discussing the qualities that made them most poignant from overlapping artistic and anthropological viewpoints. Feld wrote an essay on race and representation to accompany the sixty photographs. The essay blurs voices, mixing analytic and evocative registers, incorporating fragments of recorded conversation with Ryan, and situating the work in perspectives from art/photo/film history, anthropology, African studies, and critical race and gender studies. The images and essays were published as a book[12] and the essay was

also translated to Italian and published with a small selection of images in *Voci*, an anthropology journal of La Sapienza University, Rome.[13]

The sixty images were subsequently exhibited in embassy, gallery, museum, university, and research centre settings through 2007 and 2008 in Ghana (Accra, at the Australian Embassy), Italy (Rome, at St Stephen's Cultural Centre; Spoleto, at the Galleria Civica d'Arte Moderna), and the US (Harvard University Dept. of Anthropology; School of Advanced Research, Santa Fe; University of Wisconsin Milwaukee Department of Film), in each case combined with a forum or symposium on race and photographic representation, involving critical feedback and conversation from artists, academics , and community participants.

The publications, exhibits, and conversation join art and anthropology as anti-erasure, getting 'in your face' with the visible evidence of what race and postcolonial privilege look like in contemporary Accra and West Africa. In resonance with the title 'Exposures,' and the highly ironic subtitle 'A White Woman in West Africa', they ask what has changed, or been left unchanged, about the look or display of whiteness since colonial times, and who and what is exposed, made vulnerable through the gazing of inter-race encounters.

The book and exhibits exploit the *double-entendre* of the title word *Exposures* to ask how the trope of photographic exposure, of concentrating light onto celluloid film, finds its double in social exposure, of the vulnerability of racial gazing. And as a method of inquiry, both the images and text ask how this trope of exposure can operate simultaneously on the planes of analysis and poesis. Ryan's artistic revelation about the awkwardness and recognition of gaze was to seize on the double exposure of her skin as a canvas onto which images, and thus stories, were beamed, projected, fixed, destabilized. Feld's anthropological response was to write about the duality of gazing through transparency, rejoining the image of the skin to the skin of the image. In the juxtaposition and slippage of image and text we find moments of art and anthropology mutually exposing and exposed.

FRAGMENTS FROM A CONVERSATION ABOUT *EXPOSURES*

VR: Going back to ground zero, so to speak, what did you first see in my pictures that interested you, anthropologically, that is?

SF: What I saw in the photographs, what interested me most, was the gesture of reflexivity, the photographs as instances of you looking at people looking at you.

VR: Well it was even one step beyond that, because it was also about me looking at the photographs of other people looking at me.

SF: From there, this project really followed a kind of classic and obvious pathway of collaboration between art and anthropology. You created the visual work as an artist and used me as an anthropological sounding board, to sort of see what kinds of images resonated with what kinds of issues or ideas, particularly about colonialism and post-colonialism. And that became another artistic collecting process, so to speak, collecting reflective distance from the immediacy of those pictures after you left your Ghana posting in 2005.

VR: I'm very aware of that, and was from the very beginning, when I first started taking the photos. I knew that they would become more powerful and more poignant with time. But one way that I collected distance was by learning how an anthropologist thinks of or thinks with a photograph. What I found interesting, probably the most obvious aspect but maybe the most important, was the way everything is so carefully contextualized in anthropology. Of course, this can be so in an art project as well, but with art you can somehow remain more on a level of surface, within the boundaries of the material, whereas as soon as we started talking about these pictures we were cataloguing and discussing all of the things that were outside the frame as well, and it made me aware of this anthropological way of thinking across the lines of the frame, how you tended to contextualize the inner material with regard to everything that is not rendered there directly.

SF: Well, that acknowledges an anthropological commonplace about the social lives of photographs: that photographs are the beginning of telling stories, not just the ends of them or the summaries of them. That's why anthropologists think of photographs as doubly social. First because the material they encode is about social moments or social events. Second because they bring out the sociality of storytelling, their viewing unleashes stories about when and where and what, about feelings, memories. They're not just private events. You offered these photographs in public.

VR: Okay, but had I not been talking to you, the anthropologist, had I just presented these as a series of art self-portraits, for example, in a gallery, I would have never have told even the beginning of a possible story. It was that anthropological dialogue that made me focus on the myriad meanings of being exposed. As I started to see the photographs as a possible continuum in book-like form I was taken by the nauseating fear that 'Oh God, she's still there. I'm so sick of her. She should get out of the picture.' That was a realization of extreme vulnerability for me, not as an artist but as the person behind the artist.

The word exposure is so evocative of different ways of being vulnerable in the world, being under a constant strong light, and with that the inability to hide from being constantly noticed. And of being farcical, being more than me, being a character in a history play, the 'White Woman', that whole way of making fun of colonial roles and what just won't go away in the postcolonial. Because when you are in a moment of vulnerability or exposure, you try and find ways to lighten the load. So using a little bit of irony and trying to pull people into the joke, that's a way of exposing that the White Woman also sees the completely banal and unimportant side of herself in the mirror. But you know and I know and most people who look at those photos intently, with attention, will know that actually there's nothing farcical at all. Because there was no masquerade. That's me, that's how I lived, and what I did, and who I met, and how my life there unfolded. So that's important to me, that in the end, you don't see a farce, you see a certain dignity, at least I do. You see a lot of people accepting or dealing with their roles on all sides, and doing their best with them, even when struggling. But tell me, in that regard, were there any images that made you particularly uncomfortable as an anthropologist?

SF: No. But there are images that I would say are extremely edgy, in terms of cutting more quickly to artistic techniques of visceral provocation.

VR: Like which ones, or which one most does that for you?

SF: Several, like The Night Guards, The Gym, The National Museum, but a perfect example is the photograph of you in bed, the one you called The Malaria Attack.

Figure 10.1. Malaria Attack, photograph from *Exposures,* © Virginia Ryan, 2003.

VR: Why?

SF: Because you are in bed, very pale, and wrapped in white sheets. And there is a black woman sitting next to you, but not looking at you. She's dressed in a white uniform, and she's sitting there staring off into space. But she's your guardian, she's looking after you because you can't look after yourself. Maybe she's a nurse, maybe a maid. You're obviously vulnerable because you have to be cared for by somebody else. You are asleep and we can't see your face; she is awake, but she is looking far away. You're exposed because you are sick and in bed and for all we know you weren't aware that a photo was being taken in such a private moment, behind closed doors. She's exposed because she is doing her job but maybe not comfortable with it, or not comfortable with being photographed in that scene. We can't know. We can only look at the image and ask the questions. But surely for many people, black or white, it's uncomfortable to see a picture of a black woman like that in a nurse's uniform or a maid's uniform attending individually to a white woman in the bed, someone who is getting this kind of attention because of power and privilege. It's not like she's standing there giving you an injection or handing you a pill or doing something directly to help you, so we would not read this strictly as a photograph made in a medical institution. The larger context makes clear we are not in a hospital room, we are in a private bedroom. And everything is heightened by the fact that your bedding is bleached white, that you're shrouded in white, that you're sick and very, very white, that there are white flowers at the bedside, and that the burst of colour is a black woman who is all dressed in white.

In terms of both the word 'exposures' and the words 'white woman in West Africa', it's a hugely provocative image around anthropological issues of race and class and wealth and power and what those categories mean in health or domestic care, of who looks after and has looked after whom in the world. For anthropologists too, as for colonial historians, there is also the *tristes tropiques* written all over the image here; we're in the sad tropics, the place where whites get sick with malaria and have to be looked after. Isn't that a classic part of colonial storytelling, or anthropological storytelling? What does the explorer do? The explorer gets sick. But lives to tell about it.

VR: And with it a sort of colonial glamour, too, you know, 'I survived malaria.' What you say makes me think immediately about the diplomatic life and the fact that a huge amount of time before one goes on a tropical posting is spent talking about possible diseases and illnesses in the place that you're going to and how you're going to protect yourself, which I always found really curious. But to go back to art, that image also references renaissance portrait paintings, reclined women with attendants, I mean, there are art historical ways that you could read that image in terms of representations of attending to and being attended. So picture reading is really about reference points, isn't it? If one is aware of certain sorts of paintings, or photographs, one also will read that picture in particular kinds of ways. If one's main reference or only reference is to colonial history and power of race relations it is another set of associations.

SF: Yes, and of course, there are, outside of renaissance paintings, other visual histories of imaging the attended and the attender; Edward Said talks about some of them in his book on *Orientalism*[14] where this is a very potent kind of template, resonant with other legacies of colonial and imperial power and privilege.

VR: Anyway, the whole thing about exposure here is about risk, isn't it? Artists take risks. Anthropologists too. So yes. But I liked the idea of asking what someone who's not in the artworld would say about this, and particularly, what someone who's not in the artworld but has been in this place would say about it. But also I'd read texts on African art or contemporary art in Africa and I knew the genre and its limitations. I wanted to learn something different. So I liked the idea of taking a different risk for the text, by exposing my art to anthropological scrutiny, and wondering if it would bounce back in a way by exposing anthropology to art.

THE CASTAWAYS PROJECT

From 2003–8 Virginia Ryan made, in her Accra studio, 2,000 sculptural paintings titled *Castaways*. Each collage is 9 × 11.5 inches/23 × 29 cm and constructed from objects Ryan and collaborators collected on Ghana's shorelines at Pram Pram, Jamestown, Labadi, Anomabo, Korlegonno. These are objects that were once desired and purchased, used and worn, carried and discarded, left to wash out on the tide and then carried back in. All the collected materials were then white-washed by Ryan, composed, and flicked through with grey-gold, resonant with the colours of foam and sand as the waves break on the very shores from where the inhabitants were once taken and enslaved to build the new world. *Castaways* are exhibited as a collective artwork, walls or rooms, 200 or more pieces hung closely together in rows

Figure 10.2. *Castaways*, Whitworth Art Gallery, © Steven Feld, 2007.

creating continuous wave of memory and repetition, referencing gold, slavery, oceans, beaches, people and displacements. This exhibit format emphasizes the power of repetition and number, of place and pasts in the present.

Feld first saw Ryan's *Castaways* in 2004 at her Ghana studio and found them quite echoic. In their material tactility, colour, volume, and assemblage he found them audible as a complete sound environment. Viewing some one hundred *Castaways* on Ryan's Accra studio floor, he told her that he felt like he was putting an ear to a huge seashell and listening to the detritus of history. In the rows of objects he could hear the washing-up-and-out sounds that deposited Ryan's raw environmental data, her signs of multiple human and material pasts, on the shorelines of Ghana in the present.

The conversation that followed led to Feld's production of *Anomabo Shoreline*, an ambient sound composition where he responded to this way of hearing the visual material of the *Castaways*, creating for and with them an acoustic memory of the Gold Coast becoming the Black Atlantic.[15] Recorded at Anomabo beach, one of Ryan's key collecting sites, then created in the recording studio, the 60-minute composition consists of a continuous and seamless mix of eight separate spatial stereo sound tracks recorded from the shore, at the water's edge, in the ocean, in and behind rocks and rock pools, and even under the sand. Constructed as a site-specific sound installation to accompany exhibit of *Castaways*, the soundtrack plays continuously at ambient volume, bringing the water's motion to the viewer as s/he moves in to experience of waves of *Castaways*.

As an additional accompaniment to *Castaways,* Feld produced a 15-minute video on DVD, *Where Water Touches Land,* also made for an installation. The video consists of time manipulations of multiple visual elements, from still photographs of the shoreline's sand and water formations, to portraits of individual *Castaways,* to video of Ryan at Anomabo beach collecting washed-in objects, and in her Accra studio working on composing and transforming them into *Castaways.* The video uses as key soundtrack material ambiences from the Anomabo Shoreline recording. But it adds additional ambient sounds from Anomabo beach and from Ryan's studio, as well as music from two tracks of the CD *Meditations for John Coltrane* by Accra Trane Station, [16] featuring Accra musicians Nii Noi Nortey and Nii Otoo Annan, with whom Feld has been performing and recording since 2005. *Where Water Touches Land* mixes real time images with different kinds of contracted or expanded time, fusing time-lapse photography with the real time of waves coming in, evoking a sense of place and history while at the same time documenting artistic work.

Ryan presented early exhibits of *Castaways* in Ghana (W. E. B. DuBois Center for Pan African Culture, Accra; Alliance Française, Kumasi) and Italy (Palazzo Trinci, Foligno); these were purely visual installations. The development of the project for presentation in Ghana and Italy followed on from a similar way of presenting, and creating cultural conversations, around her earlier, and first large-scale Ghana project, *Landing in Accra.* [17] In the aftermath of arriving in Accra Ryan drove around the city, getting to know it and its artists by stopping to meet commercial sign painters who work along the roads. After looking at their work she showed them hers, in particular a painting about a floating dream of landing in Accra. This led to over one hundred collaborative paintings, the left side of each canvas a scene painted by an Accra sign painter, and on the right side a variation of Ryan's dream painting. The project was exhibited in Ghana (National Museum in Accra; Alliance Française in Kumasi) and then Rome (Sala 1 Gallery) and Viterbo (Palazzo Calabrese).

Castaways exhibits with the sound and video installation were presented in Ghana (Alliance Française, Accra), UK (The Whitworth Gallery, Manchester, 2007) and Italy (Galleria Civica d'Arte Moderna, Spoleto, 2008, which also involved a major catalogue). *The Castaways Project,* a collaborative publication consisting of a small catalogue of *Castaway* images, plus an audio CD of *Anomabo Shoreline* and DVD of *Where Water Touches Land,* was published in 2007. [18]

FRAGMENTS FROM A CONVERSATION ABOUT *THE CASTAWAYS PROJECT*

SF: Do you remember that I stepped on one of the *Castaways* when I first came to your studio in 2004? I was kind of tiptoeing along the edge of one line of them on the floor, and lost my balance. That must have been related to the sensation of their audibility, that sense of listening into a conch shell.

VR: Don't you think that's connected with your life as an anthropologist? It's a kind of metaphor for the anthropologist as listener, no? I remember very distinctly when you talked about listening to the shell, but that thought reminded me of childhood and magic, of the beaches of Australia where I grew up. And that resonated with

how some of the *Castaways* were dolls, and together with other miniatures in these little domestic environments there was a feeling of protection, childhood and both the pleasure and the mystery of hearing the ocean, finding shells as they wash in, and seeing them wash out and just being taken over by the water's rhythms.

SF: Anthropologists writing about shorelines picked up this phrase 'contact zone' from the literary scholar Mary Louise Pratt, to talk about places where cultural histories become porous, clash, and struggle in contexts like slavery and colonialism. This is in her 1992 book *Imperial Eyes: Travel Writing and Transculturation*.[19] Beaches are a perfect example of sites where histories blur because so many kinds of objects and people wash up. And then there are the things that are taken away, again objects and human beings. So collecting things on beaches is always sensuously connected to the memory of all the stuff that happened there, all the crossings of people and objects. And the contact zone is not just a zone of actual things that happened between groups of people at a site. The contact zone is also a history of memory as well; James Clifford extends the idea to discuss museums in his influential 1997 book *Routes: Travel and Translation in the Late Twentieth Century*.[20] But from the side of sensuous anthropology of place, I also want to connect contact zones to the dreamy side of memory, to Gaston Bachelard's *The Poetics of Reverie*.[21] That's perhaps the Australian beach connection for you; there's a piece about beaches that takes this up, by an Australian anthropologist, Mick Taussig.[22]

VR: I think reverie is a good word here and connects well with the sensual history of this project. I makes me think of walking along up and down Anomabo shoreline countless times with that sea breeze and the very hot temperatures and sort of wandering along and seeing things and choosing intuitively which to pick up and which to leave. It was very dreamlike, very concentrated at the same time, like any intense activity where you are totally in the moment with it, any creative activity. Reverie suggests how you give yourself to the place and the place gives itself to you. Both your sense of time and your sense of space go and then there is a kind of mirage effect too, of seeing things in the distance and then you get close to them, or seeing things as they get swept back into the water, or seeing things as the tide deposits them in front of you and sort of gifts you with these charms. The reverie part of it is perhaps also tied to taking care of something that's been abandoned that was really important. I felt like I was kind of mothering these discarded things, taking them and transforming them into something that people might care about. And giving back some kind of innocence to the objects. But I was helped very much in the process by the sea itself, because these objects had all been in water, or near water, touched by water. And then they were literally sun-bleached. So they'd already gone through a cleansing rite before they got to me. In a way I just kept the process going.

SF: Can we talk about how that historical sense of place, memory, and reverie worked in the context of the installation for the Whitworth Art Gallery in Manchester, in June 2007? I mean it was there in an art gallery and thus contextualized as art. But the exhibit was timed to be a featured part of *Beyond Text*, a conference on anthropology of the senses that linked the Whitworth exhibit up to The Granada Centre for Visual Anthropology at the University of Manchester. And in addition to the art gallery and visual/sensuous anthropology connections there was the historical setting of 2007, the fiftieth anniversary of Ghanaian national independence

and the UK bicentenary of the Abolition of the Slave Trade. A long wall featured eleven stacked rows of *Castaways*, about 680 of them, and the sound speakers were on the floor of the opposing wall, emanating out in a 5.1 surround mix. So the sound was shooting along the floor from directly across the room, moving *towards* the pieces, and then, almost like water waves, hitting the wall and then floating up to them, floating up with them, and rising in the room and swirling into a massive wave-like roof structure of the gallery.

VR: What I recall very well was something that I felt every time I was there, which had an impact on other people too. Before you got into the room with the *Castaways* you could hear the sound of the waves drawing you there, lighting the path to them. There was a sense of very much entering into a different sort of relationship with the museum but also of entering a much more intimate place, an acoustic premonition of entering the place for viewing. I hadn't been there to set up the work, the actual visual installation was complete when I arrived, so having that sound coming more from behind created in me a sense of almost being *in* the water, rather than walking towards the water. And I imagine this was so for a lot of people, because many came in and sat down and rested or lay down on the benches. That was for me the most remarkable moment in the audience encounter of that exhibit, people not just standing in between the speakers and the objects or walking close to the objects, but actually sitting on the floor or lying down halfway between them as if they were on the beach. Did you get comments about the relationship between the visual and the acoustic?

SF: Do you mean about the transport, the sensation of being at the beach?

VR: Yes. There was something quite synaesthetic about it in terms of the sensation on the skin; that wetness, that reverberant space, that sense of time being a little more watery or elastic.

SF: Yes, people made comments to me about that, especially about the feeling of wetness of the room and work. It did create a more timeless sensation for the work, and I think people let time and space expand to open up to the acoustic horizon. People also made comments about that to Rupert [Cox, the conference organizer who liaised with the Whitworth about the exhibit and led several tours and discussions of the exhibit].

VR: I'm listening to this and I'm thinking, hey, we're supposed to be talking about collisions and collusions of art and anthropology, but basically we're talking both as artists, talking about the materials and how they affected people, right? I think that's interesting.

SF: Well, in a sense the project involved equal or more participation from me as an artist, but it was hardly clear-cut, because I responded to your *Castaways* first in an anthropological way. I mean after I saw them for two years I really wanted to use sound and image to theorize these key ideas about the sensuousness of place, the materiality of memory, the beach as a contact zone, the presence of the past in the present, the continuous horizon. I wanted to bring everything together around this great line from Walter Benjamin's essay 'Theses on the Philosophy of History' where he says: 'The past can be seized only as an image which flashes up at an instant when it can be recognized and is never seen again.'[23] I wanted to use sound and picture to make that *image* that *flashes up* and I wanted to use the ephemeral and material nature of sound to grasp that idea of historical seizure so poignant in

Benjamin's thinking. It is such a key to the sensuous material of the contact zone. With the sound I took one approach, from ambient sound art and installation, making a piece that was equally dreamy and hyper-real. But with the film I wanted to try something even more radical in terms of representation, something that used and acknowledged all the conventions of art film in terms of both acoustic and visual space-time compression and expansion, but where that artful evocation was equally part of a multi-site document of the birth and maturation of artwork, in other words, an anthropological film about how an artist theorizes place and sensuous history through the materiality of collecting and making and installing objects.

VR: I had to accept that in some way by being in that film I was something like a case study, a subject of anthropological gaze, whereas usually I think about my work as something I can disappear from after its creation. So, to me, that was the moment when I guess I had to shift and ask myself how you were working as another artist but also really thinking as an anthropologist and doing something very different to what I was doing.

SF: What about the moment when I shot that very brief sequence that's used in the film, the one shot from over your shoulder where you're sitting in your apartment in Accra and looking through a book of old images of these slave castles. All of a sudden we go from images and sounds of the sensuous power and reverie of the washings in and out to oh, there's this other historical set of traces that is all over this work: the forts, slavery.

VR: The question was, then, what kind of story are we going to tell about it? Because this was not to be an anthropological film about slave forts and castles. The story is about an artist in a place, about how art meets and makes memory. And watching me look at that book acknowledges that artists are also viewers with a visual relationship to history, not just a visual relationship to their own art.

SF: You become a particularly reflexive agent at that moment in the film, because while we're listening to the sound of that water, we see you, from over your shoulder, looking at the book of slave fort pictures. We're not looking at your face. We don't know what kind of state you're in, but you're turning the page and that visible evidence of you turning the page, like the evidence of your hands picking things up and putting them in your bag as you collect from the beach, is a point of reference, like the way the radio is playing in your studio during the sequences where you are at work. So while the image of you looking at the pictures of the castles has one level of suggestion of historical awe, there is this other, more ironic relationship to history on the soundtrack...

VR: ... the BBC ...

SF: Yes. In your studio, in your workspace, the BBC Africa Service was on constantly, it's the drone of history, playing everything from the Pink Panther theme song to banal news stories about the history of the Queen's head on British money. And that's the acoustic background that anchors what you're doing in the moment. We don't see the source of that sound. You never see a picture of the radio, because I didn't do the standard ethnographic or documentary film thing of using a cutaway shot of the radio itself. But the radio's sound is the actual synchronous sound recorded in that moment and directly attached to images of you at work in that moment.

VR: I liked having the BBC on the soundtrack, both because the BBC Africa Service is constantly replaying the past, but it's also constantly playing the moment of what's

going on. And it's comforting for an artist alone in a studio to be at the same time connected to hundreds of thousands of other people all over the continent listening to the same program. I feel like the years I lived in Ghana were often accompanied by the BBC's African service. It was like a heartbeat. And yes, on one level it is very banal, but on another level it was often whimsical and quite poignant. And that's how I often experienced the passage of time there, working in that tiny little studio with my little battery-operated radio.

SF: And that's the metaphoric suggestion I make in the editing of the soundtrack – that in your studio the BBC was your ocean, and that sound is as much inside the *Castaways* you made as the sound of the waves breaking at Anomabo is part of the histories of the sun-bleached *prima materia*. So the sound of radio and the sound of the ocean become parallel tracks, as both have important relationships to the experience of space and time at the beach and in the studio, to the histories of the material objects that became *Castaways* and to the process of making the *Castaways*, and to the sensuous experience of place. The place of the BBC is triangulated by the washings-in and out of the water, and the music tracks of Accra Trane Station.

But enough about my blurring roles between anthropology and art, because I think you do too. I mean there is an anthropology in your art here, and it comes out as you attach the history of making that work to the sounding out of the waves of history on the BBC. And the way you collected, transformed, and displayed the work speaks to the anthropology of place. Aren't you doing work that grapples with displacement, replacement, emplacement? That speaks to your own sense, historically, of often moving places? Of your experiences of being displaced? Anthropologists spend time theorizing their consciousness of what it means to be out of place. Perhaps what you are doing is migrating art to anthropology and vice versa. Even your reference to the stuff on the beach as data, environmental data; I was very taken by the metaphor. You're even using a kind of social science language, no? That's exactly the kind of thing that interests Arnd Schneider in his writings on art appropriations of/as anthropology.

VR: Well, I've been displaced many times and have lived in a number of different countries. But rather than that becoming a kind of misplacement and just asking what am I doing here, the experience of displacement feeds into my work totally, because I am always trying to create some kind of stability amidst experiences of movement. And perhaps that is why I have so often worked with shoes, with the visible evidence of feet and motion, and the historical patina of things that have been used, worn, and hold history in that kind of way. You see that from *Cento Passi*, where my way of moving into a new place was to go around and ask people if they would give me a pair of their old shoes and tell me a story about them. That was a way of connecting the movement of my feet to theirs. And creating a work for exhibit in that place so that people might understand how something like their old shoes could become a shared poetry, an art exhibit that validates their stories in mine.[24]

So yes, my work is about migration in multiple ways, because a great portion of my work is about settling and unsettling and the experience of home and movement. Moving into cultures or places that aren't my own and where I am the outsider has created approaches to how my temporary residence relates to other

histories of residence, temporary or not so. So in Ghana I wanted to work with place and history at the water, with objects that have left and come back, or moved in from far away brought by water. But I was very aware that I did not want to become known as the strange white artist who deals in rubbish. It was very clear to me that this would get in the way of people being able to see the work. So I thought, well, I have to immediately find another way of talking about this, I'm not going to refer to it as rubbish, and so it seemed obvious that it should be called environmental data. So in that sense, like you as an anthropologist, yes, I was collecting data about the experience of place, even if in a very different kind of way and with a very different purpose.

TOPOGRAPHIES OF THE DARK

Topographies of the Dark is a very different kind of collaboration from *Exposures* or to *Castaways*. Following and repeating the collecting and construction techniques for *Castaways*, and a sculptural painting series called *Blues for Charlie* completed in Accra in 2006, Ryan began, in January 2007, to experiment with various scale (2' × 2' to 4' × 8') sculptural paintings composed of macheteed flip-flops collected from Accra beaches where they had washed up. Assembled in two and three density layers, nailed and glued to plywood, the pieces are covered in shiny and dull mixtures of black paint, sand, and coal tar. One immediate local reference for the work was a November 2006 *New Yorker* magazine article talking about architect Rem Koolhaas describing

Figure 10.3. *Topographies of the Dark*, Galleria Civica Spoleto, ©Lorenzo Ferrarini, 2008.

flying over Lagos, Nigeria and experiencing the density and chaos of habitation and refuse there.[25] Another reference was the darkness of blackouts experienced every other day in Accra due to power cuts. And yet another was the question of the oil spills along the coastline. Additionally, there was the question of travel across oceans, particularly poignant to Ryan as Accra geared up for the March 2007 celebrations of Ghana's fiftieth anniversary of independence.

During the period that Ryan was working on these pieces, early 2007, Feld was continuing to collaborate as producer and musician with Nii Noi Nortey and Nii Otoo Annan on their Accra Trane Station recording projects. Nortey is inventor of a family of instruments called afrifones, African winds with saxophone mouthpieces. He also plays Western wind instruments (saxophone and flute) as well as African strings and percussion. Annan plays APK, the African percussion kit of local drums, bells and xylophones together with jazz cymbals. Feld joined them playing *ashiwa*, a West African rhythm box bass, working on musical connections between Africa and the legacy of the African American saxophonist and innovator John Coltrane.

In the early part of 2007 Nortey and Feld conversed about the confluence of Coltrane's 1957 classic LP record *Blue Train* and Ghana's 1957 independence. That led to Accra Trane Station's 2007 CD project *Another Blue Train*, a train ride through the blue diasporic night of African jazz to celebrate the two fiftieth anniversaries and to join them in the image of Ghana's night train, which was coincidentally painted blue. On a visit to Ryan's studio near the anniversary of independence, Nortey, who is also a visual artist working in sculpture, saw the first *Topographies* paintings, and said he wanted to sound them. So in the process of recording *Another Blue Train*, two dark and moody textural improvisations, each titled *Topographies of the Dark*, were recorded, each connecting Ryan's paintings to the deepest part of the night train ride. A few months later, when Nortey and Annan visited Feld in the US to perform together with American jazz artists, a full-blown project was created in a Santa Fe recording studio, a complete CD of compositions, *Topographies of the Dark*, in dialogue with some of Ryan's paintings that had just arrived.[26]

FRAGMENTS OF A CONVERSATION ABOUT *TOPOGRAPHIES* *OF THE DARK*

VR: What is quite powerful to me about *Topographies of the Dark* is not just its connection to night, to the African coastline, to oil and electricity, but that the work crossed the ocean multiple times. The flip-flops landed on the beaches where I plucked them, washed and macheteed them, worked them into the paintings there in Accra, where you and Nii Noi and Nii Otoo saw them at the studio. And that led to the pieces you composed for *Another Blue Train*. Then some of the paintings went to the USA, and after that Nii Noi and Nii Otoo went there and recorded with you. So that was another crossing, both for the work, and the musicians, and a very unique kind of conversation between art and audibility of transport. Moving big and physically weighty artwork is hard, moving music was easier, and like *Castaways*, there is a story about mobility, the movement of things and people through the waves, as an art of replacement.

SF: One of the things I had been encouraging Nii Noi to work on more was the relation-ship between his music and his own sculpture. So the connection between the feeling or the sounding-ness of visual art material was familiar to him, and he even called his work 'sounding sculptures' like the ones he made named for titles of major Coltrane compositions. And the instruments he made, they were also sculp-tures. So this connection to your work developed slowly and organically, first using two tracks from the Accra Trane Station *Meditations* CD to mix in with the sound of the *Castaways* video, and then the conversation about crossings in the night for *Another Blue Train*, then the full development of a Black Atlantic conversation for the *Topographies of the Dark* CD. But the idea of actually composing music that could connect to the paintings and could be published together with pictures of them was not something that we all sat down and worked out in advance of going into the studio. What was going on in the studio was much more a process of trying things out and things just developed that way.

VR: Exactly like me … seeing what will happen, hearing what will happen.

SF: We didn't sit down and say, we'll relate this piece to this painting or something like that. I wasn't even thinking about a CD when we went into the studio. We just recorded to experiment with bringing Nii Noi and Nii Otoo and me together with Alex (Coke) and Jefferson (Voorhees). It's kind of amazing that in just two recording sessions, five people meeting for the first time would come up with this music …

VR: … but there's going to be that sort of frisson, that inspiration in first meetings which is often hard to repeat, especially because it was a first crossing to America for Nii Noi and Nii Otoo, and you brought them together with people who had not been to Ghana, but who were musically kindred spirits, people who knew the Accra Trane Station music. There's something quite magical about the idea of the music arriving from travel and footsteps and …

SF: … and then you told me that a major retrospective of your African work would be mounted in Spoleto during the annual international festival, and that you wanted to feature the *Topographies* like the *Castaways* and *Exposures* projects. But this time there was no explicit anthropology in the conversation about exhibit; it was a conversation about having sounds of the musical compositions interact with the sculptural paintings.

VR: When we did *Exposures* I would describe you as my anthropologist collabora-tor. Then for *Castaways*, you were anthropologist, but also film maker, sound artist, sound designer, both a documentarian and collaborating artist. But for *Topographies*, your role was as a musician despite the conversations about envi-ronmental reclamation and damage, about ecological vulnerability, and the crisis of energy and society in Ghana as revealed by all the blackouts.

SF: Yes, at the Spoleto exhibit[27] collaboration itself was on display as part of the idea of a 2001–8 retrospective of your work in Ghana. With *Exposures* my role as anthropological interlocutor took on another kind of life once juxtaposed and in the same exhibit space with the collaboration you did with Accra sign painter Nicholas Wayo. His paintings of you, and his later collaborative paintings with you, reframe the White Woman photographs and the issues they raise about gaze and the representer becoming the represented.

 The dual role of documentary and art collaboration around *Castaways* took on another kind of life in the exhibit space at Spoleto too, because of the juxtaposition with exhibiting the *Topographies*.

The *Topographies* sound installation featuring the CD was confined to a room in the centre of the whole show, a room with two series of the smaller pieces. But what led to that room was the long hallway with the massively imposing large door-like *Topographies*, an extraordinary presence, facing Western windows such that their lighting constantly changed, particularly into the afternoon. That hallway featured the sounds of the ocean, so there was this water bridge from the exhibit's first rooms, featuring *Castaways*, to the hallway of *Topographies*, and into the room where the *Topographies* CD was playing. That centre room was like a little heart space, an inner chamber, and there were chairs there so people could pause and listen and look. Meanwhile, the sound of the *Topographies* soundtrack left that room and acoustically mingled and flowed into the sounds of the water, which was piped into all of the twenty rooms. So what starts as a focused experience of the water, the ambient sounds of the shoreline in the two first rooms filled with *Castaways*, then continues and sonifies the whole exhibit. Spatially – all the rooms – and temporally – the history of the work – make the Black Atlantic connection by this surround ambient of the water, and in its centre, the musical pulse of the *Topographies* suggesting the aesthetic figures of jazz, of race, of movement. The sounds of the water interacted differently with the exhibit in each of the twenty rooms. But having that moment where water takes you to music and music leads back out to the water, really created, for me, a special relationship of the visual and audible materiality of the *Castaways* and *Topographies* projects ...

VR: Because I think it worked aesthetically as visual display and also sonorically to have that little pulsing heart there in the middle with the different waterway entries into the room.

SF: Now it's me whose thinking about how comfortable I am with this conversation, speaking about materials and materiality to you as an artist, but thinking that where my anthropology migrates toward art is also where your art migrates toward anthropology. This is not a difficult conversation for me to have with an artist. But it is considerably more difficult, a good deal of the time, to try to have these kinds of conversations with anthropologists, because they are just so much less familiar with how we make visual and acoustic things, so much less familiar with how visual and acoustic materials are also media of articulation through which one can work on or express very complex ideas. I mean, the more I work with art, and with artists, and try to migrate the sensuous materiality of sound and image and object into zones of anthropological knowing the more I encounter this kind of academic fundamentalism, like when people say 'that was very poetic, but you didn't theorize the material'. What is to be done about anthropologists reducing theory to the literal, anthropologists refusing the possibility that theory gets done in all media and in multiple ways, including artistic assemblage, performance, exhibition? I mean just a couple weeks ago we were talking about that with Howie Becker, whose *Artworlds* book laid it out thirty years ago, you know, how once audiences put genre categories onto works they create rigid frames that constrain declarations about what is 'documentary' and 'art'.[28]

Remember what happened at Manchester? We had the *Where Water Touches Land* video playing constantly in the room with the *Castaways* exhibit at the Whitworth, so the work and video and *Anomabo Shoreline* sound track in that room were all mutually reinforcing and contextualizing and interacting. So there the film

was 'art,' and a number of people told me that it was a beautiful art film, and that they loved being able to walk back and forth between the wave-wall of *Castaways* and the video where they could see you walking the beach, collecting the pieces, and building the work in your studio. People really stood and watched the video.

But what happened when I screened the whole video in the context of giving the keynote speech for the *Beyond Text* conference just down the street in a university auditorium? The viewing frame shifted to 'documentary' because people assumed that it was to be an academic lecture. And I violated all of those genre expectations. I mean, that keynote deliberately made no academic citations or quotes. I just used images and sounds, told stories, just indulged completely in taking the trope of 'Currents' and suggested the way it sits between analysis and poesis, playing with the electrical, current affairs, and ocean senses of the term with musical, ambient, and criss-crossed art and anthropology materials from New Guinea, Europe, Japan and Africa. Well, this was meant to keynote a conference on the anthropology of the senses and my idea was to perform sensually the idea of anthropology as a quest in currents, to suggest that analysis meets poesis at that place of sensual 'flash' that was so poignant to Walter Benjamin. So I ended that talk with the screening of the film, making the connection between the conference and the Whitworth instal-lation. But talking with anthropologists in the following days I found that people mostly asked me to paraphrase myself, to explain what I really meant, to make it theoretically legible. So is it safer and easier to migrate or appropriate anthropology to art than art to anthropology? Art creates so much space for a sensuous theoriza-tion of knowledge. And I would think anthropologists would be more inspired by that. After all, anthropology has, like contemporary art, been committed to the rupture of epistemic obstacles. Hopefully that will only escalate.[29]

Making Art Ethnography: Painting, War and Ethnographic Practice

Susan Ossman

Since the early 1990s, visual anthropology has helped anthropologists to develop a keener eye. We have become increasingly sophisticated in analysing visual arts and aesthetic practices around the world. Our use of photography, film and video as a part of the research process, and as a way to present our findings, opens up anthropology to new audiences while encouraging us to become more sensitive to how we represent the people we study. Much less attention has been paid to the ways that the practice of other kinds of aesthetic practice can play a role in the development of anthropological knowledge. While at least some attention has been given to musical performance, to theatre or to the poems of sketches of anthropologists, the possibility of painting in the field has been pointedly ignored. Although painting and the art market have been the object of anthropologists' interest, the role that painting might play in developing anthropological knowledge has not been widely discussed. Is this because of the strong association of painting with Euro-American High Culture?[1] Is it because of the way that speaking of 'the painter' calls up the image of the quintessential 'artist' in many people's minds? Photography and film walk the line between art and science, playing on realist tropes in ways that are well known in anthropology. An anthropologist painting moves out of this point of tension into what some might see as the more settled and comfortable, but scientifically irrelevant, role of the artist. In this article, I will draw on my own moves amidst anthropology and art through my painting to suggest not only that painting can be a pertinent aspect of fieldwork practice, but that it is essential to how I have conceptualized the field. Beginning with a piece that I painted in Casablanca in 1990, I will explore the connections between art and anthropological invention, the ethnographic process and artistic/authorial authority.

RED THREADS FOR FIELD WEAVING

This is the triptych I painted in Casablanca in the summer of 1990 (Figure 11.1). It was inspired by a trip that I made to the northern Morocco, particularly the town of Chaouen. While it is not 'realistic' or 'figurative' in the usual sense, for me, it portrays the region quite precisely. It ties the landscapes together with the same hand woven red and white lines that women of the Jebel region wear as they work on golden

Figure 11.1. *Hills of Chaouen,* 1990. Oil on canvas, three panels, collection of Rabia Bekkar.

hillsides. Their paths and the hands of the weavers working on their skirts framed and made sense of the land.

This painting is related to other pieces I was making during that period, for instance, a series of mixed media on paper pieces called 'Tables and Tabliers' – tables and aprons that focused on the domestic universe of women (Figure 11.2). In previous visits to the northern Jebala region I had bought some of the red and white aprons that the peasant women wear to use as table cloths on my *mida* – a low, round dining table. So the combination of table and apron or skirt was perhaps inspired by this unlikely innovation. But the Chaouen piece conceptualizes the red and white skirts of the women in the landscape in quite a different way than these pieces on paper, where the centrality of the table dominates the folds of the table's clothes and aprons as it does in many women's daily lives. The spread of an oil paint over the canvases brings this piece closer to another group of paintings I was doing on canvas and canvas board that I never named, but I think of as the 'puzzle pieces'. This series came directly out of academic research I did in the 1980s on Moroccan debates about authenticity in cinema and art. Writers in magazines like *Souffles* and *Lamalif* proposed that traditional art forms like mosaics or calligraphy serve as templates for new ways of conceiving of film, photography or painting.[2] Influenced by these readings, I began to conceive paintings made up of several panels or parts that could be assembled in various ways. Unlike mosaics, these works were mobile and could be manipulated by the viewer. While a mosaic works to move the eye through a pattern, these pieces were painted as though they ought to fit together – I painted many of them side by side, so different panels shared fields of colour or a common brush stroke. So the eye was attuned to the edges in these works – drawing attention to the process of sight in a way that responded to the modernist tones of the structuralist-inspired critics I was reading.

In the Chaouen triptych, tables and tabliers and mosaic puzzles are combined, but in a way that directs the viewers gaze much more firmly than in the mosaics. It calls on calligraphy, but instead of echoing a letter or a voice, it spins red lines to

Figure 11.2. *Tables et Tabliers*, 1991. Acrylic, ink and paper on paper, collection of the artist.

weave new landscapes. The apron/skirt of the Jebala women appears against the blue Mediterranean and the yellow hills as if to spread the domestic universe over a vast landscape. Like peasant women everywhere, the Jebala women transform the natural world. It is their activity that gives this parched land a meaning. This piece is thus fundamentally about how they define the landscape.[3]

The painter's brush mimetically follows the way the bright skirts appear to cut into the hills – the brush extends to create relationships amongst colours and forms in terms of this red and white connection. Instead of covering and hiding the sway of the woman's hips, the lines in this painting are turned lose to gather up pieces of things across a landscape of colour – the strands became thus 'fils' – elephants of memory stumbling heavily along – red patches where some yarn broke and tumbled upon itself.[4] Perdre le fil? Red strings as scratches – as wounds, as a violent approach to the ethnographic art? A way of disengaging the skirt and the weaving process from the landscape? The work of art emphasizes what is already apparent to imagine a landscape tied up by the movement of these peasant women.

The 'red writing' of this piece thus bears little resemblance to the 'white writing' of Cy Twombly. It translates a way of engaging art and others that is quite unlike the more physically contemplative stance of abstract expressionism or to the culture as text school of interpretive ethnography. It is like a piece of thread that one sees enter at one point and exit at another – but it is not thread like Ghada Amer uses in her recent work. My mother taught me to embroider when I was three years old, but I

instead of stitching I adopted a distancing from the act of weaving or sewing through a painterly miming of thread. I used these *fils* to redefine the landscape. The tableau drawn out by these red connections brings together maps, European conventions, mosaic tiles and Moroccan calligraphy in terms of women's skirts. It produces a field that does not simply see these women as involved in the milieu but shows them as also creative of this place. It turns the calligrapher into a seamstress who notices how threads stitch together the land, as they tie the heavy bundles of wood the women carry over the hillsides. And it proposes a figure of the ethnographer as a weaver who feels free to use these threads to reconfigure how we look at the land.

PAINTING AS A POINT OF CONFLICT

When I completed this painting inspired by waving skirts and golden sunlight in August 1990, I decided to put it on my wall and I played around with how to hang it. One afternoon I received a visit from Kamal. He sat down next to my *mida* covered by the Jebala skirt and I served him coffee. The new painting caught his attention and he said without warning: 'So you're painting the red blood of war' he said. 'It is the blood of the Arabs in Iraq after the arrival of the Americans.' Suddenly, the painting took on a new form. The soft weave of the fabric the read and white lines evoked were sharpened by my friend's words – like scalpels, I saw them dig into the land and sea, felt the needle cutting as it moved to piece these different elements together. The tight-knit fabric of the women's skirts was unbound by Kamal's words, as he looked at me as though I might somehow hold responsibility for the outcome of the situation. As the painter, the one who wielded the brush, I was being aimed at – as though my brush, or the fact that I had decided to use it, was turning red from being a symbol of life and connection into a sign of murderous intent.

Kamal's look reminded me how paintings and other art works can act as screens against which to project reactions to personal feelings or current events. A piece of art that was made by someone who is present gains added intensity in this regard. The art can become both a point of conversation and the artist's double. All anthropologists are familiar with how the image of a TV actor, or a particular object or phrase, might be related to themselves by people around them. But Kamal's aggressive association of my brush strokes with (as yet) hypothetical military action was much more aggressive than any commentary he might have made on a news item in the paper or on the television screen. Had he said 'you Americans are up to bad tricks again' or something similar in its generality, I would have laughed. But, instead, he turned my own brush strokes against me.

I wondered whether it was more the fact that I was American, or the idea that I would dare to paint that annoyed him more. Kamal was born in a small town in the mountains, but had managed to go to the university and study French. He taught for a couple of years but then he was imprisoned for political activity. Once released, he set up an alternative bookstore in Casablanca before going on to become a successful businessman. I noticed in his response a tone that I recognized. The angular edge of the voice seemed to respond to my work by saying 'I should have been the one' – or

'how does she dare?' Under the circumstances, this edge widened the scope of my audacity to include my apparent access to power through my position as an American citizen, by blending the privileged role I had dared to assume by painting or writing with the position of the 'American' whose art was another example of her privilege. Such a movement might immediately remind anthropologists of discussions about power dynamics in the field, of questions of ethics and giving voice to subaltern people. But a quick glance at Kamal's address book would immediately reveal his many connections to the world of real politics – had he wanted to make his views public, he was in a position to do so. His reaction to my painting called up a host of questions to my mind, but my most immediate feeling was that I had heard this before, most often from the mouths of older men.

And this led me to wonder whether there was not indeed something inherently troubling or challenging about the painting itself, something about how I dared to see the women's skirts as holding the world together that posed a question. I began to see that making the Chaouen weave hold together the hillsides, rather than placing women's skirts in a landscape that served to conceptualize them, was in fact a provocative act. So when Kamal read the yarn as blood, was it really Iraqi lives he was mourning? Or was he sensing this way of seeing the women's and the artisans' work as the defining move in the constitution of a landscape, or by extension, of a nation? Was he debating the act of pulling things together through art in ways that challenge how maps are made and territories imagined? As I contemplated the notes I took at the time last month, I decided to ask my friend Rabia, who now has the Chaouen painting in her Parisian living room, to write to me what she saw in it. She noted how the painting evoked a landscape and 'the play of sunlight' but also suggested 'tormented dreams'. She wrote that

> the domination of red is like a brandished sword, like a moussem that is moving toward a saint. A rift traverses the centre, like a void, emptiness or a separation between two universes. It's as though on one side a storm is beginning while on the other it is pouring down, becoming a whirlwind of colour and movement. I don't know why red bothers me; maybe that's what it means to you. The white isn't really tranquil either, while the blues and ochres are more peaceful and relaxing. The horizontal movement of the brush reinforces the impression of movement, almost of a storm. Is it a storm in the mind?

The painting surely related to a 'storm in the mind' – the kind of hurricane that disturbs the mind of anyone writing a dissertation, but especially someone like myself whose work was intimately engaged in trying to study objects in motion. My research at the time focused on how media movements in and around Casablanca built up images of the city and consolidated a particular form of modern monarchy in Morocco.[5] My analysis of the way that couples like modernity and tradition, urban and rural are produced in dynamic interaction seems to be present in this piece, at least as Rabia observes 'a rift traverses the centre, like a void, an emptiness or a separation between two universes.' In fact, all of this did emerge from what for me, but also for anthropology, was a period of change and intellectual storms.

But what is one to make of the string turned into a sword? Does the troubling nature of the red lines relate to Kamal's reaction to the painting so many years ago? As I remember painting this piece, allusions to the red threads of the Chaouen weavers appeared more as life-lines than as threats. I appropriated them as something strong and bright and flexible enough to follow though dark and stormy places, something that could tie together the disparate pieces of a world in motion. When previous notions of the field were dissolving, media and exchange turning the notion of borders upside down, one could still get a sense of the landscape by stitching, weaving or tying things together. This would gradually lead me from a kind of 'collage' constructivist approach to the ethnographic writing toward a more tightly knit manner of conceiving of the ethnographic field.

THE RED LINES OF THOUGHT

The Chaouen painting played a role in elaborating a kind of 'strong position' as an ethically and practical necessary part of the research process. It also led me from a topical interest in motion toward a means of incorporating motion into the very way that the field is imagined. The gesture of the paint-soaked brush pushed my mind in new directions. In 1991 I began a new project that featured the crafty weaving of distant places into a single cloth, a field that moved out of Casablanca toward Paris and Cairo. I looked at how women like those of Chaouen were left behind in the quest for modern beauty – but also how diversity developed to set the modern body against itself. I wove the field with threads of history, media and migration that tied Casablanca to Paris and Cairo. In the Chaouen painting I reconfigured a territory in terms of women's skirts, but to understand how modern beauties are related to mobility and conceptions of self and freedom, I rethought theories of democracy and body techniques in terms of social interactions in beauty salons.[6] Over the ten years I spent carrying out this research people asked me all kinds of questions regarding how I conceived of these linked comparisons, the growth of the beauty professions, not to mention women's waxing or curling or dying practices. But my friend Daniel repeatedly described my project as a study in 'fils rouges' – a work of woven or tied or interconnected red threads or lines. He unwittingly recalled to my mind a painting he had never seen, reminding me of how painting had preceded anthropological invention.

NEW LINES FOR ANOTHER WAR

Even today the red lines of thought resurface in unexpected ways. In 2003 when another war was beginning in Iraq, I remembered the 1991 Gulf war: the endless hours of listening to radio stations in different languages; the tension in the market and the round face of the French engineer who was stabbed to death in his office during the war. This time, I was living in Washington, apparently positioned at the very vortex of world power. Now it was 'the French' who were being attacked in the local media. I was jeered at for being French this time, and this brought to mind Kamal's comments

on the red blood of the painting by me, the American. But was my dual nationality the real issue here? Were we witnessing a new era of crusades? My fieldwork and writings like my affection for the triptych, demonstrate an almost obsessive concern with triangulation. But could one address the discursive realm of this war in such terms?

My response was to conceive a work on two canvases. I centred the piece with the torn title of an Arabic language paper printed in London, *Sharq al Awsat*. In fact, I only used the word 'Awsat' which means middle. (Figure 11.3). I joined the two canvases with this word, then pulled them apart, cutting the clipping into unequal halves. By blurring stock phrases in French, English and Arabic, with red, white and cerulean blue, I played on the hues of military might, but also what they shared with my other tongue, so thoroughly reviled by those who otherwise are quite willing to pay fortunes for an old glass of Bordeaux. The painting plays on this 'middleness' and the 'Middle East' through a collage of news clippings and phrases written or painted in Arabic, English and French. There is no attempt to stylize or beautify the words and no reference to calligraphic traditions. The involvement of the red lines with landscapes of papers and writing becomes an interrogation of the map of the region – for 'al-Sharq' (east), which usually goes with 'Awsat' (middle), is stuck in the lower left, and the 'janub al-Awsat' (middle south) is in the upper right. Other words mark locations of the 'Middle Earth' and the *juste milieu*. The red lines expand to become puddles of colour – or connect words denoting geographic place, but which should usually not be beside one another. This painting addresses the make-up of a region defined by its being somehow in 'the Middle'. It also plays on claims to good measure, negotiation and balance.[7] It asks if any war be represented war in terms of balance and good measure, The question is directed not only at newspapers or politicians, but

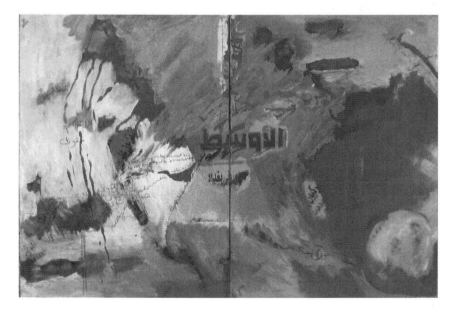

Figure 11.3. Awsat, 2003. Diptych mixed media on canvas, private collection.

anyone who would see the world according to either a Manichean mathematics or a comfortable theory of the golden mean.

The red and white colours of the 'Awsat' piece, like its use of more than one canvas, tie it to the previous time of war. I realized how thoroughly Kamal had bloodied the colour of my art a decade before. The red slashes showed how thoroughly Kamal's voice had altered how I saw the Chaouen piece, and indeed, the very way I could paint about war.

CONCLUSION

A sketch or painting can be rather like a field note – it can focus attention on certain objects, regularities or connections. Once it is hung in public, it can stimulate exchanges about aesthetics, or politics. It can become a projection or a double of the ethnographer – by hanging the Chaouen piece I gave Kamal the opportunity to curse Americans and provoke me, while simultaneously opening up a space for me to inhabit where I could be distanced from the scene he saw unfolding on the wall. But could I continue to work and think were I to occupy that space? Was it not only by maintaining my connection to the lines of my art that my interlocutor had bloodied that I could pursue the kinds of conceptual exploration that are needed to keep anthropological vital and meaningful?

When the ethnographer mimics the movements of the weaver, or borrows his red threads to tie together a field, when she centres the word on a shaky middle and displays it on the wall, the transformations that engagement with 'the field' has wrought upon her, the voices she hears and the direction her brush strokes take become apparent. Art becomes a method of working out and working with others in ways that can include those who cannot read, or cannot understand her academic language. This gives these others power. But producing a coherent piece of work also means owning up to creating a strong position for oneself. We are accustomed to ethnographers taking the positions of the respectful listener, or, in a more activist vein, defenders of 'their people' or preservers of their voices in a world that would silence them. In many ways, these positions are similar to those that Kamal hoped to open up for me by distancing me from my own painting. But my paintings like my written work would not exist were I to absent myself from them or position my self in the kinds of static terms that have become standard in accounts of 'subject position' in the introductions of ethnographies. Like good ethnographic writing art produces palpable accounts not only of 'their' world, and how it differs from 'ours'. It also strives to find ways to explore how we all move through the world differently together.

Cultural Knowledge on Display: Chinese and Haudenosaunee Fieldnotes
Morgan Perkins

The inspiration for this article arose from the first two exhibitions that I curated to explore the cross-cultural role of contemporary art exhibitions. The first, co-curated with Katsitsionni Fox in 2002, was entitled *What Are We Leaving for the Seventh Generation? Seven Haudenosaunee Voices*. The show was a group exhibition that included seven artists from different Haudenosaunee (Iroquois) tribal nations.[1] The second exhibition was a 2003 retrospective of work by the Chinese artist Zhang Hongtu entitled, *Icons and Innovations: The Cross-Cultural Art of Zhang Hongtu*.[2] While my discussion of these two exhibitions does not seek to compare the artists and their different cultural traditions, the projects are drawn together on a number of levels. The exhibitions and the multimedia works of the artists offer a range of interpretations concerning the relationship between contemporary art and anthropology. My focus will primarily deal with the concepts and dynamics involved in the exhibition process and those artworks that relate most directly to my main themes, since space does not allow a discussion of each artwork that was exhibited.

These exhibitions will be considered as forums for interpreting cross-cultural conventions of contemporary art practice and the educational process through which these conventions are learned. As an anthropologist involved in curating exhibitions of contemporary art, much of my attention has recently turned towards the cultural role of display.[3] Display practices are fundamentally connected to the many different systems of knowledge that exist within a cross-cultural artworld. These practices are guided by cultural conventions that may be followed or challenged, and they include the expectations of both presenter and viewer. Depending on the culture, conventions may include differing restrictions on the handling of objects, the use of frames or scrolls for paintings, ritual gatherings, exhibition openings, and so on. These practices also vary considerably according to different settings for display such as galleries, outdoor spaces, websites or intimate spaces like homes or studios. These two exhibitions were presented in a conventional gallery space and featured work by artists who have all received academic training. Since these artists are also familiar with the artistic practices of their native cultures, theirs are ideal voices to reveal the tensions that may exist between different artistic systems. With the relationship between education and the conventions of art practice in mind, let us turn to the two examples at hand.

SEVEN HAUDENOSAUNEE VOICES

When the decision to organize an exhibition of contemporary Haudenosaunee art was first made, I was just becoming familiar with the culture through fieldwork at the Akwesasne Mohawk reservation and collaborations with the Akwesasne Museum. While there has been much debate over the nature of collaborations between museums and Native American communities, I was fortunate that Katsitsionni Fox agreed to curate the show with me so that we could bring a number of perspectives to bear on the subject. I found that my perspective as a curator and anthropologist teaching both anthropology and art students – many of whom have been Mohawk – influenced my perception of the exhibition as a multilayered educational experience and highlighted the different conventions of anthropology and art museums. She approached the exhibition with the unique perspective of an artist working on themes from her own culture – indeed she suggested the Haudenosaunee philosophy of the seven generations as the unifying theme for the show. In her introduction to the exhibition catalogue, Fox quotes Oren Lyons (Faithkeeper and spokesman for the Haudenosaunee Confederacy) to provide an interpretation of this fundamental component of their traditional culture. 'In our way of life, in our government, with every decision we make, we always keep in mind the Seventh Generation to come ... When we walk upon Mother Earth we always plant our feet carefully because we know the faces of our future generations are looking up at us from beneath the ground.'[4] This particular conception of the seven generations has inspired several of Katsitsionni Fox's artworks, including the piece that appeared in the exhibition that features faces of children constructed from earth and placed beneath images of her family (see Figure 12.1, background).

Therefore, at the centre of this contemporary art exhibition was a traditional philosophy. The seven artists who responded to this theme with their own voices were Ed Burnam (Akwesasne Mohawk), Katsitsionni Fox (Akwesasne Mohawk), Sue Ellen Herne (Akwesasne Mohawk), Greg A. Hill (Mohawk/French), G. Peter Jemison (Seneca), Shelley Niro (Bay of Quinte Mohawk), and Jolene Rickard (Tuscarora).[5] In her curatorial statement Katsitsionni Fox reflected on the many layers of meaning that this traditional concept offers to the contemporary lives of the Haudenosaunee and to the population at large.

> We have a responsibility, not only to our own children, but also to the generations yet to come. I reflect on this quite often as I make decisions for myself and for my children, and in the path I follow in life ... The Haudenosaunee believe that everyone is born with a gift from the Creator. Perhaps one might be a teacher, a great lacrosse player, a musician, an orator or, in my case, an artist. This gift is precious and carries with it great responsibility, a responsibility that is evident in all of the work included in this show. The artists, in their own way have created a visual language of icons, symbols and imagery that have the deepest roots in their culture, and who they are today. They have used their gifts to communicate a teaching, a philosophy, a belief or their own unique understanding, through a variety of media. Today our generation faces new challenges including diabetes, heart disease, pollution of the sacred

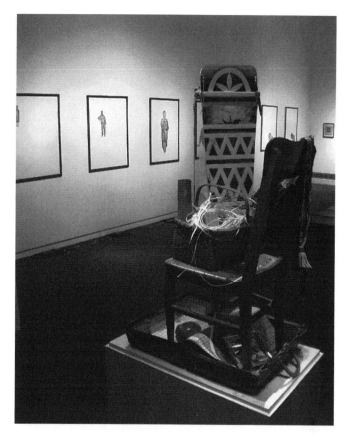

Figure 12.1. Exhibition view, 'What Are We Leaving For The Seventh Generation? Seven Haudenosaunee Voices.' In the foreground is *Mohawk Samsonite,* 2002. By Sue Ellen Herne, mixed media. In the background is *What Are We Leaving For The Seventh Generation?* 2002. By Katsitsionni Fox, collagraphs, earth, rocks and beads. Photograph: Morgan Perkins.

earth, water and air, the loss of our language, culture and way of life ... We need to ask ourselves: 'What are we leaving for the 7th Generation?' This exhibit asks that question of Seven Haudenosaunee artists, who respond visually through various mediums including prints, mixed media, video and installation.[6]

With this philosophy as the central theme of the exhibition, our goal as curators was to use the art as a form of education for a Native and a non-Native audience. We asked each of the artists to write extensive statements to appear in the gallery and catalogue to contextualize their work. The exhibition proved quite successful as a forum for a dialogue on local issues, since several of the artists made references to the impact of pollution, the loss of language, violence, and other social concerns that have influenced Akwesasne and its neighbouring communities.[7] Various members - both Native and non-Native - of the local community visited the exhibition, including

school groups, local artists, college students and faculty. Fox arranged several visits and projects for her own art students at Akwesasne and, after the exhibition, copies of the audience comments were sent to the artists to further the dialogue.

Personal connections between generations and a sense of obligation were central themes in many of the artworks. *Mohawk Samsonite*, the contribution by Sue Ellen Herne, the Curator of the Akwesasne Museum, was the first work of installation art that she had done and it included a range of objects with personal connections including her father's suitcase and ironworking tools as well as a traditional cradle-board that she painted and used to carry her sons whenever possible (see Figure 12.1, foreground). Due to her father's job as a steelworker, she lived a rather nomadic childhood and was often the only native student in the schools she attended. The piece reflects her feelings that her family's culture and identity were carried around like a suitcase when they were not living on the Reservation. In her description of the work, she describes the potency of the objects assembled to relate to seven generations in her own family:

> My first installation, 'Mohawk Samsonite', is an autobiographical piece. It relates to my painting in that it is personal, yet it is vastly more autobiographical than my paintings. It is created with actual objects and images that are from my home … It is based on the premise that what we have to give to the next seven generations is, in large part, what we have been given over the past generations. Baggage and all.[8]

Shelley Niro's contribution to our exhibition, entitled *Weapons for the 7th Generation*, draws upon traditional forms of weaponry that she encountered while visiting museums (Figure 12.2). The complex relationship between different Native American cultures and museums has often resulted in cultural objects (many of which are being repatriated) being held in museum collections so that members of the producing cultures feel like visitors when they view them. In describing the inspiration for her creation of images of these weapons using beadwork, Niro highlights the link between learning in a museum about her own cultural past and the need to pass knowledge on to future generations:

> This series has been influenced by looking at actual weapons of war in museums and books. At first I noticed the elegance and craftmanship that have gone into the creation of these particular instruments used by my ancestors. Words can be used like weapons or rather more like protection. It seems we have to become aggressive in our teachings. The seventh generation is innocent and I feel time marches on – never having enough time to tell that generation what is important. 'Listen' and 'Learn' are gentle love taps urging the youth to do just that.[9]

The current historical period marks a resurgence of interest in tradition among the younger Haudenosaunee generation at a time when some elders can still pass on their knowledge in the form of artistic practices and meanings. Since this exhibition featured artists working in both traditional and experimental styles of Haudenosaunee art, we were particularly interested, as curators, in presenting all of the work as

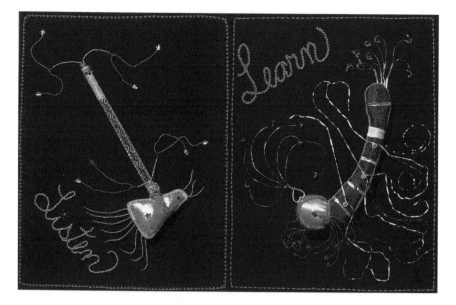

Figure 12.2. Shelley Niro, *Weapons for the Seventh Generation* [detail] 2002. Beadwork and mixed media, collection of the artist.

contemporary conceptual art even though many of the objects and images might be considered either traditional or contemporary depending on the context or the audience. Indeed many of the artists create objects that could be considered traditional for use within their communities.

THE CROSS-CULTURAL ART OF ZHANG HONGTU

My collaboration with Zhang Hongtu began many years ago with research into the official and unofficial aspects of the Chinese avant-garde art movement. We first met in New York as I was gathering material on the experiences of expatriate Chinese artists to supplement fieldwork on art education in mainland China.[10] The works chosen for the exhibition relate to his experiences with traditional Chinese culture, the conditions of communism, and immigrant life in America. In discussing the content and display of Zhang Hongtu's art, I will reference relevant biographical details and examples from three distinct though conceptually connected bodies of work that appeared in the exhibition and that parody cross-cultural display practices.[11]

Zhang began his academic training in the techniques of both Western and Chinese art in Beijing at the high school attached to the Central Academy of Fine Arts and he then entered the Academy of Arts and Crafts in 1964. His education was interrupted when the academy was closed for a time during the Cultural Revolution (1966-76) and, like many of his generation, he was sent to the countryside for re-education. When he was allowed to return to school and eventually graduate in 1973, the

government assigned him a job in a jewellery factory. When his requests to find a position as an art teacher were refused, he took an opportunity to immigrate to the US in 1982. He then began the process of escaping one set of artistic conventions and learning another.

The imagery that first marked his primary influence on contemporary Chinese art involves the reconfiguration of images of Chairman Mao Zedong in a range of provocative and often irreverent settings.[12] The exhibition featured an alternate version of one of his most politically charged works. In the *Last Banquet* Zhang transformed Leonardo Da Vinci's *Last Supper* into a commentary on Chinese politics with references to the political and ritual role of banquets in China and Mao's elevation to the level of a near deity (Figure 12.3, foreground). The image of Mao presiding over disciples, each remade in his own image, symbolizes his ultimate betrayal of his revolutionary ideals. This is most poignantly depicted by the Judas Mao who is grasping, in place of a bag of silver, the 'Little Red Book' of Mao's quotations. This book was a virtual Bible of political standards during the Cultural Revolution and its actual pages form the background of the original image.

Like all artists working in China during the Mao era, Zhang had learned a form of self-censorship that evolved with the changes in political policy. Mao's official policy asserted that the only proper function for art was to serve politics.[13] He sought to

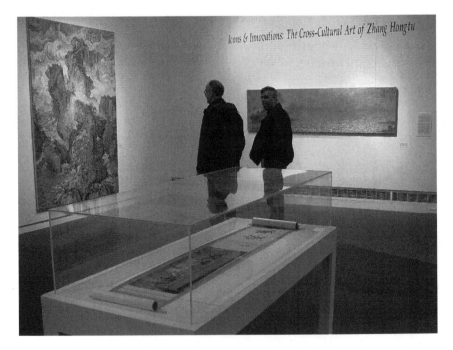

Figure 12.3. Exhibition view, 'Icons and Innovations: The Cross-Cultural Art of Zhang Hongtu.' In the foreground is the digital hand scroll version of the *Last Banquet,* 1989. In the background are *Guo Xi – Van Gogh,* 1998, on the left and *Wang Shen – Monet,* 1998, on the right, both oil on canvas. Photograph: Morgan Perkins.

abolish the elite nature of art in order to make it useful to the masses on a practical level. In reflecting on his series of Mao images Zhang said, 'I remember feeling so guilty when I first cut Mao's image for a collage, but then the creation of different images of Mao slowly became a form of psychotherapy. The series ended because Mao no longer had power over me.'[14] Many younger artists who still live in China have followed Zhang's lead in deconstructing Mao, but in 1989 a piece like the *Last Banquet* could only have been produced by an expatriate artist.

The second incarnation of the work encodes the culturally relative practice of display in the most obvious fashion. He has given the work a classical twist through the use of the hand scroll format on which he has a digital image of the work printed and then adds a range of seals and inscriptions onto the different scrolls depending on the recipient.[15] The use of this format allows for multiple reproductions of the original work while referencing the manner in which literati paintings (*wenrenhua*) in China could be viewed as evolving forms that take on new artistic and social meanings through time.[16] In Chinese painting subsequent artists and collectors could record their own reactions to a painting through inscriptions on the body of the work itself or indicate possession through the addition of seals. This frequent practice created physical evidence – recording provenance and the response of some viewers – on the painting itself or on the material of the surrounding scroll mount.

A similar effort to mix cultural forms and practices, by facilitating a direct encounter between artists of different cultures, lies at the heart of the on-going landscape painting project that Zhang once described as an effort to 'hide himself' using a profound intimacy with medium, style and practice. The series of paintings replaces Chinese ink with oil paint and merges famous compositions of Chinese landscape painting or *shanshuihua* (literally 'mountain water painting') with the styles of Cezanne (1839-1906), Monet (1840-1926) and Van Gogh (1853-90) (Figure 12.3, background). Once one moves beyond the surprise at the fusion of styles, it becomes apparent that in many ways his response to the display of past forms remains true to traditional philosophies and practices.

Having now spent years studying the techniques and styles of each of these artists to add them to his own unique repertoire of skills, he can draw upon this intimacy to create new compositions. This closely follows the method of traditional education in Chinese ink painting in which the student spends many years copying the styles and brushwork of past masters in order to have the skill to create original compositions. By viewing and copying the works of these artists in the same spirit, Zhang is not simply imitating techniques so much as he is reinterpreting the original artists' inspirational experiences through subsequent creative acts. As with the scroll in the last case, he often adds painted seals and inscriptions to these paintings with content that may include his own responses to the paintings or comments targeting those who subsequently view them. He has often integrated material from comment books written in Chinese characters into the framework of his exhibitions to highlight the importance of the reciprocal relationship between artists and viewers in Chinese art. All of the comments, as well as copies of some student papers about our exhibition, were sent to Zhang, who was particularly delighted to learn that his art had inspired subsequent artworks in the form of music by students in a musical composition class.

Perhaps the work that most directly parodies the cultural practices of display is the Christie's catalogue project that targets the role of auction catalogues and their strategic approaches to the art market (Figure 12.4). Through a series of digital images that place imaginary Chinese objects on simulated catalogue pages, he questions cultural conventions of display, the relationship between form and function, and the value and definition of fine art. Objects from China are regularly displayed as works of art in the catalogues of the most prestigious auction houses but the buyers may often understand little about the complex meanings and functions of objects that are culturally and historically specific. When formatted on the pages of the catalogue, the series of imaginary objects highlight the conventions of language and photography used to create value and satisfy certain tastes in fine art and antiquities while often obscuring context and original functions. The ink painting on the cover of the catalogue, for example, uses a subtle cross-cultural slight-of-hand since it is, in fact, a direct digital reproduction of a painting by the American artist, Jackson Pollock, with the simple addition of false Chinese seals to provide a semblance of authentication, value and history (Figure 12.4, left).

The content of Chinese calligraphy is as likely to be an ordinary comment as a poetic composition. The calligraphic style on a simulated silk fan is that of Wang Xizhi (ca. 303–ca. 361), one of China's most renowned calligraphers (Figure 12.4, right). The text, however, is borrowed from an actual advertisement that would be familiar to many Chinese immigrants looking for work in New York. It reads: 'Request for help: Skilled sewing machine operator, two positions open, one pattern maker needed. 130 Greene Street, first floor. Call (212) 925-2587.' This relates directly to his own changing

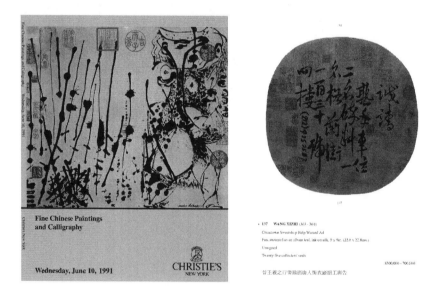

Figure 12.4. Zhang Hongtu, *Cover and Pages of a Christie's Catalogue* [details], 1998 and 2001. Computer-generated images printed on paper, collection of the artist.

experiences as an immigrant. Zhang recalls, 'I was so surprised when I was working as a laborer in New York for about fifty dollars a day and I heard that I had sold my first painting for 900 dollars – this seemed so strange.'[17] Ironically, oil paintings from his landscape series now appear frequently in actual Christie's catalogues and generally fetch quite high prices. This project as a whole draws on a central theme that has often been at issue in the anthropology of art – categorization of particular objects as art or artifact and whether they should be displayed according to either form or function. As imaginary objects these works have no inherent meaning, however, they function as parodies of types that often have their many meanings obscured when displayed to audiences unfamiliar with the original meanings or unwilling to learn them beyond a superficial level.[18]

FIELDNOTES ON DISPLAY PRACTICE

These two exhibitions, though very different in scope, raise many similar themes regarding the role of contemporary artists as interpreters of cultural art practices. A central concern in the anthropology of art is the question of how the increasingly broad spectrum of artifacts, art works and their producers is assessed.[19] At one end might be the seemingly 'traditional' or 'authentic' objects that are produced solely by members of a particular culture for exclusively indigenous purposes and feature relatively continuous standard forms. At the other end might be so-called 'modern' or 'contemporary' artworks that are produced in predominantly innovative forms for exhibition or for sale in various forums within the international artworld. The artists and their works discussed here cross this spectrum in their intent, their materials and their meanings. They are all contemporary artists and define themselves as such. Their art, however, is simultaneously rooted in the traditions of their native cultures. The roles these artists play in different contexts are by no means mutually exclusive – indeed the very terms of 'art' and 'artist' have varying levels of cultural meaning for them.[20] Their familiarity with the artistic practices in both realms often allows them to retain their cultural distinctiveness while adapting to the institution of 'art' and creating new functions for their work as sources of income, markers of cultural identity or catalysts for political action.

There is considerable enthusiasm for voices from different cultures to be included within institutions of international contemporary art, but less effort is made to understand the complex social systems of artistic knowledge from which that art emerges. A view of contemporary art that restricts its scope to that which conforms to limited conceptions of progress or experimentation often fails to recognize the importance of artistic continuity in many cultural systems. There remains a danger that distinctive voices from across cultural and institutional boundaries might simply be absorbed into the stew of international contemporary art. To see this one need only review the vast array of international contemporary art biennials and triennials to witness the inclusion of artists from virtually every nation or culture as well as the almost complete exclusion of artists who work in forms that might be considered traditional unless they alter those traditional forms in some post-modern fashion. Rather than accept

the dynamic of an international artworld that absorbs and adapts peripheral forms, it is more useful to conceive of multiple artworlds that interact in different ways under differing circumstances. All contemporary arts draw on particular knowledge systems even if the objects or their producers remain primarily within one cultural context or circulate in broader global networks.

In their analysis of ongoing debates on contemporary museum practice Ivan Karp and Corinne Kratz have observed that museums have 'presented exhibitions and narratives that claimed particular worldviews and ordered knowledge in ways that would enlighten visitors about them and simultaneously inculcate particular ways of seeing and being. Yet visitors could always produce counternarratives, whether through different knowledge bases, resistance, or sheer miscomprehension.'[21] These counternarratives, particularly as they relate to different knowledge bases, are at the core of my questions about display and perception.

As displays are presented in a range of open forums with multiple interpretations, there are often opportunities for artists and their viewers to interact with one another to alleviate such miscomprehension. By curating exhibitions with those artists who are interested in displaying their work, anthropologists can participate in the artworlds that we observe, use a dynamic forum to disseminate our own anthropological knowledge, and give something back to the artists and cultures for all that we learn.

Since these two exhibitions featured pieces that are readily classified as contemporary, and art gallery display conventions - unlike those of anthropology museums - often encourage labels with minimal information, negotiations had to be made to include extensive labels and artist statements to contextualize the material. By presenting art from cultures that were unfamiliar to much of the audience, or familiar objects in an unfamiliar setting in the case of audience members with the same cultural background as the artists, we sought to demonstrate the degree to which exhibition in a gallery is simply one cultural convention for display. For example, Sue Ellen Herne's cradleboard, which features her own painting and which she had used to carry her sons, acquired a new attribution briefly as the centrepiece for her first art installation, and her father's ironworking tools were borrowed and then returned so that he could continue to use them. The placement of the scroll of the *Last Banquet* inside a vitrine, according to the display practice of the gallery, is perhaps the most poignant illustration of conflicting conventions. Most Chinese ink paintings that are placed on hand scrolls (note the term) have been composed specifically for that horizontal format so that portions of the paintings are revealed in narrative stages as viewers handle the scroll. Now standard museum practice, even in China, has begun to conflict with this cultural practice. In smaller cases the audience often sees only a small portion of a long scroll, and they certainly are not permitted to handle the object.

Many of the pieces in the exhibitions can readily be related to readymade and found object work originating with Marcel Duchamp since these artists are transforming images and functional objects into art. Yet these images and objects are themselves part of complex alternative artistic systems with which the artists have intimate familiarity. These different systems can encounter one another in galleries

and other spaces, but the other systems have not been erased; they coexist despite their new context. It is the choice of the artists to be shown in a gallery and by simple virtue of the unfamiliar nature of their work or by conscious parody they may help the viewer to recognize the cultural conventions of galleries themselves.[22] The audience may then recognize that these other complex display systems exist even if the art is their only window into sophisticated, yet unfamiliar alternate artworlds. In presenting their own work in exhibitions, thus speaking for themselves, the artists can offer culturally informed voices in response to the innumerable occasions when others have appropriated their forms and symbols.[23]

One effective method for revealing the conventions of display that are often taken for granted from within a system is through critique by those from the outside.[24] It has become common for artists to share methods with anthropologists, such as interviews and fieldwork, to create works that often reflect their intimate experiences with different communities.[25] As artists are adopting forms of fieldwork for their explorations, so too are anthropologists seeking new formats to communicate their intimate experiences of fieldwork. It therefore seems natural that those who have often been the subjects of artistic and anthropological inquiry should return the gaze. The artists in both of these exhibitions demonstrate different ways to use contemporary art to critique the institutions and practices of the international artworld and connect them to alternate systems of artistic knowledge. Fieldwork is essentially an educational experience and these artists have been learning the customs and social networks that lie at the core of the contemporary artworld. Since these artists are not trained in anthropological methods of fieldwork it may also be useful to refer to their explorations and insights as artistic 'fieldnotes'.

I would argue that their participation in exhibits constitutes a form of fieldwork on the museum and gallery system, yet I believe that their experience goes much deeper. These artists have been educated on a number of levels about how to be artists in their own cultures and in the international art world. Their art education laid the foundations for their knowledge of the varied social and artistic practices of these interconnected systems.[26] Art education often takes place in a formal classroom or under similarly structured conditions, yet the communication of visual and cultural knowledge from one person or generation to another varies based upon the different methods adapted to the needs of the artist and culture. I approach art education from two directions. It is a method for learning techniques and meanings in a personal, community or academic setting, but art is also used to educate the artist and the viewer on an infinite range of personal and cultural levels. While many of these artists acquired their skills and knowledge through their families and communities, all have received academic art training. Some are now art educators in academic settings, some teach in their local communities, and all use their art to communicate their different forms of personal and cultural knowledge. On many levels, their art translates the knowledge that they have learned through experience (or fieldwork) into a form that audiences can understand. Their experiences in art schools and subsequent participation in exhibitions can be viewed as a form of fieldwork on the social networks and customs of a contemporary artworld that is dominated by a Western system of art practice and valuation.

Western art education methods have often influenced the evolution of art forms and practices in different cultures. This influence varies greatly, ranging from the subtle influence of individuals, to the wholesale adoption of academic models.[27] In China the creation of a system of art academies modelled on the European system of art education has been fundamental in the development of the Chinese avant-garde art movement.[28] Academic art education has also played a major role for many Native North American artists – both Sue Ellen Herne and Katsitsionni Fox, for example, attended the influential Institute of American Indian Arts in Santa Fe.[29] Academic training facilitates experimentation with new forms and media but it also validates graduates with fine arts degrees as 'artists' who then often orient themselves towards an international artworld. Such academic credentials may allow some artists to circulate more readily within the institutions of contemporary art, yet they do not guarantee value in the marketplace. While institutions like the National Museum of the American Indian, for example, have given prominent attention to the work of many Native artists, their equally interesting and high quality work is unable to attract the same prices and interest from collectors as their Chinese counterparts now that the Chinese art market has risen with the same velocity as the Chinese economy.[30] While the rules and rituals that guide the institutions of international contemporary art can be learned, attention is never guaranteed.

The effort to understand how artists from communities that stand outside the original scope of art in the West have learned the conventions and meanings of art in both realms offers a valuable method for the anthropological study of contemporary art (and perhaps the artistic study of contemporary anthropology). As a method for anthropological fieldwork on contemporary art, detailed studies of different philosophies and methods of art education reveal much about the contextualized nature of art practice. If anthropologists are interested in developing new techniques for communicating the complexities of different systems of cultural knowledge, they may sometimes be best served by collaborating with artists from those cultures as they communicate through the unique forms that their art embodies. If a supple interpretation of disciplinary methodologies is permitted, their efforts qualify them in many ways as participant observers par excellence. It has been my privilege to work with and learn from each of these artists.

Making Do: The Materials of
Art and Anthropology

Anna Grimshaw, Elspeth Owen and Amanda Ravetz

Figure 13.1. *Stitched Texts* Elspeth Owen, 2009.

This essay is a report from the field. It addresses what Schneider and Wright have called 'the challenge of practice' through an exploration of initiatives pursued in the space between art and anthropology.[1] Since the year 2000 or so, Grimshaw, Owen and Ravetz have embarked on a number of collaborative ventures. Beginning in the context of academic anthropology and developing sporadically through other sites, we have pursued work that cuts across conventional boundaries of practice. Ethnography has served as the shared ground of our endeavour, ethnography understood not as a specialized disciplinary method but rather, following Clifford, as 'a willingness to look at common sense everyday practice – with extended, critical and self-critical attention, with a curiosity about particularity and a willingness to be de-centred in acts of translation.'[2]

Our collaborations have brought us together in formal and informal ways, in separate and joint ventures, generating a body of work that has encompassed different media – photography, performance, video, installation, text, and CD Rom.[3] At the centre of the project has been friendship mixed with inquisitiveness about each other's practice. Given our different backgrounds (one an anthropologist, another an artist, the third trained in art and anthropology), each of us set out with certain preconceptions about the other but we have attempted, through the process of *making*, to engage more expansively and reflexively with our assumptions about art and anthropology. The field of visual anthropology has been important to this project. When we began, it offered us both a space for experimentation and a framework by which we could critically evaluate the conceptual, methodological and formal questions raised by our attempt to creatively align different perspectives.

The challenge of practice is, however, open-ended and ongoing. It defines specific occasions of work but it is never contained within such moments. Instead it continues to resonate as projects move beyond their original sites, raising questions of representational form that have to be addressed with every subsequent iteration. Hence, in working together to assemble this essay, we have struggled with the distinctive nature of collaborative practice – separations in time and space, the unevenness of disparate materials, the back and forth, the flows and stoppages, the fluidity of exchanges. Its title, *Making Do*, refers to the active process of fashioning – our attempt to work with what we have got and to find some kind of meaningful shape from a series of mismatched parts. At the same time we have tried to remain attentive to the possibility that something quite unexpected might emerge from the stitching together of pieces generated in the space between art and anthropology – and between Atlanta, Cambridge and Manchester.

The report that follows is built around particular moments in our unfolding collaboration but it also constitutes a new stage in our explorations for by bringing together three participants it moves our project beyond a dialogic model. We have long been aware that working in dyadic partnerships (AG/EO, AG/AR) has the danger of reifying established positions rather than challenging them. The shift away from dialogue toward triangulation or what has been called 'threeing' fundamentally changes the dynamic of exchange.[4] It results in a dislodging of categories that can otherwise seem self-evident and allows for identities to be constituted in and through the collaborative process itself.

I. VISUAL ANTHROPOLOGY

Our explorations at the interface of art and anthropology have their origin in the field of visual anthropology. Although visual anthropology has always been something of a misnomer, it has remained useful as a term to designate an experimental space within the discipline. There is, however, a certain paradox here for the field has traditionally been regarded as hidebound, dominated by a certain kind of ethnographic filmmaking and oblivious to innovation in related areas of practice (avant-garde filmmaking for example).[5] Anthropologists working with image-based media have often found themselves criticized for holding a naïve conception of the camera as a tool for the generation of objective data or their work has been dismissed as unsystematic, self-indulgent, and about the distortion of 'life' in favour of 'beauty'. If visual anthropology has been associated with a simple-minded scientism, it has also been condemned for its artfulness.[6]

What is clear though – from even the most cursory review – is that the field has functioned as a foil for anthropology's conflicting impulses, a sort of blank screen onto which the discipline's unconscious can be projected. Certainly the strength of feeling that has surrounded debates across the so-called textual/visual divide should alert us to this role. For unlike other sub-disciplines (for example, the anthropology of media, urban studies, political anthropology), visual anthropology tends to provoke responses that are surprising in their intensity. Sometimes referred to as evidence of anthropology's 'iconophobia',[7] they reveal that something important is at stake – and worthy of further investigation.

Writing in the mid-1990s, Ginsburg characterized the field of visual anthropology as 'unruly', an eclectic collection of interests and approaches that involved working with the visual as either an object or as a medium of inquiry.[8] The former, as the anthropology of art or media, has tended to be pursued according to existing disciplinary conventions. The latter has more often entailed projects that push at the limits of the established forms. Here, for example, one finds innovative forms of collaboration from the early pioneering efforts of Robert Flaherty in the 1920s, to Jean Rouch's shared anthropology and David MacDougall's model of participatory cinema, as well as modes of anthropology that run counter to the discursive forms of academic textuality (including film, video, photography, hyper-text, installation and so on). Moreover, among those anthropologists for whom the visual is the medium of their research, there is an unusual commitment to practice – and to *improvisatory practice* – as the foundation for critically engaging disciplinary assumptions and forms of knowledge.

When we embarked on our collaborative initiatives we sought to align ourselves with those areas of visual anthropology that involved speculative, open-ended work. Given the rise of what Strathern calls the 'audit culture'[9] the system of accounting that has streamlined and formalized academic production, we felt especially fortunate in discovering that there still remained a niche in which things might be explored without the burden of disciplinary expectation. We realized that if visual anthropology had been dismissed as an enterprise without intellectual heft, its marginalization as a sub-discipline offered us a unique opportunity for the development of exploratory projects.

The Granada Centre for Visual Anthropology at the University of Manchester was the initial site for our collaboration. Both Grimshaw and Ravetz were based there. They were using video to explore anthropological questions about the role of the senses and ways of knowing in the context of fieldwork-based research. Working with the techniques of observational cinema, they sought to investigate aspects of lived experience that were difficult to render discursively. At the same time they were interested in how these problems might be linked to formal innovation – how might new kinds of anthropological understanding be rendered? Despite the discipline's so-called post-modern turn, anthropologists still tended to think in rather limited terms about form. There was anthropology 'proper' (a certain kind of text to be read by one's colleagues) and there was popularization. To eschew disciplinary convention, to experiment with different media (textual and non-textual), to extend oneself beyond the academic seminar room was viewed less as a creative move and more of a professional risk. Hence, in thinking about form and sites for the presentation of anthropological work, Grimshaw and Ravetz acknowledged this challenge. How could such questions be made an integral part of the enquiry itself? Was it possible to be taken seriously as an anthropologist, while actively exploring non-conventional forms and sites?

It was not perhaps surprising that particular areas of contemporary art practice became important foci of attention, since Ravetz had initially trained as a fine artist before moving into anthropology and, during the 1990s, Grimshaw had begun to exchange ideas with a number of artists (most notably, Elspeth Owen) whose approach was marked by an ethnographic sensibility. Ironically, though, it was observational film making that emerged as central to their forays into adjacent domains of practice. For, contrary to its perception as one of the most formally and conceptually backward areas of visual anthropology, Grimshaw and Ravetz found that it offered a crucial framework for experimentation in the space between art and anthropology. In describing these efforts as 'experimental', we refer to our attempt to move beyond what were familiar ways of proceeding and to our willingness to try things out, even though they might seem awkward, or puzzling, or to yield nothing tangible. But we also use the term 'experimental' to draw attention to the self-consciousness that we brought to the task. We were committed to reflecting on what happened between us and what it meant for our assumptions about 'art' or 'anthropology'.[10]

For Owen, anthropology had long been a source of interest. She had been drawn to the writings of Lévi-Strauss (especially *Tristes Tropiques*) and to the work of feminist artist, Susan Hiller (whose early training had been in anthropology). In different ways, both wanted to give a place to individual subjectivity within academic enquiry. Owen recognized that Grimshaw was pursuing something similar in her book, *Servants of the Buddha*. Later, when they embarked on a project together, ethnography, interpreted as a particular kind of material practice in the world, served as its foundation. Rooted in a commitment to 'dailiness', anthropology suggested to Owen different ways of engaging with objects that combined tacit and conceptual experience. Through collaboration with Grimshaw, she hoped to discover whether, in fact, there were fundamental differences between them in the ways as artist and anthropologist they went about their work, their choice of representation forms (the kind of medium, two or three dimensionality etc.) and sites of exhibition.[11]

II. CASE STUDIES

Although the narrative presented here suggests coherence in our collaboration, it belies the fact that our work proceeded in a haphazard, piecemeal manner. It was not conceived in advance as a 'project' but emerged slowly from the convergence of individual interests, opportune moments of connection and attenuated exchange. Conceived as a report from the field, our case studies - Grimshaw's and Owen's *Give Me A Call* (2000) and *Material Woman* (2003-5) and Ravetz's *Connecting Art and Anthropology* (2007) - are intended, then, as the ethnographic counterpart to the broader discussion about art and anthropology as related ways of exploring and knowing the world. What actually happens in the space between these two domains? What lessons might we draw from experimental collaboration pursued in this space? How might these examples of practice shape the terms of debate between artists and anthropologists?

It was during the late 1990s that Grimshaw began to exchange ideas about art and anthropology with Cambridge-based artist, Elspeth Owen. Owen's background was in ceramics. She is an acclaimed potter, notable for her distinctive technique and aesthetic. She 'pinches' pots - that is, she works with a single body of clay held in her lap, nothing is added or taken away and, with her hands immersed in the clay, she slowly feels her way toward uncovering the shape of the piece. The pot is then fired at a low temperature. This method produces not a hard surface covered with a glaze but an open, porous membrane that gives Owen's pots their unusual delicacy and 'beautiful, unpredictable surfaces'.[12] Using minimal technology, Owen fashions pieces by means of a self-conscious, embodied process such that the resulting work stays close to the ground, so to speak. Her pots do not call attention to themselves and yet they are insistently present. Over the last decade, Owen has increasingly experimented with other media - most notably performance, video, photography. Nevertheless, clay remains at the core of her work.

One of the central threads running through Owen's work (whatever its particular medium) is what Gillian Beer identifies as *between*. Specifically she discusses this notion in relation to Owen's provocative and unsettling video, *Between Me and My Sister*. For here Owen explores the complex relationship of sisterhood understood in its narrow and broader political sense, layering images and sounds in such a way as to suggest 'the gaps and hollows in relationships as well as the sharp edged moments of recollection and shared memory, shared mother.'[13] It goes without saying that Owen's video has important resonances with the shapes, surfaces, textures of her pinched pots, drawing attention to the *between* as a dynamic state that disturbs the clarity of inside and outside, the material and the imaginary, containment and formlessness, figure and ground.

Grimshaw's interest in pursuing collaborative possibilities was initially sparked by *Between Me and My Sister*. She was intrigued by the way Owen worked with the medium of video - in particular, by the highly developed tactile quality of the piece - literally her *handling* of the materials. *Between Me and My Sister* came out of an approach toward video that foregrounds the materiality and opacity of the medium drawing attention to its haptic surfaces rather than its transparency. It was one that involves working with the expressive potential of these qualities. Moreover,

Between Me and My Sister, along with other pieces Owen made, seemed interesting to consider as modes of ethnographic intervention. As an artist concerned with relationships (with people, materials, things), she was often drawing on techniques of participant observation to interrogate areas of everyday cultural practice.

The idea of developing a project with Owen was linked to Grimshaw's concerns about forms of anthropological representation. Despite her location in the field of visual anthropology, she felt constrained by the expectations of a certain kind of ethnographic film rooted in narrative and explanation. What questions might emerge from an exploration of art and anthropology as similar processes of making? How might one serve as the basis for reflecting on the other? How might the challenge of practice dislodge established identities and assumptions around both fields, generating novel ways of communicating anthropological understanding?

Give Me A Call

Give Me A Call, Elspeth Owen's photographic essay, followed from her involvement over one semester in a fieldwork techniques course for anthropology students. It gave visual expression to the complex dialogue that emerged from the initial attempt to work together. By inviting Owen to participate, Grimshaw's intention had been to generate an expansive conversation about the nature of ethnographic practice and the making of artifacts. Given Owen's developed ethnographic sensibility, she had been interested in how the artist's presence might bring into focus taken-for-granted assumptions about anthropological ways of working. In particular, she wondered if Owen's participation would enable the exploration of a broader range of representational forms than might usually be found in such a context. A number of questions serve to frame this initial collaboration. What sort of materials do artists and anthropologists work with? How do they go about fashioning these into meaningful objects? What is lost and what is gained in the shift from processes of making to finished objects? What spaces do these objects inhabit and what value is attached to them?

From the outset, the course was built around practices of making. In place of formal instruction about method (observation, interviews, life histories, note-taking, filing etc), students were asked to leave the seminar room and go out into the areas around the university to develop small, exploratory projects. These projects involved working with 'found materials'. Students were encouraged to build something from what was available and to attend carefully to the distinctive qualities of materials collected – that is, how the things looked, felt to the touch, smelled, moved etc.[14] Having selected certain materials, the next step required the students to work together to fashion a representational object – one that was intended to communicate a particular interpretation of the world. What might be learned in working with the material properties of things? How might the process of making yield new insights about how knowledge is generated and given expression? Other questions followed. To whom did the object belong? What was the significance of its siting? What kinds of understanding were communicated through three-dimensional rather than two-dimensional forms?

The purpose of Grimshaw's and Owen's approach was to introduce students to the sensory, material and performative dimensions of fieldwork and to try to persuade them of the intellectual challenge – and creative possibilities – that might follow from a commitment to a perspective that might be called 'being in the world'. Owen's intervention here was crucial. Her practice as an artist was predicated on (literally) handling materials. The layering of surfaces in Owen's work relied on an intimate knowledge of the unstable qualities of different materials and the fluidity of form. Meaning was similarly approached as something unstable and open – unbounded by disciplinary conventions of evidence and argument.

The intention behind the exercise was to try and dislodge anthropologists' attachment to explanatory frameworks, linear narratives and 'flat' thinking.[15] Grimshaw and Owen hoped to encourage an exploration of three-dimensional as well as two-dimensional forms – material objects, performance, things that were temporary as well as those that endured. Rather than presenting this work as a preliminary step towards further analysis, they were interested in the capacity of making itself to yield new insights, to become a mode of enquiry in its own right. Approached like this, fieldwork had the potential to become an intensely sensory experience in which tensions between materials generated new interpretive possibilities.

The collaborative experiment largely failed. It provoked intense resistance from many of the students and resulted in a breakdown of communication between the tutors and a good part of the class. Working with things in the world, rather than appropriating them to a fixed schema, meant having to figure things out from the bottom up rather than invoking other forms of authority. This was seen as unsystematic, redolent of art rather than constructive learning, about description not analysis. The exercise was deemed to be without value in the context of the academy – with its rules, expectations and established form. Moreover, the dissenting students identified Owen as a disruptive element that distracted them from their proper task, since what she brought to the class had no use for those who were embarked on a particular professional trajectory.

Grimshaw's and Owen's early attempt to creatively align perspectives from art and anthropology was pursued in an academic setting – one that, with the benefit of hindsight, was clearly not neutral. The experiment underscored how the dialogue between art and anthropology never develops in a vacuum or neutral space but is always located in specific sites and subject to particular pre-existing hierarchies of value.

Material Woman

The second collaboration between Owen and Grimshaw, *Material Woman*, developed in a context of art-making rather than academic culture. Their positions were reversed. For this time, it was the artist who invited Grimshaw into her performative space. *Material Woman* was animated by different questions reflecting the change of location. The identification of who was the artist and who was the anthropologist was now without conflict because the work was pursued outside an academic setting. Grimshaw was now in Owen's environment – an 'open' space – a performance

site in which both art and anthropology were being produced as the event unfolded. Hence the questions that emerged here were about: what or where was the 'art'? And what or where was the 'anthropology'? What significance, if any, might be attached to things produced in this space?

Material Woman was commissioned by the Taxi Gallery in Cambridge (UK), an out-of-service London cab parked in the front garden of a residential street. Its founder, Kirsten Lavers, invited different artists to make work that related to the unusual space and site of the gallery. Owen's residency at the Taxi Gallery was literally that – she lived in the cab for three weeks, occupying herself by sewing curtains from scraps of fabric given to her by friends and people from the neighbourhood. She became 'material woman' , transforming the cab into her home through the material process of habitation. The making of curtains both symbolized the domestication of the space and the theatrical nature of Owen's enterprise.

In accepting Owen's invitation to film her at work, Grimshaw was interested in exploring how as an anthropologist she might approach art practice not by reporting on it or describing it, but through the making of something equivalent or analogous. We might say, following Trinh Minh-ha, that this involved resisting the familiar stance of speaking 'about' in favour of 'speaking nearby'.[16] Could the notion of between-ness be approached through the medium and aesthetics of the film itself?

To effect such a shift, Grimshaw endeavoured to model her filmmaking techniques after Owen's artistic ones, self-consciously developing an approach that mirrored or resembled that of her collaborator. It was conceived as an exercise and experiment in mimesis – an attempt, as Taussig put it, 'to get hold of something by means of its likeness'.[17] Observational film making techniques were central to this task. Understood as a form of mimetic practice, they were intended to raise questions about how knowledge comes to be generated not through a process of distance and objectification but through proximity and contact.[18]

Owen's performance in the Taxi Gallery unfolded over the course of three weeks. In turning away from the social location of Owen's work (the taxi in the street, the arrival of visitors, exchanges, interactions), Grimshaw instead directed her attention inwards toward the curtain-making itself – that is, toward the relationship between the artist and her own practice. Conceptualizing herself as engaged in a parallel sequence of actions, Grimshaw used her camera to follow an unfolding choreography of moments – measuring, sorting, tearing, sewing, stitching, hanging, resting, thinking, puzzling – and, in so doing, she sought to reflexively chart the process of making sense/making knowledge in the world irrespective of whether it was considered 'art' or 'anthropology' .

Working with the camera in this way represented an attempt to convey something of the fundamentally non-discursive aspects of Owen's activity. But the bringing together of an anthropological practice with an artistic one also meant attending to how the medium of video might allow something other than explanatory meaning to emerge. By keeping shots long, holding together image and sound, building extended scenes, Grimshaw's intention was not to achieve some kind of transparency – rather it was to use observational techniques to render what MacDougall has termed the 'obduracy' or excess of the image, to embrace those disparate elements (visual and

aural) that cling to the image but that we lose sight of once we consciously direct our attention toward certain aspects of the social reality represented.[19] For example, one of the effects of the approach adopted concerned the perception of the site of the work itself. Through filming the taxicab underwent something of a metamorphosis, no longer appearing to be a securely grounded, recognizable object but instead a rather peculiar, hybrid creature suspended within a surreal landscape. The everyday was revealed as something strange rather than something to be made understandable or familiarized.

Having concluded that the first effort to explore the space between art and anthropology had largely failed (since far from dissolving distinctions, the collaboration had only served to reify them), *Material Woman* represented a second attempt to connect distinct but related practices. On this occasion, video was the medium through which perspectives converged. It was the material expression of curtain making and filmmaking, performance and documentation. Pursued outside the conventional sites of both art-making and anthropology, the collaboration yielded an interesting shift in identities. Grimshaw's self-conscious acknowledgement of the formal qualities and aesthetic of video aligned her practice more closely with conventions of artistic practice, while Owen's relinquishing of a concern with the 'look' of the work in favour of the process of making, took her in the direction of anthropology. But, although the unusual site of the collaboration offered a freedom to explore/inhabit the identity of the other, what was produced there hovered uncomfortably between established domains. The resulting video was a hybrid. It was difficult to recognize as either art or anthropology.

Connecting Art and Anthropology

Connecting Art and Anthropology (CAA) was an intensive, highly choreographed event attended by a small group of anthropologists, artists and curators. Taking place over three days in January 2007, it was intended to catalyse a particular kind of engagement between the participants.[20] The event was designed by Ravetz as a response to recent high-profile conferences exploring the crossovers between anthropology and art (most notably at Tate Modern and Harvard University's Carpenter Center). While building on the emergent dialogue, Ravetz wanted to shift the scale of engagement and at the same time change its dynamics. She sought to create the conditions in which participants would be willing to relinquish their habitual identities and practices in order to become caught up in each other's ways of thinking and doing.

The workshop was part of Ravetz's broader interest in 'aesthetic ethnography' – a way of pursuing ethnographic enquiry through the dual lens of anthropology and art.[21] This notion had arisen from her movements between the spaces of art-making and anthropology. Initially Ravetz had been drawn to anthropology through her work as an artist. Making drawings and sculptures in the land around her Pennine home had led her to consider the skilled practices and cultural meanings that shaped not only her own, but other people's relationships to place. While art was the basis for her observations, anthropology suggested insights into how landscapes are perceived, inhabited and given meaning.

While studying anthropology, Ravetz continued to be interested in visual ways of thinking and working, but in doing so, she discovered fundamental tensions between the fields of art and anthropology. The artist's practice or art-work remained a fundamental premise of contemporary art, despite its growing interest in social worlds. This premise mediated other important relationships such as those between artist and audience. In anthropology, however, the crucial element was not individual practice but the social world studied. Without it, anthropology had little meaning.

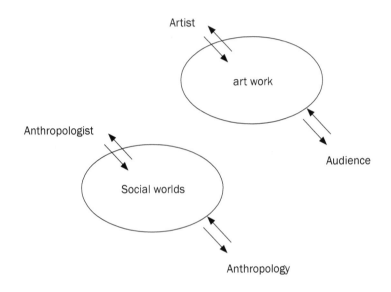

Located at the Granada Centre during the 1990s, Ravetz had become interested in observational film making as a way of bringing these different threads together. Drawing on particular techniques, she attempted to create resonances between her aesthetic sensibility as a film maker and the 'otherness' of the realities being filmed.[22] Ravetz's concern was to establish a relationship between art and anthropology in which an individual's artistic practice and the imperatives of social realities might come together without either being eclipsed. She thought of this as about generating a third space, one in which the identities of artist or anthropologist were less important than the pursuit of a single, expansive approach.

In 2004, the context of Ravetz's practice changed from anthropology to fine art. Now located in a different space, she invited conceptual artist, Pavel Büchler, to engage with the practice of aesthetic ethnography by viewing a selection of her work. His response was intriguing. He said that it 'looked' like art but it did not 'work' like art. It was, as he put it, 'contaminated' by anthropology. When asked if she lacked artistic ability, Büchler responded with the suggestion that the problems in the work followed from Ravetz's attachment to anthropology – joking that she had 'an ethnographic chip' on her shoulder.

Büchler's comments suggested that thinking like an artist while at the same time thinking like an anthropologist might be neither possible nor desirable. According to him, intimate contact between the two fields engendered something inherently impure for which art had little use. For Ravetz, though, working as an observational film maker had brought her to a different understanding. It suggested a way of holding 'in reserve' these conventional categories. Interpreted as a mimetic practice, working observationally enabled Ravetz to approach other realities at the same time as she remained open to the possibilities thrown up by an encounter, mindful that the shape of a piece - the interplay of aesthetics, knowledge and form - could not be known in advance.

In convening CAA, Ravetz wanted to work with artists, anthropologists and curators to extend this enquiry. What would happen when anthropologists and artists were asked to work together? Would it be possible to find shared ground? How might notions of impurity and hybridity be challenged or re-asserted through such an experiment? Participants were invited on the basis of being artists with an interest in social worlds, anthropologists experimenting with aesthetic forms, and curators committed to dialogue between artists and non-artists.

THE WORKSHOP

At the end of the first day, two crucial questions emerged from the workshop: 'What do artists *desire* of anthropologists?' 'Why is there believed to be a special relationship between them?'

Some of the anthropologists explained that they were interested in the art and anthropology dialogue because disciplinary conventions made it difficult to communicate certain dimensions of human experience. Grimshaw said she had found anthropological discourse unhelpful when trying to represent certain things she had come to know during fieldwork, since translation always meant losing something essential about them. Castaing-Taylor suggested that anthropologists could learn from artists what he called 'an aesthetics of estrangement' rather than continuing their usual practice of domesticating difference.

The artists spoke in subtly different terms about their reasons for being at the workshop. Unlike their anthropological counterparts, they did not highlight a lack in their field of practice but had instead a clear sense of how anthropology might be useful in extending it. For instance, Nashashibi spoke of her interest in the fieldworker as a mythical figure, suggesting that some of anthropology's more archaic practices - representing others' worlds as exotic and strange - could be used by curators of contemporary work to highlight art's alien rather than its familiar qualities. Peltz described how his recent work in Cameroon drew on his background in anthropology. But, in now working cross-culturally as an artist, he no longer felt compelled to translate different contexts of action in the way an anthropologist might do.

This early discussion reinforced the perception that there was indeed a special attraction between anthropology and art. The second day of the workshop, however, began to reveal what *distinguished* them. For Peltz: 'artists are very comfortable

talking about their process and what's personal about it to them, but the personal element of their process is something I rarely hear from anthropologists ...What you [Amanda] wouldn't be willing to let go of is that there is also something – there is also this "Other" that exists, that you could know something about?' Castaing-Taylor challenged this suggestion, saying that anthropologists – just like artists – often combine a sense of the personal with an interest in the 'Other'. But while Peltz conceded this point, he also suggested that acknowledging something outside oneself was not an *essential* requirement for contemporary art. For anthropology it seemed to be the case.

Related to Peltz's perception of the anti-solipsism of anthropology was a question concerning the different responsibilities of artists and anthropologists to their subjects and to their fields. Tan and Nashashibi commented that some anthropologists seemed to be hemmed in by the processes of disciplinary legitimization – the clear demarcation between what was and was not proper anthropology – and that perhaps it was this that inhibited the development of individual practice. Rooney reminded the workshop that a number of the artists were still waiting to hear from the anthropologists about their methods or practices, extending the sense that anthropologists were unwilling or unable to speak in terms of personal vision or authorship.

In seeking to put these initial perceptions to the test, Ravetz divided the participants into small groups and invited them to devise projects of making that might clarify the connections and differences that had begun to emerge. The examples discussed below reveal the challenge of evaluating what happens *between* different fields, aesthetics, modes of practice.[23] Stepping outside familiar ways of doing things – seeing ideas 'filtered back and forth' as Peltz put it – was an unsettling, if productive, experience for many of the participants.[24]

GROUP WORK

Group 1 began by going for a walk, videoed by Jos van der Pol.[25] Before setting off there had been a brief exchange between van der Pol and Bouquet. Van der Pol described how at some point in any project 'you have to come up with something' and Bouquet remarked that this corresponded to how she worked, suggesting that they 'walk somewhere and look at things that are not just ourselves.' The rest of the group agreed. Later it was remarked that van der Pol, an artist, had taken on the classic role of ethnographer. It was he who listened attentively to the people they met, drew them out and filmed them. The idea for what the group might *do* had come from an anthropologist. After returning to the workshop site, group members edited the video footage and drew a diagram summarizing the landscape and the people they had met.

The presentation by Group 1 provoked intense, heated debate among the workshop participants. Some wondered if they were mocking their fields. There was particular unease about how subjects had been represented. Both artists and anthropologists expressed concern that the group had classified people according to class and ethnicity, 'effacing' the humanity of people encountered and undermining the potential that parody has to challenge authority in meaningful ways. Others felt this was a misplaced response to a report on the group's interaction – something not

intended as 'art' or 'anthropology' . However as Group 1 responded to these charges, giving more information about how they had worked together, different layers of their gesture emerged. The structure adopted by the group – 'looking for an idea' – had allowed them to weave together different methodologies and analytical forms from art and anthropology. The notion of 'speed anthropology' they had arrived at was not a simple parody. It was an attempt to articulate the experience of working together through experimentation with self-consciously problematic forms.

As long as Group 1 was judged in relation to an established idea of what makes good art or anthropology, key elements were found to be missing. The results looked unpromising. Art and anthropology gone to crumb, as Peltz put it. However, once the ideas behind the presentation became the focus of critical attention (rather than the final product), something else came into view. Bik commented that the idea of going out asking for an idea had been a strong one, resulting in 'an Alice in Wonderland kind of scene, rolling, rolling.' She added that despite people's annoyance at the clumsiness of the piece and its use of satire 'what you get in this walk, totally by coincidence, wrapping it up in package of an idea, is ... an interesting form for asking about the whole investigation.'

Group 2 began by going around each person in turn, soliciting ideas about how to proceed.[26] The concept of threeing, proposed by Peltz, emerged as a guiding principle.[27] Having settled on this idea, the group began to play with positions of protagonist, interlocutor and audience in a dynamic trio. They tried out a number of different possibilities for conversing, interrogating and interjecting. While experimenting with various kinds of 'dialogue', they discussed ideas for further action, reflecting on workshop dynamics and comparing their responses to work shown by participants.

For the final presentation, CAA participants were shown into the large chapel in which Group 2 had been working and invited to sit round a central space. Two members of the group then sat back to back in the middle of the space. The pair began to question each other, discussing their feelings about the workshop, the relationship between anthropology and art and the work they had seen. At the same time the audience wrote questions on slips of paper, handing these to one or other of the pair who used them as prompts to push the conversation in different directions. After about 15 minutes the exchanges came to a close. The slips of paper were laid on the floor. Volunteers from the audience were asked to read them aloud, revealing how the written questions and the back-and-forth between the two players had all been closely entwined. The audience had intervened in a dialogue between two people, transforming it into an open, expansive conversation with a markedly original shape and texture from the one that characterized the initial two-way exchange.

In a similar way to Group 1's use of speed anthropology, Group 2 drew on an idea on the cusp of anthropology and art. From this they devised a form that worked to rearrange the engagement of workshop participants in the art-anthropology dialogue. Grimshaw commented that the form had arisen from the group's desire to get away from the boxes of art and anthropology. Nashashibi suggested the importance of a third element in the art-anthropology exchange – art, anthropology AND, as she put it. In adopting the idea of threeing, Group 2's presentation raised specific issues: the discomfort many had felt during Group 1's presentation; the difficulty of not

understanding art work; the question whether art's purpose is to make people feel unsettled; the puzzle of what might be at stake for someone who chooses anthropology and what their means for getting to that space might be. But the presentation also proposed, through practice, an alternative way of negotiating difference. The principle of three generated a space between the two fields. The differences between anthropology and art were visible. But there was neither a rush toward resolution nor toward dissolution into unproductive conflict.

CONCLUSION

When we began our experiments in collaborative work, a new dialogue was developing between anthropologists and artists. Hal Foster's essay, 'The Artist as Ethnographer'[28] had been an important catalyst, dislodging the traditional terms of engagement between these two fields. At the same time the emerging debate reflected changes internal to the fields themselves. On the one hand, anthropology had undergone its 'post-modern turn' and the dominant semiotic frameworks (that privileged textuality and interpretation) were starting to give way. With the rise of phenomenologically inflected work, questions of practice increasingly came to the fore. On the other hand, contemporary art was marked by a movement away from the studio to the site and a growing interest in art as process or performance rather than exclusively focused around the production of specific kinds of objects. As a consequence both anthropologists and artists started to recognize that it was in the area of practice, rather than in discourse about artifacts, that their interests converged.

Within anthropology, 'art' began to be approached less as an object of enquiry (the anthropology 'of' or 'on' art) and more of an analogous mode of investigating the world. In place of a concern with objects - their aesthetic qualities, social use, cultural meaning and so on - attention re-focused around making. Ingold and his collaborators, for example, advocated 'anthropology and art' , an anthropology pursued *with* artists not separate from them.[29] Schneider and Wright[30] proposed 'border crossings' or appropriative practice in which artists and anthropologists borrowed techniques and forms from one another. Although there are strengths in each of these positions, there are also weaknesses. In particular, there is a danger in over- or under- playing the differential social/intellectual values attached to 'art' and 'anthropology' and the ways these continue to resonate through collaborative endeavours. Conceiving of the two practices as either perfectly analogous or categorically distinct results in an erasure of the critical rhythm - the blockages and flows - between them. As our initiatives reveal, the space *between* is, in fact, what is critical. But it is a volatile, highly charged space in which collaborative experimentation can as often end in failure as success.

The significance of the three examples lies in what each tells us of the practical challenges involved in attempting to shift the conventional boundaries between fields. In each case, artists and anthropologists came together and were expected to make something of unfamiliar circumstances things and people. In the first (*Give Me A Call*), different modes of knowledge were brought into direct contact with one another. Given the context in which the encounter took place, this juxtaposition

precipitated a crisis. The ways of knowing of art and anthropology were perceived to be in conflict. Specifically, the anthropologists feared 'contamination' by art, since it posed a threat to the legitimacy of their work, understood to be part of a collectively sanctioned disciplined enquiry. The fear, however, was only one way. Owen was surprised – but invigorated – by the intense reaction to her participation, acknowledging that a crucial part of her role as an artist was to provoke, intervene, challenge. For her, shaking the fence *was* a small shifting of the boundaries.

In the second and third case studies (*Material Woman, Connecting Art and Anthropology*), the outcome of collaborative work was a sort of puzzlement. In *Material Woman* there was neither conflict nor synthesis. The project and its residue could not be assimilated into existing frameworks, since judged in relation to the 'parent' field, the work easily appeared a simulation rather than the 'real thing' – 'looking like' anthropology or 'looking like' art. In *Connecting Art and Anthropology*, certain fundamental differences between the two fields became visible and were held in tension through the forms generated by the two groups. However, as with *Material Woman*, the gestures that came out of CAA appeared to lack a wider context and without such a reference, the group projects were hard to place. Hence their value was unclear.

For artists and anthropologists 'making do' in each other's worlds meant allowing well-worn priorities, assumptions and habits to be disturbed. It required artists to be accountable and anthropologists to risk irrelevance, prompting the question from both participants and those beyond the immediate dialogue – what's the point? Taken together, however, the case studies suggest that the process of re-arrangement and the strangeness and failure that often accompanies it, is an overlooked but crucial element of practices *in the making*. By patiently attending to what happens when art and anthropology come together, we encounter a form of knowledge that we often fail to recognize or interpret as preliminary in some way – that is, craft knowledge built from the bringing together of differences or the migration of skills from one context to another. Creating a space in which this might take place is a necessary first step in any re-conceptualization of the boundary between art and anthropology. When we began our collaborative experiments, visual anthropology served this purpose. It was a third space in which innovative work could be pursued. If once acknowledged as a distinctive site within anthropology, visual anthropology is now widely considered to be obsolete. The creation of an experimental space where disciplinary certainties might be unsettled by practices and knowledge-in-the-making, nevertheless, remains important. Reports from the field are intended as a contribution to this task.

ACKNOWLEDGEMENTS

Anna Grimshaw is very grateful to Angelika Bammer for her generous contributions to the development of her ideas about creativity and forms of intellectual life.

Elspeth Owen is especially appreciative of the support offered by Kirsten Lavers at the Taxi Gallery in Cambridge and is grateful to Anna Grimshaw for sustaining contact across the Atlantic Ocean.

Amanda Ravetz would like to thank all the participants who took part in the Connecting Art and Anthropology workshop. *Connecting Art and Anthropology* was funded by the Arts and Humanities Research Council and the Manchester Institute for Research and Innovation in Art and Design (MIRIAD).

Elspeth wrote to Anna recently Servants of the Bhudda led me to imagine your life as hazardous and eventful and I remember thinking, when I asked you to film me in the Taxi gallery, that therefore that meant you would spot the wildness and the wilfullness in what I was doing. I realize now that underlying this assumption was a (completely unfounded) expectation that your filming and our editing would also be wild and wilfull, that, if you like, academic anthropology would be seduced by irresponsible art. Instead, of course, we made the work *together* in our *different* ways and as I look at the film Material Woman now, I see the wilfullness is missing. This is something I did not see clearly at the time

Figure 13.2. *Layered Texts* Elspeth Owen, 2009.

Notes

Chapter 1 Between Art and Anthropology

1. The abstract painter and op-artist Bridget Riley used the expression 'interactive power' of colours when commenting on her method of work. Bridget Riley, 'At the End of My Pencil', *London Review of Books*, (8 October 2009), p. 21. For António Ole, see his recent major exhibition 'Hidden Pages: Fotografie-Installation-Video', Bayreuth, 2009, which included his installation *Hidden Pages - Stolen Bodies*, and catalogue (English/German) Johannes Hossfeld and Ulf Vierke (eds) *António Ole - Hidden Pages* (Wuppertal: Peter Hammer, 2009).

2. Lucien Taylor, 'Iconophobia: How Anthropology Lost it at the Movies', *Transition* 69, (1996), pp. 64-88; David Batchelor, *Chromophobia* (London: Reaktion, 2000); Michael Taussig, *What Colour is the Sacred?* (Chicago: University of Chicago Press, 2008).

3. Batchelor, *Chromophobia* , pp. 22-3.

4. Taylor, 'Iconophobia'.

5. See also the art historian Julian Stallabrass writing about similar problems with the work of photographer Sebastião Salgado, i.e. J. Stallabrass, 'Sebastião Salgado and Fine Art Photojournalism', *New Left Review* 1(223) (May-June) (1997), pp. 131-60.

6. J. Ivens, *The Camera and I* (New York: International Publishers, 1969), p. 88.

7. See, in particular, Kirsten Hastrup, 'Anthropological Visions: Some Notes on Visual and Textual Authority' in David Turton and Peter Crawford (eds) *Film as Ethnography* (Manchester: Manchester University Press, 1992) and the arguments around Robert Gardner's film *Forest of Bliss,* including Jonathan P. Parry, 'Comment on Robert Gardner's "Forest of Bliss"', *Society for Visual Anthropology Newsletter* 4(2) (September 1988), pp. 4-7, and Radhika Chopra. 'Robert Gardner's Forest of Bliss: A Review' *Society for Visual Anthropology Newsletter* 5(1) (March 1989), pp. 2-3.

8. Taylor, L. 'Iconophobia', p. 66.

9. Ibid., p. 67.

10. Ibid., p. 69.

11. Olu Oguibe and Okwui Enwezor (eds), *Reading the Contemporary: African Art from Theory to the Market Place* (Cambridge, MA: MIT Press, 1999).

12. Ibid, pp. 17-19.

13. See James Weiner's seminal text 'Televisualist Anthropology: Representation, Aesthetics, Politics', *Current Anthropology* 38(2) (April 1997), pp. 197-233.

14. *Fieldworks: Dialogues between Art and Anthropology* at Tate Modern, London, 2003, http://channel.tate.org.uk/media/37110346001#media:/media/371103 46001/27688590001&context:/channel/most-popular; also A. Schneider, 'The Art Diviners', *Anthropology Today* 9(2) (1993), pp. 3-9, and A. Schneider 'Uneasy Relationships: Contemporary Artists and Anthropology', *Journal of Material Culture* 1(2) (1996), pp. 183-210; Hal Foster 'The Artist as Ethnographer?' in G. Marcus and F. Myers (eds), *The Traffic in Culture: Refiguring Art and Anthropology* (Berkeley, CA: University of California Press, 1995);Anna Grimshaw and Amanda Ravetz (eds) *Visualizing Anthropology* (Bristol: Intellect Books, 2005);A. Schneider and C. Wright (eds), *Contemporary Art and Anthropology* (Oxford: Berg, 2006); also, the international conferences, workshops, and exhibitions, 'Beyond Text', University of Manchester, 2007, 'Connecting Art and Anthropology', Manchester Metropolitan University, 2007, 'Art/Anthropology: Practices of Difference and Translation', University of Oslo/Museum of Cultural History, 2007, 'Experimenting the Visual in Art and Anthropology', National University of Science and Technology, Trondheim, 2008, and 'Performance, Art and Anthropology', Musée du Quai Branly, Paris, 2009, 'Ethnographic Terminalia', Crane Arts, Philadelphia, 2009.

15. See Nicolás Bourriaud's now famous work, *Relational Aesthetics* (Paris: Les presses du réel, 2002).

16. See Grant H. Kester's important study, *Conversation Pieces: Community and Communication in Modern Art* (Berkeley: University of California Press, 2004).

17. Peter Benson and Kevin Lewis O'Neill, 'Facing Risks: Levinas, Ethnography, and Ethics', *Anthropology of Consciousness* 18 (2) (2006), 29-55.

18. There are myriad publications of anthropologists in these fields; for an interesting example where artists have worked with anthropological theories of exchange and political economy see Neil Cumming's and Marysa Lewandowska's project *Capital* (2001), which was inspired partly by Marilyn Strathern writings, and involved the Tate Modern and the Bank of England. See also George Marcus's comments on their project, 'Contemporary Fieldwork Aesthetics in Art and Anthropology: Experiments in Collaboration and Intervention', in Neni Panourgiá and George E. Marcus (eds) *Ethnographica Moralia: Experiments in Interpretive Anthropology* (New York: Fordham University Press, 2008).

19. Steven Feld, *Sound and Sentiment: Birds, Weeping, Poetics, and Song in Kaluli Expression* (Philadelphia: University of Pennsylvania Press 1982).

20. At the *Sensorium* exhibition, MIT, 2006, see also Caroline Jones (ed.) *Sensorium: Embodied Experience, Technology, and Contemporary Art* (Cambridge, MA: MIT Press, 2006).

21. T. Ingold, 'The Eye of the Storm: Visual Perception and the Weather', *Visual Studies*, 20 (2) (October 2005), pp. 97-104 and Ingold, T. 'Rethinking the Animate, Re-Animating Thought', *Ethnos* 71 (1) (March 2006), pp. 9-20.

22. T. Ingold, 'The Eye of the Storm', p. 104.

23. T. Ingold, 'Rethinking the Animate', p. 19.

24. N. Bourriaud, *Relational Aesthetics*.

25. A. Gell, *Art and Agency: An Anthropological Theory* (Oxford: Oxford University Press, 1998).

26. H. Belting 'Toward an Anthropology of the Image', in Mariet Westermann (ed.), *Anthropologies of Art* (New Haven, CT: Yale University Press/Clark Art Institute, 2005).

27. Schneider, A. *Appropriation as Practice: Art and Identity in Argentina* (New York: Palgrave, 2006), Chapter. 7.

28. Teresa Pereda, *Recolección/Restitución: Citas por América,* artist statement, Buenos Aires, 2007–present, p. 2. Also, *Flores para un desierto. Salar de Uyuni,* 2008, artist statement, Buenos Aires, 2008.

29. See also Penelope Z. Dransart, *Earth, Water, Fleece, and Fabric: An Ethnography and Archaeology of Andean Camelid Herding* (London: Routledge, 2002), p. 82.

30. Pereda, *Recolección/Restitución,* p. 10.

31. Sharon MacDonald and Paul Basu, 'Introduction: Experiments in Exhibition, Ethnography, Art and Science', in Sharon MacDonald and Paul Basu (eds) *Exhibition Experiments* (Oxford: Blackwell, 2008), p. 2.

32. For a range of examples, see MacDonald and Basu, *Exhibition Experiments.*

33. Ibid., p.13.

34. Bourriaud, *Relational Aesthetics.*

35. Latour, Bruno 2005. *Reassembling the Social: an Introduction to Actor Network Theory,* Oxford: Oxford University Press.

36. Gell, A. *Art and Agency.*

37. Sutherland, Ian /Krzys Acord, Sophia 2007, 'Thinking with art: from situated knowledge to experiential knowing', *Journal of Visual Art Practice,* 6, 125 – 140, p. 134.

38. Ibid., pp. 126, 130.

39. Colin Renfrew, *Figuring it Out: The Parallel Visions of Artists and Archaeologists* (London: Thames & Hudson, 2003), p. 7.

40. G. Marcus, 'Introduction: Notes toward an Ethnographic Memoir of Supervising Graduate Research Through Anthropology's Decades of Transformation', in James D. Faubion and George E. Marcus (eds) *Fieldwork is Not What it Used to Be: Learning Anthropology's Method in a Time of Transition* (Ithaca, NY: Cornell University Press, 2009), p. 10.

41. V. Samanta, C. Knowles, J. Burke, F. Wagmister and D. Estrin 'Metropolitan Wi-Fi Research Network at the Los Angeles State Historic Park', *The Journal of Community Informatics* 4 (1) (2008), at http://cijournal.net/index.php/ciej/article/view/427/422 . In the more restricted view of anthropologists, despite notions of networks, this remains however research *on* and not *with* people, see Jenna Burrell, 'The Field Site as Network: A Strategy for Locating Ethnographic Research', *Field Methods* 21 (2009), pp. 181-99.

42. Orrantia Documentography 11, see http://www.documentography.com/issue/11/ph/Juan/1.html .

43. J. Orrantia, *Aqueous Recollections: Moments of Banality, Intimacy, and Unexpectedness in the Aftermath of Terror in Colombia,* unpublished PhD thesis, Yale University 2009, p. 5.

44. A. Irving, 'Ethnography, Art and Death', *Journal of the Royal Anthropological Institute* 13(1) (2007), pp. 185-208.

45. P. Hockings (ed.), *Principles of Visual Anthropology*, 2nd edn (Berlin and New York: Mouton de Gruyter, 1995).

46. W. J. T. Mitchell, 'There Are No Visual Media', *Journal of Visual Culture* 4(2) (2005), p. 257.

47. See, for example, www.soundimageculture.org, run by Laurent Van Lancker and others.

48. See, for example, Gail Pearce and Cahal McLaughlin (eds), *Truth or Dare: Art and Documentary* (Bristol: Intellect Books, 2007).

49. Schneider, A. 'The Art Diviners'.

50. There are a variety of spellings; we shall follow N. A. Chagnon, *Yanomamö, The Fierce People* (New York: Holt Rinehart & Winston, 1968). Where other authors (i.e. Downey, Michaels, the Cartier Foundation catalogue) adopted a different form, we left it in the original.

51. For fuller treatments of Juan Downey in relation to experimentation in anthropology, see A. Schneider, A. 'Three modes of experimentation with art and ethnography', *Journal of the Royal Anthropological Institute* (N.S.), 14 (1) (2008), pp. 171-94 ; also Eric Michaels, 'How To Look at the Yanomami Looking at Us', in Jay Ruby (ed.), *A Crack in the Mirror: Reflexive Perspectives in Anthropology* (Philadelphia, PA: University of Pennsylvania Press, 1982).

52. For a full analysis of the film see Nick Hamlyn, *Film Art Phenomena* (London: BFI Publications, 2003), pp. 103-4; also Le Grice's own essays, Malcolm Le Grice, *Experimental Cinema in the Digital Age* (London: BFI Publications, 2001). For experimental film in relation to anthropology, see also A. Schneider, 'Expanded Visions: Rethinking Anthropological Research and Representation through Experimental Film in Tim Ingold (ed.), *Redrawing Anthropology: Materials, Movement, Lines* (Aldgate: Ashgate, *forthcoming*). Catherine Russel writes more generally on narrative, and reflective issues between experimental film, video, and anthropology but does not consider in depth the material and formal, 'structural' aspects of experimentation; see Catherine Russel, *Experimental Ethnography: The Work of Film in the Age of Video* (Durham, NC: Duke University Press, 1999).

53. Gregory Bateson, *Naven : A Survey of the Problems Suggested by a Composite Picture of the Culture of a New Guinea Tribe Drawn from Three Points of View* (Cambridge: Cambridge University Press, 1936); George E. Marcus, 'A Timely Reading of Naven: Gregory Bateson as Oracular Essayist,' *Representations* 12 (Fall 1985), pp. 66-82.

54. James Clifford, *The Predicament of Culture* (Cambridge, MA: Harvard University Press), pp. 70-1.

55. Michel Foucault, *Discipline and Punish: The Birth of the Prison* (London: Allan Lane, 1977).

56. Rane Willerslev and Olga Ulturgasheva, Olga, 'The Sable Frontier: the Siberian Fur Trade as Montage', *Cambridge Anthropology* 26(2) (2006), pp. 80-98, p.80.

57. Alyssa Grossman and Selena Kimball have eloquently written about their collaborations in this respect, see *The Memory Archive*: Filmic Collaborations in Art and Anthropology', *Reconstruction* 9 (1) (2009) see http://reconstruction.eserver. org/091/grossman&kimball.shtml. See also Alyssa Grossman's film *Into the Field*

(2007) which, in collaboration with Selena Kimball, used 16 mm stop-motion animated film for specific sequences .

58. Susanne Küchler, 'The String in Art and Science: Rediscovering the Material Mind', *Textile* 5(2) (2007), pp. 124-39.

59. Susanne Küchler, 'Technological Materiality: Beyond the Dualist Paradigm', *Theory, Culture and Society*, 25(1) (2008), pp. 101-20, p.110.

60. http://www.littlewhitelies.co.uk/interviews/gideon-koppel/, accessed 20 April 2010.

61. Mark Ford, *Guardian*, 9 May 2009.

62. Incidentally, Jeff Silva, is also an instructor at the Sensory Ethnography Lab at Harvard University run by Lucien Taylor - see www.jeffdanielsilva.com.

63. See the online magazine *Roland,* No.3 (2009), published by the Institute of Contemporary Arts www.ica.org.uk .

64. Marcus, G., 'Introduction: Notes toward an Ethnographic Memoir of Supervising Graduate Research Through Anthropology's Decades of Transformation', p. 24.

65. Ibid, p. 27.

66. Ibid, p. 28.

67. Although Marcus does not address here the visual arts in this paper, the implications are clear.

68. Barbara Rose, 'Claes Oldenburg's Soft Machines', *Art Forum* (Summer 1967), pp, 30-5, referring to Claes Oldenburg: 'Extracts from the Studio Notes', *Artforum* (January 1966) and 'Claes Oldenburg Skulpturer och Teckningar' (exhibition catalogue, Moderna Museet, Stockholm, 17 September-30 October 1966).

69. C. Kelty et al., 'Collaboration, Coordination, and Composition: Fieldwork after the Internet', in Faubion and Marcus, *Fieldwork is Not What it Used to Be*, p. 187.

70. Schneider, A. 'Three Modes of Experimentation', pp.177-82.

71. 'Relinquishment is a fundamental moment of appropriation and distinguishes it from any form of 'taking possession' writes Paul Ricoeur (1981) *Hermeneutics and the Human Sciences* (Cambridge: Cambridge University Press, p.191).

72. Kester develops the concept of 'dialogical aesthetics' in relation to a range of art practices that develop, or are based on, social relations with communities and individuals, even if these relations, established by artists, are temporal. Taking inspiration from philosopher Gemma Fiumara, he suggests 'listening' is a better approach in such encounters, rather than just assuming dialogue between supposed equals (as in a Habermas' 'ideal speech act' situation). G. H, Kester, *Conversation Pieces: Community and Communication in Modern Art* (Berkeley: University of California Press, 2004), pp.82-123, especially p.106; cf. also Fiumara, Gemma. The *Other Side of Language: A Philosophy of Listening* (London: Routledge, 1995).

Chapter 2 Farther Afield

1. Lucy R. Lippard, *Overlay: Contemporary Art and the Art of Prehistory* (New York: Pantheon, 1983). The New Press 1994. I now wish I had simply used the word his

tory instead of 'prehistory', because history did not begin when white folks began to write down their versions.

2. *The Lure of the Local: Senses of Places in a Multicentered Society* (New York: The New Press, 1997).The latest book, referred to above, is *Sightlines:The Tanos of the Galisteo Basin, 1290-1790*, forthcoming from the Museum of New Mexico Press, Santa Fe, in 2010.The second half is still in progress.

3. Susan Hiller, 'Art and Anthropology, Anthropology and Art,' in Susan Hiller, *Thinking About Art: Conversations with Susan Hiller* (Manchester: Manchester University Press, 1996), p. 24.

4. Suzanne Lacy, 'Seeking An American Identity:Working Inward from the Margins', www.AmericansFor TheArts.org./Animating Democracy.

5. Julian Lang, quoted in Ferdinand Lewis, 'The Arts and Development:An Essential Tension,' in Caron Atlas and Pam Korza (eds), *Critical Perspectives:Writings on Art and Civic Dialogue* (Washington DC:Americans for the Arts, 2005), pp. 41-2.

6. Hulleah Tsinhnahjinnie, 'When Is a Photograph Worth a Thousand Words?' in *Native Nations* (London: Barbican Art Gallery, 1998), p. 11, and 'Compensating Imbalances,' *Exposure,* 29 (1993), p. 30.

7. Theresa Harlan, quoted in Hulleah Tsinhnahjinnie, *Memoirs of an Aboriginal Savant* (Davis: C. N. Gorman Museum, University of California at Davis, 1994).

8. Hullean Tsinhnahjinnie, 'Hulleah Tsinhnahjinnie:Taking Risks', *Reflex*, December 1994/January 1995, pp. 8-9.

9. Hulleah Tsinhnahjinnie, in Stephen Jenkins, 'A Conversation with Hulleah J.Tsinhnahjinnie', *Artweek* 24(9), (6 May, 1993), p. 4.

10. Hulleah Tsinhnahjinnie, 'When Is a Photograph Worth a Thousand Words?'. p. 11.

11. Hulleah Tsinhnahjinnie, *Memoirs of an Aboriginal Savant.*

12. Ferdinand Lewis, unpublished response to book project.

13. Suzanne Lacy, lecture at the Maine College of Art, Portland, Maine, 26 June 2003.

14. Suzanne Lacy (ed.), *Mapping the Terrain: New Genre Public Art* (Seattle: Bay Press, 1995).

15. I have paraphrased some of Lacy's statements here.

16. Suzanne Lacy, Maine College of Art lecture, 2003.

17. From unpublished description of *The Skin of Memory* project, September 8, 2003, courtesy of Suzanne Lacy.

18. Suzanne Lacy, 'Finding Our Way to the Flag: Is Civic Discourse Art?' *Public Art Review* 28 (Spring/Summer, 2003), p. 29.

19. 'Richard' (recorded by Tim Rollins) 'See you in the East River,' in Alan Moore and Marc Miller, eds., *ABC No Rio Dinero:The Story of a Lower East Side Art Gallery*, New York:ABC No Rio, 1985.

20. Abdelali Darouch, quoted in Laura Kuo, *Desert Sin Revisited:Abdelali Dahrouch* (Pomona: Pomona College Museum of Art, 2003), p. 3 and p. 9.

21. Dahrouch, Ibid.

22. Laura Kuo, *Desert Sin Revisited.*

23. See Susan Hiller, 'Art and Anthropology/Anthropology and Art,' and 'An Artist Looks at Ethnographic Exhibitions,' in Susan Hiller, *Thinking About Art* (Manchester:Manchester University Press, 1996) and Susan Hiller (ed.), *The Myth Of Primitivism* (New York: Routledge, 1991).

24. Gayatri Spivak, 'Subaltern Studies: Deconstructing Historiography', *In Other Worlds* (New York: Routledge, 1987), p. 205.

Chapter 3 The Artist as Shaman: the Work of Joseph Beuys and Marcus Coates

1. M. Eliade, cited in R. E. Ryan, *Shamanism and the Psychology of C.G. Jung: The Great Circle* (London: Vega, 2002), p. 8.
2. M. Eliade, *Shamanism: Archaic Techniques of Ecstasy*, London: Arkana Penguin Books 1989, p.4. It is worth noting, however, that on the following page Eliade follows this statement with the qualification that similar phenomena were later noted 'in North America, Indonesia, Oceania, and elsewhere', suggesting that the association between shamanism and Siberia may have resulted from the fact that it was in Siberia that travellers first recorded the practice.
3. M. Tucker, *Dreaming With Open Eyes: The Shamanic Spirit in Twentieth Century Art and Culture* (London: Aquarian/Harper San Francisco, 1992), p. 66.
4. M. Eliade, *Myths, Dreams and Mysteries: The Encounter between Contemporary Faiths and Archaic Realities* (London: Harvill Press, 1960), p.77, Eliade's italics.
5 Eliade, M., *Shamanism*, p. 299.
6. K. Armstrong, *A Short History of Myth* (Edinburgh: Canongate Books Ltd, 2005), p. 27.
7. M. Eliade, *Shamanism: Archaic Techniques of Ecstasy*, p.200.
8. M. Harner, *The Way of the Shaman*, (3rd edn) (San Francisco, CA: HarperCollins, 1990), p. xix.
9. Ibid. pp. xix–xx.
10. E. Pasztory, *Thinking with Things: Toward a New Vision of Art* (Austin, TX: University of Texas Press, 2005), p. 93.
11. A. Finlay, 'Chthonic Perjink' in Coates, M. *Journey to the Lower World*. Edited by Finlay, A., Newcastle-upon-Tyne: platform projects and morning star, 2005, no page numbers.
12. H. Stachelhaus, *Joseph Beuys* (New York: Abeville Press, 1991), pp. 48–50.
13. P. Nisbet, 'Crash Course – Remarks on a Beuys Story' in G. Ray (ed.), *Joseph Beuys, Mapping the Legacy* (New York and Sarasota: DAP, 2001), pp. 7–9.
14. M. Coates, cited in V. Groskop, 'Chirps with everything' in the *Guardian*, 25 January 2007, http://www.guardian.co.uk/artanddesign/2007/jan/25/art.vivgroskop, accessed: 8 May 2009.
15. A. Finlay, 'Chthonic Perjink', no page numbers.
16. H. Stachelhaus, *Joseph Beuys*, p. 12.
17. G. Deleuze, 'Body, Meat, and Spirit, Becoming-Animal', in G. Deleuze, *Francis Bacon: The Logic of Sensation* (London and New York: Continuum Books, 2003), p. 21.
18. A useful parallel could be made between 'Dawn Chorus' and current anthropological work being undertaken by Andrew Whitehouse on the relationship

between humans and birdsong. Working with Tim Ingold, Whitehouse is interested in 'what happens when people hear a bird' and 'what people do' with these sounds. His study encompasses an engagement with 'how musicians, artists and scientists respond to bird sounds', an emphasis on both sound and sight, and an engagement with the role of technology in people's understanding of bird sounds. This would suggest that a discussion between Whitehouse and Coates might prove highly fruitful for them both, however, it also raises the vexed question of what form such an interaction might take, as Coates' artwork already constitutes a form of anthropological investigation of its own. See Whitehouse, A., 'An Anthropologist Listens to Birds', http://www.abdn.ac.uk/birdsong/an_anthropologist_listens_to_birds.php], accessed 20 May 2009.

19. A. Finlay, 'Chthonic Perjink', no page numbers.
20. J. Beuys, 'Questions to Joseph Beuys', in J. Beuys, *Joseph Beuys: The Multiples,* edited by J. Schellmann, translated from German by C. Tisdall, Busch-Reisinger Museum, Harvard University Art Museums, Cambridge Walker Art Centre, MN, Munich and New York: Edition Schellmann, 1997, p. 24.
21. M. Coates, 'Linosa Close (Sheil Park)', in M. Coates, *Journey to the Lower World,* edited by A. Finlay (Newcastle-upon-Tyne: Platform Projects & Morning Star, 2005), no page numbers.
22. M. Wallinger, 'Foreword' in M. Coates, *Journey to the Lower World*, edited by A. Finlay (Newcastle-upon-Tyne: Platform Projects & Morning Star, 2005), no page numbers.
23. A. Finlay, 'Chthonic Perjink', no page numbers.
24. G. L. Ulmer, *Applied Grammatology: Post(e)-Pedagogy from Jacques Derrida to Joseph Beuys* (Baltimore, MA: John Hopkins University Press, 1985), p. 238.
25. J. Beuys, cited in C. Tisdall, *Joseph Beuys* (Guggenheim exhibition catalogue) (New York, NY: Thames & Hudson, 1979), p. 23.
26. M. Tucker, *Dreaming With Open Eyes: The Shamanic Spirit in Twentieth Century Art and Culture*, p. 292.
27. N. Bourriaud, 'Art of the 1990s', in N. Bourriaud, *Relational Aesthetics* (Dijon-Quetigny: Les Presses du Réel, 2002 [1998]), pp. 30-1.
28. M. Coates, 'Linosa Close (Sheil Park)', no page numbers.
29. J. Beuys, cited in C. Tisdall, *Joseph Beuys*, p. 95.
30. A. Mackintosh, 'Beuys in Edinburgh', in *Art and Artists* 5 (8) (1970), p. 10.
31. M. Coates, 'Linosa Close (Sheil Park)', no page numbers.
32. Weiss, P., *Kandinsky and Old Russia: The Artist as Ethnographer and Shaman* (New Haven and London: Yale University Press, 1995), p. 86.
33. M. Coates, 'Journey to the Lower World', in M. Coates, *Journey to the Lower World*, edited by A. Finlay (Newcastle-upon-Tyne: platform projects and morning star, 2005), no page numbers.
34. E. Manouelian, 'Found Artefacts: Allegories of Salvage in the Siberian Fiction of Waclaw Sieroszewski', in *Slavonic and East European Review* 84 (1) (2006), pp. 16-31.
35. J. Griffin and M. Coates, *Frieze 108* (Jun–Aug) (2007) http://www.frieze.com/issue/article/focus_marcus_coates], accessed 8 May 2009.

36. A. Schneider, 'Appropriations', in A. Schneider and C. Wright (eds), *Contemporary Art and Anthropology* (Oxford, New York: Berg, 2006), p. 36. Schneider also notes that appropriation is a global phenomenon, and can no longer be seen as solely a Western form of activity.

37. C. Tisdall, interviewed in *Joseph Beuys and Me*, documentary Directed and Produced by Martina Hall, BBC/World of Wonder, TV, 2005.

38. D. Kuspit, 'Joseph Beuys: between Showman and Shaman', in D. Thistlewood (ed.), *Joseph Beuys: Diverging Critiques* (Liverpool: Liverpool University Press and Tate Gallery Liverpool, 1995), p. 39.

39. S. Rainbird, interviewed in *Joseph Beuys and Me*, documentary directed and produced by Martina Hall, BBC/World of Wonder, TV, 2005.

40. D. Kuspit, 'Joseph Beuys: between Showman and Shaman', pp. 37-40.

41. H. Stachelhaus, *Joseph Beuys*, p. 174.

42. M. Coates, interviewed for *In Profile: Marcus Coates*, documentary directed and produced by Picture This Moving Image, DVD, 2007.

43. A. Schneider, 'Appropriations', p. 39. Schneider draws from Rosalind Krauss's terminology and its exploration by Lynne Cooke. Rosalind Krauss, 'Giacometti', in Rubin, *Primitivism in Twentieth Century Art*, p. 514. L. Cooke, 'The Resurgence of the Night-mind: Primitivist Revivals in Recent Art', in S. Hiller (ed.), *The Myth of Primitivism*, pp. 141 - 2.

44. Beuys, J., *What is Art? Conversation with Joseph Beuys.* 2nd ed. Edited by Harlan, V., S. Forest Row: Clairview Books, 2007, p. 22.

45. J. W. Goethe, 'Zur Farbenlehre' ['Theory of Colour'], in J. Naydler (ed.), *Goethe on Science: An Anthology of Goethe's Scientific Writings* (Edinburgh: Floris Books, 1996 [1810]), p. 116.

46. A. Schneider, 'Appropriations', pp. 39-40.

47. P. Weiss, *Kandinsky and Old Russia: The Artist as Ethnographer and Shaman*, p. 777.

48. D. Kuspit, 'Joseph Beuys: between Showman and Shaman', p. 34.

49. M. Wallinger, 'Foreword', no page numbers.

50. J. Charlesworth, 'Art is Good for You. Art is Good For You.' in M. Coates, *Journey to the Lower World,* edited by A. Finlay (Newcastle-upon-Tyne: Platform Projects & Morning Star, 2005), no page numbers.

Chapter 4 Hearing Faces, Seeing Voices: Sound Art, Experimentalism and the Ethnographic Gaze

1. Hal Foster, *The Return of the Real: The Avant-Garde at the End of the Century* (Cambridge, MA: MIT Press, 1999), p. 183.

2. Lucy Lippard, *On the Beaten Track: Tourism, Art and Place* (New York: The New Press, 1999), p. 8.

3. Rosanna Hertz, *Reflexivity and Voice* (London: Sage Publications, 1997), p. viii.

4. Miwon Kwan, in Alex Coles (ed.), *Site-Specificity: The Ethnographic Turn*, de-, dis-, ex-. Volume 4, (London: Black Dog Publishing, 2000), vol. 4, p. 87.

5. Arnd Schneider and Christopher Wright, *Contemporary Art and Anthropology* (New York: Berg, 2006), p. 25.

6. Fernando Calzadilla and George Marcus, 'Artists in the Field: Between Art and Anthropology,' in Schneider and Wright, p. 112.

7. Foster, p. 276.

8. Michael Taussig, keynote address at *Fieldworks: Dialogues between Art and Anthropology,* conference at Tate Modern, London, September, 2003.

9. Erika Brady, *A Spiral Way: How the Phonograph Changed Ethnography* (Jackson Mississippi: University Press of Mississippi, 1999), p. 63.

10. Alan Hall, executive producer of both my pieces for BBC radio coined this term to describe the combination of composition and documentation in these works.

11. John Miller Chernoff, *African Rhythm and African Sensibility: Aesthetics and Social Action in African Musical Idioms* (Chicago: University of Chicago Press, 1979), p. 11.

12. Katharine Norman, 'The Space Between the Jump Cut: A Double Portrait', Canadian Electroacoustic Society's Sonus website, http://www.sonus.ca/curators/norman/wynne.html (2004).

13. Adrian Rifkin, talk at *Encounters, Curiosity and Method: The Making of Practice* symposium at Tate Britain (2006).

14. Michel Foucault, *Theatrum Philosophicum* quoted in 'Confronting Stupidity', Glen Fuller http://eventmechanics.net.au/?p=454 (accessed 4 April 2010), p. 190.

15. Linda Tuhiwai Smith, *Decolonizing Methodologies: Research and Indigenous Peoples* (London: Zed Books, 1999) p 5.

16. Tom Rice, 'Sound and the Boundless Body', in Victoria Hume (ed.) *Transplant,* (London: rb&hArts, 2008), p. 41.

17. Schneider and Wright, p16

18. Susan Stewart in Lippard, p. 8.

19. Bill Nichols, *Representing Reality* (Bloomington, IN: Indiana University Press, 1991), p. 218.

20. Roland Barthes, *Camera Lucida* (London: Vintage, 2000), p. 5.

21. M. A. Biesele, Stories and Storage: Transmission of Ju/Hoan Knowledges and Skills, paper presented at the Ninth International Conference on Hunting and Gathering Societies, Edinburgh, Scotland (September 2002), p. 6.

22. David Toop, 'A foreword to John Wynne's *Hearing Voices'* on *Hearing Voices: Speakers/Languages* (CD-ROM), (London: Sensitive Brigade and Hans Rausing Endangered Languages Project, 2005).

23. Amanda Coffey, *The Ethnographic Self: Fieldwork and the Representation of Identity* (London: Sage, 1999), p. 147.

24. Foster, p. 203.

25. Michael Taussig, *Mimesis and Alterity: A Particular History of the Senses* (New York: Routledge, 1993), p. 198.

26. Taussig, p. 208.

27. Francisco López, 'Profound Listening and Environmental Sound Matter', in C. Cox and D. Warner (eds), *Audio Culture: Readings in Modern Music* (London: Continuum, 2005), p. 84.

28. Brady, p. 60.

29. Martin Heidegger, 'The Question Concerning Technology', in *The Question Concerning Technology and Other Essays* (London: Harper & Row, 1997), p. 13.

30. Jonathan Sterne, *The Audible Past: Cultural Origins of Sound Reproduction,* 2nd edn (London: Duke University Press, 2005), pp. 112–13.

31. Sterne, p. 116.

32. Simon Waters, personal email, 2007.

33. Jean Wainwright, 'Warhol's Wife', in *Art Monthly* March 2002, no. 254, p. 39.

34. Keyan Tomaselli, *Appropriating Images: The Semiotics of Visual Representation* (Højbjerg, Denmark: Intervention Press, 1996), p. 153.

35. Walter Goldschmidt in Tomaselli, p. 163.

36. Justine Laymond, http://www.thetransplantlog.com, 2007, accessed 4 April 2010.

37. Tim Wainwright, 'Tim Wainwright and John Wynne in Conversation with Angus Carlyle', in Hume *Transplant,* p. 12.

38. David Toop, 'Depths and Clamour; Inside and Outside', in Hume *Transplant,* p. 33.

39. See http://www.daviddarling.info/encyclopedia/V/vonBraun.html (2009), accessed 4 April 2010.

40. See http://history.msfc.nasa.gov/vonbraun/bio.html (2009), accessed 4 April 2010.

41. Smith, p. 39.

42. See http://www.buffalomedicine.com/index.php?id=491 (2009), accessed 4 April 2010.

43. Schneider and Wright, p. 4.

44. George Marcus in Schneider and Wright, p. 95.

45. John Corbett, 'Experimental Oriental: New Music and Other Others', *Western Music and its Others: Difference, Representation and Appropriation in Music,* G Born and D Hesmondhalgh (eds) (Berkeley: University of California Press, 2000), p. 166.

46. John McAllister, personal email, 2006.

47. Jimmie Durham in Lucy Lippard, 'Jimmie Durham: Postmodernist "Savage,"' *Art in America* 81(2) (February 1993), p. 65.

48. Smith, p. 39.

49. See http://lists.econ.utah.edu/pipermail/margins-to-centre/2006-March/000794. html, accessed 4 April 2010.

50. Daniel Nettle and Suzanne Romaine, *Vanishing Voices: The Extinction of the World's Languages* (New York: Oxford University Press, 2000), p. 38.

51. The language is being taught to a limited extent in some native schools but it is not being used in the home, so few, if any, children will develop full competency in the language.

52. Jonty Harrison, liner note for *Évidence matérielle,* http://www.electrocd.com/ en/cat/imed_0052/notices/ (2009).

53. Toop, 'A Foreword to John Wynne's *Hearing Voices.'*

54. Toop, 'Depths and Clamour; Inside and Outside', p. 32.

55. Michaela Wolf, 'Translation as a Process of Power:Aspects of Cultural Anthropology in Translation', *Translation in Intercultural Communication,* M. Snell-Hornby, Z. Jettmarová and K. Kaindl (eds) (Amsterdam: John Benjamins, 1995), p. 123.

56. Sarat Maharaj, in Sanjay Sharma, 'The Sounds of Alterity', in Michael Bull and Les Back (eds) *The Auditory Culture Reader* (Oxford: Berg, 2003), p. 414.

57. Stuart Hall, in Sanjay Sharma, 'The Sounds of Alterity', in Michael Bull and Les Back (eds) *The Auditory Culture Reader* (Oxford, Berg, 2003), p. 414.

58. Bobbi Sykes in Smith, p. 24.

59. James Clifford, 'An Ethnographer in the Field: James Clifford Interview', in Coles, p. 62.

60. Mary Bosanquet, *Canada Ride:Across Canada on Horseback* (London: Hodder & Stoughton, 1944), p. 186.

61. Mirjam Hirch, 'Subversive Humour: Canadian Native Playwrights' Winning Weapon of Resistance', in Hayden Taylor (ed.), *Me Funny* (Vancouver: Douglas & McIntyre, 2005), p. 112.

62. Ian Ferguson, 'How To Be as Funny as an Indian', *Me Funny,* p. 132.

63. *Border Zones: New Art Across Cultures,* curated by Karen Duffek, at the UBC Museum of Anthropology in 2010. *Anspayaxw* installation also at the 'Ksan Gallery in Gitxsan territory, 2011.

64. Karen Froman, 'Buffalow Tales and Academic Trails', *Me Funny,* p. 140.

65. Nichols, p. 225.

66. Museum of Anthropology internal document.

67. Peter Morin, *My Life as a Museum and Why I Am Not Afraid of Rebecca Belmore or Bruce Lee*, unpublished.

68. Smith p. 24.

69. Sterne p. 392 (the term originated with Frederic Jameson).

70. Lippard, p. 75.

71. Steven Feld, 'From Schizophonia to Schismogenesis: On the Discourses and Commodification Practices of "World Music" and "World Beat"', in S. Feld and C. Keil (eds) *Music Grooves: Essays and Dialogues* (Chicago: University of Chicago Press, 1994), p. 258.

Chapter 5 In the Thick of It: Notes on Observation and Context

1. Ralph Rugoff in the catalogue *Cameron Jamie* (Ostfilden, Germany: Hatje Cantz Verlag, 2006).

2. Ibid.

3. Alex Farquharson in *Frieze 83* (May) (2004), pp. 79–80.

4. This is the subject of much debate within anthropology – see David MacDougall, *Transcultural Cinema* (Princeton: Princeton University Press, 1998).

5. For an overview of some of the issues involved see Roy Dilley, 'The Problem of Context in Social and Cultural Anthropology', in *Language and Communication* 22(4) (October 2002), pp. 437-56.

6. See for example Paul Stoller, *Sensuous Scholarship* (Philadelphia, PA: University of Pennsylvania Press, 1997) and the amazing body of work produced either by David Howes, or under his initiation, such as *Empire of the Senses: the Sensual Culture Reader* (Oxford: Berg 2005).

Chapter 7 Affinities: Fieldwork in Anthropology Today and the Ethnographic in Artwork

1. James Clifford and George E. Marcus (eds), *Writing Culture: The Poetics and Politics of Ethnography* (Berkeley: University of California Press, 1986). James Clifford, *The Predicament Culture* (Cambridge: Harvard University Press, 1988).

2. James Faubion and George E. Marcus (eds), *Fieldwork Is Not What It Used To Be: Learning Anthropology's Method In a Time of Transition* (Ithaca: Cornell University Press, 2009).

3. Raymond Williams, *Politics and Letters: Interviews with New Left Review* (London, Verso, 1981).

4. Hal Foster, 'The Artist as Ethnographer?' in George E. Marcus and Fred Myers, *The Traffic in Culture* (Berkeley: University of California Press, 1995), pp. 300-15.

5. Foster, 'The Artist as Ethnographer?', p. 306.

6. For instance see, Grant H. Kester, *Conversation Pieces: Community and Communication in Modern Art* (Berkeley: University of California Press, 2004); Miwon Kwon, *One Place After Another: Site-Specific Art and Locational Identity* (Cambridge: MIT Press, 2004); Nick Kaye, Site-Specific Art: Performance, Place and Documentation (London: Routledge, 2000) and Erika Suderburg (ed.), *Space Site Intervention: Situating Installation Art* (Minneapolis: University of Minnesota Press, 2000). In another essay I take up the ethnographic qualities in the interesting 'Capital' project of Neil Cummings and Marysia Lewandowska presented at the 2003 Tate Modern conference. See George E. Marcus, 'Contemporary Fieldwork Aesthetics in Art and Anthropology: Experiments in Collaboration and Intervention', in Neni Panourgia and George E. Marcus (eds), *Ethnographica Moralia* (New York: Fordham University Press, 2008), pp. 29-44.

7. My own personal experience and sense of this value of theatre practice for a realist ethnography in question began with Raymond Williams comments in a 1981 book of interviews, Williams 1981, on the potential of the techniques of Brechtian theatre for rescuing the realist tradition of leftist social science and historical writing. He outlined what for me would be a project of critical ethnography based on probing scenarios of possibilities in sites of fieldwork - the replacement of an indicative by a subjunctive function for ethnographic fieldwork but still within

the realist tradition. In subsequent years, through the Writing Culture critique and after, I sustained an interest in, and an eye for, the paraethnographic dimensions of the investigations, workshops, and processes of designing the look of film and theatre productions as well as the research that went into performance styles. For instance, I was particularly interested in the construction of Gillo Pontecorvo's *Battle of Algiers*, and the pre-production work of the American independent filmmaker John Sayles for a number of his films. At the same time, for the theatre, I began to pay attention to the history of collaborations between theatre artists and anthropologists, the latter most often in the role of dramaturgs. There were the well known instances of Colin Turnbull and the dramatization of his Ik book, and the collaborations of Victor Turner with Richard Schechner toward the end of the former's life and career. More recently, I gained rich material on how theatrical productions incorporate ethnographic investigations by following Dorine Kondo's entrance into the world of Asian-American theatre and especially her work in the 1990s as a one of a group of dramaturgs for the creation and production of Anna Deveare Smith's play, *Twilight: Los Angeles* (1992), for which Kondo produced a dialogic account included in one of the volumes of my Late Editions series of annuals documenting the 1990s as *fin-de-siècle*: Dorinne Kondo, 'Shades of Twilight: Anna Deveare Smith and *Twilight: Los Angeles*', in George E. Marcus (ed.), *Connected: Engagements with Media,* Vol. 3, 'Late Editions: Cultural Studies for the End of the Century' (Chicago: University of Chicago Press, 1996), pp. 313–46.

8. See especially Arnd Schneider's 'Setting Up Roots: On the Set of a Cinema Movie in a Mapuche Reservation' in Arnd Schneider, *Appropriation as Practice: Art and Identity in Argentina* (London: Palgrave Macmillan, 2006).

9. George E. Marcus, *Ethnography Through Thick and Thin* (Princeton: Princeton University Press, 1998), Paul Rabinow and George E. Marcus with James Faubion and Tobias Rees, *Designs for an Anthropology of the Contemporary* (Durham: Duke University Press, 2008), and Faubion and Marcus, *Fieldwork Is Not What It Used To Be*.

10. Again see Schneider's revealing chapter, 'Setting Up Roots', in Schneider, *Appropriation As Practice*.

11. See Fernando Calzadilla and George E. Marcus, 'Artists in the Field: Between Art and Anthropology', in Arnd Schneider and Christopher Wright (eds), *Contemporary Art and Anthropology* (Oxford: Berg, 2006).

12. Bronislaw Malinowski, *Argonauts of the Western Pacific* (New York: Dutton, 1928), p. 32

13. George E. Marcus, 'The Uses of Complicity in the Changing Mise-en-Scene of Anthropological Fieldwork', in Marcus, *Ethnography Through Thick and Thin*.

14. See George E. Marcus (ed.), *Paranoia Within Reason: A Casebook on Conspiracy as Explanation,* Vol. 6 'Late Editions: Cultural Studies For the End of the Century' (Chicago: University of Chicago Press, 1999).

15. This account was produced by email exchanges between Fernando Calzadilla and me and from his brief unpublished notes on this production. All quotations of Calzadilla are from these exchanges and his notes.

Chapter 8 Show and Tell: Weaving a Basket of Knowledge

1. Marilyn Strathern, 'Artefacts of History: Events and the Interpretation of Images', in J. Siikala (ed.), *Culture and History in the Pacific* (Helsinki: Finnish Anthropological Society Transactions No. 27, 1990), p. 40.
2. Tim Ingold, *The Perception of the Environment: Essays in Livelihood, Dwelling and Skill* (London: Routledge, 2000), p. 340.
3. Amiria Henare, Martin Holbraad and Sari Wastell, 'Introduction: Thinking Through Things', in A. Henare, M. Holbraad and S. Wastell *Thinking Through Things: Theorising Artefacts Ethnographically* (Oxford: Routledge, 2007).
4. Rosanna Raymond, 'Getting Specific: Fashion Activism in Auckland during the 1990s: A Visual Essay', in C. Colchester (ed.), *Clothing the Pacific* (Oxford: Berg, 2003).
5. Strathern, 'Artefacts of History', p. 37.
6. Ibid., p. 38.
7. Amiria Henare, 'Artefacts in Theory: Anthropology and Material Culture', *Cambridge Anthropology*, (March/April 2003), pp. 54-66.
8. Amiria Henare, *Museums, Anthropology and Imperial Exchange* (Cambridge: Cambridge University Press, 2005).
9. Amiria Henare, '*Nga Aho Tipuna* (Ancestral Threads): Maori Cloaks from New Zealand', in D. Miller and S. Kuechler (eds), *Clothing as Material Culture* (Oxford: Berg, 2005).
10. Rosanna Raymond and Amiria Salmond, 'Introduction', in *Pasifika Styles: Artists Inside the Museum* (Cambridge and Dunedin: MAA and Otago University Press, 2008).

Chapter 9 Tracing Histories

1. Elizabeth Edwards, 'Travels in a New World: Work around a Diasporic Theme by Mohini Chandra', in Arnd Schneider and Christopher Wright (eds), *Contemporary Art and Anthropology* (Oxford: Berg, 2006), pp. 147-56

Chapter 10 Collaborative Migrations: Contemporary Art in/as Anthropology

1. 'Three modes of experimentation with art and ethnography', *Journal of the Royal Anthropological Institute* (N.S.), 14 (1) (2008) pp. 171-94, p. 172.
2. Ibid.
3. Ibid.

4. Ibid.

5. See A. Schneider, 'The art diviners', *Anthropology Today*, 9 (1993), pp. 2, 3-9; Schneider, A. (2006) 'Appropriations', in A. Schneider and C. Wright (eds), *Contemporary Art and Anthropology*, Oxford and New York: Berg. Schneider, A. and Wright, C., 'The Challenge of Practice', in A. Schneider and C. Wright (eds), *Contemporary Art and Anthropology*.

6. Virginia Ryan and Steven Feld, *Exposures: A White Woman in West Africa* (Santa Fe: VoxLox, 2007) and Virginia Ryan and Steven Feld *The Castaways Project* (catalogue/CD/DVD) (Santa Fe: VoxLox, 2007). Nii Noi Nortey, Nii Otoo Annan, Steven Feld, Alex Coke, Jefferson Voorhees, *Topographies of the Dark* (CD, with art booklet of sculptural paintings by Virginia Ryan) (Santa Fe: VoxLox, 2008).

7. Steven Feld, *Sound and Sentiment* (Philadelphia, PA: University of Pennsylvania Press, 1982/1990). Steven Feld, *Voices of the Rainforest* (CD. Boston: Rykodisc, 1991).

8. Steven Feld (with Charles Keil) *Music Grooves: Essays and Dialogues* (Chicago: University of Chicago Press, 2007). Steven Feld, *Por Por: Honk Horn Music of Ghana* (CD/book) (Washington: Smithsonian Folkways Recordings, 2007). Steven Feld, Jazz Cosmopolitanism in Accra (3 DVD/book) (Santa Fe: VoxLox, 2009).

9. Virginia Ryan, 'In Transitu', in *Intamoenia Extrart: Castelli di Puglia* (Barletta: Editrice Rotas, 2008), pp. 157-71. Virginia Ryan, *Terremotus Femminile* (Naples: Largo Barrache/Associazione Sabu, 2008).

10. Jay Ruby (ed.), *A Crack in the Mirror: Reflexive Perspectives in Anthropology* (Philadelphia: University of Pennsylvania Press, 1982). Sjoerd Jaarsma and Marta Rohatynskyj (eds), *Ethnographic Artifacts: Challenges to a Reflexive Anthropology* (Honolulu: University of Hawaii Press, 2000).

11. J. Rouch, *Ciné-Ethnography*, edited and translated by Steven Feld (Minneapolis: University of Minnesota Press, 2003) and Feld, S. 'Editor's Introduction', in Rouch, J. *Ciné-Ethnography*.

12. Virginia Ryan and Steven Feld, *Exposures*.

13. Steven Feld and Virginia Ryan, 'Guardare attraverso la transparenza', *Voci* 3(1): 63-78 (text) and 79-87 (photographs).

14. E. Said, *Orientalism* (New York: Vintage Books, 1979).

15. P. Gilroy, *The Black Atlantic: Modernity and Double Consciousness* (Cambridge, MA: Harvard University Press, 1993).

16. Accra Trane Station (Nii Noi Nortey, Nii Otoo Annan, Steven Feld), *Meditations for John Coltrane* (CD, Santa Fe: VoxLox, 2006) and *Another Blue Train* (CD, Santa Fe: VoxLox, 2007).

17. Virginia Ryan, *Landing in Accra* (Verona: Parise, 2007).

18. Virginia Ryan, *Multiple Entries: Africa e Oltre 2001-2008* (Spoleto: Galleria Civica d'Arte Moderna, 2008). Virginia Ryan and Steven Feld *The Castaways Project* (catalogue/CD/DVD) (Santa Fe: VoxLox, 2007).

19. M. L. Pratt, *Imperial Eyes: Travel Writing and Transculturation* (New York: Routledge, 1993).

20. J. Clifford, *Routes: Travel and Translation in the Late Twentieth Century* (Cambridge: Harvard University Press, 1997).

21. G. Bachelard, *The Poetics of Reverie* (Boston: Beacon, 1971).

22. M. Taussig, 'The Beach (A Fantasy)', *Critical Inquiry* 26(2) (2000), 248–78.

23. W. Benjamin, 'Theses on the Philosophy of History', in W. Benjamin, *Illuminations* (New York: Schocken, 1969), pp. 253–64.

24. Virginia Ryan, *Cento Passi* (Foligno: Edizioni Orfini Numeister, 2000).

25. G. Packer, 'The Megacity: Decoding the Chaos of Lagos', *The New Yorker,* 13 November 2006.

26. Nortey, N.N. et al., *Topographies of the Dark.*

27. Virginia Ryan, *Multiple Entries.*

28. H. Becker, *Art Worlds* (Berkeley: University of California Press, 2008).

29. The conversations between Virginia Ryan and Steven Feld were recorded in Santa Fe, New Mexico, 7 March 2009.

Chapter 11 Making Art Ethnography: Painting, War and Ethnographic Practice

1. This was a concern of at least one member of the audience at the 'Fieldworks' conference (at Tate Modern, 2003) who seemed to assume that my painting practice was the result of an elite upbringing. It is worth noting that we don't ask each other about our ability to write, even though the written word is an equally problematic medium to master, and this process takes place in institutions that are certainly at least as 'elite' as those where one learns to draw and paint. One need not get a PhD or learn to read to become a painter.

2. It is worth noting that easel painting is now widely practised in Morocco. Several artists from Morocco have achieved international recognition. I cannot go into the extensive literature on art and colonialism or anthropological studies of the art market here.

3. Given the current concerns about the contours of the 'field' and our continued dependence on visualization of this space despite calls for us to be attentive to the other senses (why not a site determined by scents after all?) more collaborative work between anthropologists and cartographers, painters, sculptors and architects is in order.

4. *Fil* means elephant in Arabic and thread in French.

5. Susan Ossman, *Picturing Casablanca, Portraits of Power in a Modern City* (Berkeley, CA: University of California Press, 1994).

6. For a more detailed explanation of this see Susan Ossman, *Three Faces of Beauty, Casablanca, Paris, Cairo,* (Durham: Duke University Press, 2002).

7. I would like to thank Pensri Ho for her commentary on issues of centre and margins in this piece.

Chapter 12 Cultural Knowledge on Display: Chinese and Haudenosaunee Fieldnotes

1. The Haudenosaunee include the tribal nations of the Mohawk, Oneida, Onondaga, Cayuga, Seneca and Tuscarora.
2. These exhibitions were curated for the Roland Gibson Art Gallery at the State University of New York – Potsdam.
3. Most recently, my inquiries into display practices for art from China resulted in a conference that brought together anthropologists, art historians, and contemporary artists to examine the history and contemporary display of Chinese art, both within China and abroad. 'China on Display' was co-organized with Francesca dal Lago at Leiden University, 6–8 December 2007, http://www.iias.nl/china-on-display.
4. Quoted in Katsitsionni Fox, 'What Are We Leaving for the Seventh Generation?' in Katsitsionni Fox and Morgan Perkins (eds), *What are We Leaving for the Seventh Generation? Seven Haudenosaunee Voices* (Roland Gibson Art Gallery, SUNY Potsdam, 2002), p. 4.
5. The exhibition travelled to the Iroquois Indian Museum, Howes Cave, NY and the Akwesasne Museum, Hogansburg, NY. The installation of the exhibition at the Akwesasne Museum included only those artists who were from Akwesasne and another Akwesasne resident, Shelby Loran, who curated an installation called *Histories of Akwesasne* for a student exhibition that I supervised titled, *Learning from Akwesasne: Aspects of Mohawk Culture* (Weaver Museum of Anthropology, SUNY Potsdam, 2002).
6. Katsitsionni Fox, 2002, p. 4.
7. This interaction was facilitated by the close relationship that the university has with the nearby Akwesasne Mohawk community – the Mohawk language is taught and the flag of the Haudenosaunee Confederacy flies on campus along with the American flag.
8. Sue Ellen Herne, 'Mohawk Samsonite: Artist Statement' in Katsitsionni Fox and Morgan Perkins (eds), *What are We Leaving for the Seventh Generation? Seven Haudenosaunee Voices*, Roland Gibson Art Gallery, SUNY Potsdam, 2002, p. 12.
9. Shelley Niro, 'Weapons for the Seventh Generation: Artist Statement' in Katsitsionni Fox and Morgan Perkins, (eds), *What are We Leaving for the Seventh Generation? Seven Haudenosaunee Voices* (Roland Gibson Art Gallery, SUNY Potsdam, 2002), p. 18.
10. Morgan Perkins, *Reviewing Traditions: An Anthropological Examination of Contemporary Chinese Art Worlds* (doctoral dissertation, University of Oxford, 2001).
11. For additional images and background information, see the artist's website: www.momao.com. For discussions of Zhang Hongtu's life, see Jerome Silbergeld, 'Zhang Hongtu: The Art of Straddling Boundaries' in *Zhang Hongtu: The Art of Straddling Boundaries* (Lin & Keng Gallery, Taipei, Taiwan, 2007), pp. IX–XXV; Zhang Hongtu and Jonathan Hay, 'Zhang Hongtu/Hongtu Zhang: An Interview' in John Hay (ed.), *Boundaries in China* (London: Reaktion Books, 1994).

12. With his first *Quaker Oats Mao* (1987) – also displayed in our exhibition – it is generally believed that he began of the Political Pop movement that has proved so popular and profitable in the Chinese contemporary art market. See Silbergeld (2007, p. xvii); Wu Hung, 'Nothing Beyond the Gate' in *Transience: Chinese Experimental Art at the End of the Twentieth Century* (Chicago: David and Alfred Smart Museum of Art, University of Chicago, 1999), p. 45.

13. Mao Tse-tung, *Mao Tse-tung on Literature and Art* (Peking: Foreign Language Press, 1967).

14. Quoted in Perkins, Morgan, 'The Supple Vision of Zhang Hongtu' in Morgan Perkins (ed), *Icons and Innovations: The Cross-Cultural Art of Zhang Hongtu*, Roland Gibson Art Gallery, SUNY Potsdam, 2003, p. 4.

15. Seals and inscriptions have often been placed directly on paintings but they are also frequently placed on the surrounding space that is available when paintings are mounted onto scrolls.

16. In Chinese painting, the term 'literati' refers to both a style and an elite social system. While changes in Chinese society during the twentieth century have fundamentally altered the social system that produced literati painting, the style is still practised extensively within transformed social contexts. For one of the most anthropologically relevant studies of this system as it relates to the work and social world of a particular painter, see Clunas, Craig. *Elegant Debts: The Social Art of Wen Zhengming* (Honolulu: University of Hawaii Press, 2004).

17. Conversation, 4 June 2004.

18. His parody acquired an additional layer in a subsequent stage of the catalogue project. For an exhibition in 2003 entitled, *Shuffling the Deck*, he was commissioned by the Princeton University Art Museum to create actual objects in collaboration with artisans in China based upon the original digital images. These were then displayed among the types of Chinese objects – ceramics, paintings and so on – which were their inspiration.

19. For approaches that draw the anthropology of art beyond frameworks of Western or non-Western, allowing it to embrace contemporary art more fully, see Coote, Jeremy and Anthony Shelton (eds), *Anthropology, Art and Aesthetics* (Oxford: Clarendon Press, 1992); Gell, Alfred, *Art and Agency: An Anthropological Theory* (Oxford: Clarendon Press, 1998); Goerge Marcus and Fred Myers (eds), *The Traffic in Culture: Refiguring Art and Anthropology* (Berkeley: University of California Press, 1995); Morphy, Howard and Morgan Perkins, 'The Anthropology of Art: A Reflection on its History and Contemporary Practice' in Howard Morphy and Morgan Perkins (eds), *The Anthropology of Art* (Oxford: Blackwell Publishers, 2005); Arnd Schneider and Christopher Wright (eds), *Contemporary Art and Anthropology* (Oxford: Berg, 2006).

20. With regard to the common anthropological question concerning the existence of comparative terms for these concepts, it is interesting to note that in China terms for 'art' and 'artist' now exist in a wide range of variation to express the complexity of particular aesthetic thoughts and practices. For example, *meishu* and *yishu* refer to the fine arts and to the arts in general (including performance) respectively. By contrast, the artists from different Haudenosaunee communities

have adopted the English terms for convenience – there being no comparable indigenous terms – in order to interact with art worlds cross-culturally. For a discussion of the latter case, see Morgan Perkins, '"Do We Still Have No Word for Art?" A Contemporary Mohawk Question', in Eric Venrux, P. Rosi and Robert. L. Welsch (eds)., *Exploring World Art* (Long Grove, Il: Waveland Press, 2005).

21. Ivan Karp and Corinne Kratz (eds), *Museum Frictions: Public Cultures/Global Transformations* (Durham: Duke University Press, 2006).

22. While the situation is improving, tensions between the Native American communities and anthropology have often been played out in the context of museums with anthropology collections – particularly in relation to repatriation debates. While art museums and galleries have played a role in the somewhat indiscriminate transformation of different cultural objects into 'art', many artists I have worked with have expressed a disinclination to have their work shown in an anthropology museum. The former validates the artistic quality of the work, while the latter has excessive colonial connotations for many. For a relevant discussion of this topic in relation to art history, see McMaster, Gerald, 'Towards an Aboriginal Art History,' in W. Jackson Rushing (ed), *Native American Art in the Twentieth Century* (London: Routledge, 1999), pp. 81-96.

23. Much has been written about the transformation of objects used for functional purposes into 'art' and the relative authenticity of contemporary objects created in older forms when produced to satisfy the desires of the art market, see for example Craig Clunas, 'Oriental Antiquities/Far Eastern' in Tani Barlow (ed), *Formations of Colonial Modernity in East Asia* (Durham: Duke University Press, 1997); Ruth Phillips, *Trading Identities: The Souvenir in Native North American Art from the Northeast, 1700-1900* (Seattle: University of Washington Press, 1998); Morgan Perkins, 'Continuity and Creativity in Iroquois Beadwork', *American Anthropologist* 106(3) (2004): 595-599; Sally Price, *Primitive Art in Civilized Places* (Chicago: University of Chicago Press, 1989). One of the most incisive efforts to document how one class of objects can be displayed in multiple contexts, highlighting their numerous qualities is Susan Vogel's essay on the *Art/Artifact* exhibition in 1988 that she curated at the Center for African Art: Vogel, Susan, 'Always True to the Object, in Our Fashion', in Ivan Karp and Steven Levine (eds), *Exhibiting Cultures: The Poetics and Politics of Museum Displays* (Washington: Smithsonian, 1991). Alfred Gell's critique of this exhibition brought the art/artifact debate in anthropology firmly into the realm of contemporary art: Alfred Gell, 'Vogel's Net: Traps as Artworks and Artworks as Traps', *Journal of Material Culture* 1(1) (1996) 15-38.

24. George Marcus has suggested that Western artists interested in understanding the power structures of the art world within which they circulate should look to those outside of those structures whose cultures have often been the subject of artistic and anthropological interest: Marcus, George, 'The Power of Contemporary Work in an American Art Tradition to Illuminate its own Power Relations' in Marcus and Myers, 1995.

25. In an international art world where the artistic cutting edge is increasingly concerned with the representation of difference, Hal Foster has questioned the

ethnographic role of contemporary artists who often position themselves as outsiders in their own culture through their association with other cultures: Hal Foster, 'The Artist as Ethnographer?' in Marcus and Myers, 1995. Arnd Schneider and Christopher Wright have explored the relationship between art and anthropology on more complex levels to identify the common histories and methodologies that are the source of affinities and tensions and that ultimately provide the potential for greater collaborations: Arnd Schneider, 'Uneasy Relationships: Contemporary Artists and Anthropology', *Journal of Material Culture* 1(2) (1996) 183–210; Arnd Schneider and Christopher Wright (eds), *Contemporary Art and Anthropology* (Oxford: Berg, 2006).

26. For a recent anthropological study of art education, see Morgan Perkins, '"Do We Still Have No Word for Art?" A Contemporary Mohawk Question' in Venbrux, Rosi and Welsch (eds), *Exploring World Art*.

27. James Houston's influence on Inuit art and Geoffrey Bardon's impact on the development of Aboriginal Australian acrylic painting are two of the most profound cases of artists' influence across cultures: Geoffrey Bardon, *Aboriginal Art of the Western Desert* (Sidney: Rigby, 1979); James Houston, 'In Search of Contemporary Eskimo Art', *Canadian Art* 9(5) (1952), pp. 99–103.

28. While Zhang Hongtu left China before the Chinese avant-garde movement had developed, his work has been highly influential on the artists who remained in China. Much of that movement grew out of the unique environment in the art academies that fostered a split between official and unofficial art worlds. For details on the development of the avant-garde and its relationship to Chinese art academies, see Julia Andrews and Gao Minglu, 'The Avant-garde's Challenge to Official Art' in Deborah Davis, R. Kraus, B. Naughton and E.J. Perry (eds), *Urban Spaces: Autonomy and Community in Contemporary China* (Cambridge: Cambridge University Press, 1995); Martina Koeppel-Yang, Lothar Ledderose and Norman Bryson. *Semiotic Warfare: The Chinese Avant-Garde, 1979-1989, A Semiotic Analysis* (Hong Kong: Timezone 8, 2003); Morgan Perkins, *Reviewing Traditions: An Anthropological Examination of Contemporary Chinese Art Worlds* (doctoral dissertation, University of Oxford, 2001).

29. For a history of the Institute, see Joy Gritton and Gregory Cajete (2000) *The Institute of American Indian Arts: Modernism and US Indian Policy* (Santa Fe: University of New Mexico Press).

30. For example, Zhang Hongtu's painting *Guo Xi – Van Gogh* (1998) that appears on the left in the background of Figure 12.3, sold at Christie's for $61,561s in 2004. Works by some Chinese artists are now exceeding a million dollars at auction.

Chapter 13 Making Do: The Materials of Art and Anthropology

1. Arnd Schneider and Chris Wright (eds), 'Introduction', *Contemporary Art and Anthropology* (Oxford and New York: Berg, 2006), pp. 1–27.

2. J. Clifford. 'An Ethnographer in the Field', in A. Coles (ed.), *Site-Specificity: The Ethnographic Turn, De-, Dis-, Ex-* (London: Blackdog Publications, 2000), p. 56.

3. For example, A. Grimshaw, *Servants of the Buddha* (London: Open Letters Press, 1992); E. Owen, 'Give Me A Call', in A. Grimshaw and A. Ravetz (eds), *Visualizing Anthropology: Experiments in Image-Based Practice* (Bristol: Intellect Books, 2005), pp. 81-9; A. Grimshaw and E. Owen, *Material Woman* (22 mins digital video, 2005), www.elspethowen.net; A. Ravetz and S. Watts, *Clearings,* Installation at Grinton Institute, Swaledale, 2004.

4. Threeing has been developed by the artist Paul Ryan. See Paul Ryan, *The Three Person Solution,* West Lafayette, IN: Purdue University Press, 2009; and www.earthscore.org.

5. See, for example, P. Loizos, 'First Exits from Observational Realism: Narrative Experiments in Recent Ethnographic Film', in M. Banks and H. Morphy (eds), *Rethinking Visual Anthropology*, New Haven: Yale University Press, 1997), pp .81-104 and A. Schneider, 'Three Modes of Experimentation with Art and Anthropology', *Journal of the Royal Anthropological Institute* (N.S.) 14 (2008), pp. 171-94.

6. If Margaret Mead personifies the former, Robert Gardner is identified with the latter.

7. L. Taylor, 'Iconophobia: How Anthropology Lost It At The Movies', *Transition* 69 (1996), pp. 64-88.

8. F. Ginsburg, F. 'Institutionalizing the Unruly: Charting a Future for Visual Anthropology' *Ethnos* 63(2), (1998), pp. 173-96; see also M. Banks and H. Morphy (eds) *Rethinking Visual Anthropology* (New Haven and London: Yale University Press, 1997).

9. M. Strathern (ed.), *Audit Cultures: Anthropological Studies in Accountability Ethics and the Academy* (London: Routledge, 2000).

10. Anna Grimshaw is especially indebted to her Emory colleague, Angelika Bammer, for discussion of this concept and its important differential meaning.

11. As Elspeth Owen explained it: 'I think I often took Anna for an artist (i.e. ordinary person) and ignored the boundaries between our practice until she challenged them - thus fitting her into the irresponsible artist category.' Examples of Owen's work, including *Give Me A Call* and *Material Woman,* may be viewed at www.elspethowen.net.

12. Harrod, T. in Owen, E., *Coming Round Again* (Cambridge: imagined corners, 1998).

13. Owen, E, *Coming Round Again.*

14. Tim Ingold describes a similar exercise that he carried out with students at Aberdeen University several years later - see: Tim Ingold with R. Lucas, 'The 4 As (Anthropology, Archaeology, Art and Architecture): Reflections on a Teaching and Learning Experience', in M. Harris (ed.) *Ways of Knowing: New Approaches in the Anthropology of Experience and Learning* (Oxford: Berghahn, 2007), pp. 287-305.

15. A. Schneider and Chris Wright (eds), 'Introduction', *Contemporary Art and Anthropology* (Oxford and New York: Berg, 2006), p. 13.

16. Trinh T. Minh-Ha *Framer Framed* (New York and London: Routledge, 1992), p. 96.

17. M. Taussig, *Mimesis and Alterity: A Particular History of the Senses* (New York: Routledge, 1994), p. 21.

18. As Taussig (ibid., p. 26) explains it: 'the concept of *knowing something* becomes replaced by a *relating to*', original emphases. For a fuller account of mimesis and the techniques of observational cinema, see A. Grimshaw and A. Ravetz, 'Rethinking Observational Cinema', *Journal of the Royal Anthropological Institute (N.S.)* 15 (2009), pp. 538-56.

19. D. MacDougall, *The Corporeal Image: Film, Ethnography and the Senses* (Princeton: Princeton University Press, 2006), p. 2.

20. Participants were: Liesbeth Bik, Bryony Bond, Mary Bouquet, Anna Grimshaw, Rosalind Nashashibi, Daniel Peltz, Amanda Ravetz, Paul Rooney, Erika Tan, Lucien Castaing-Taylor, Jos van der Pol, Soumhya Venkatesan, Chris Wright, Lesley Young. The *Connecting Art and Anthropology Workshop* ran for three days in January 2007 and was funded by the Arts and Humanities Research Council. All quotations are taken from transcripts of the event available at the website: www.miriad.mmu.ac.uk/caa (accessed September 2009).

21. A. Ravetz, '"A Weight of Meaninglessness About Which There is Nothing Insignificant:" Abjection and Knowing in an Art School and on a Housing Estate.' In Mark Harris (ed.), *Ways of Knowing? New Anthropological Approaches to Method, Learning and Knowledge* (Oxford: Berghahn, 2007), pp. 266-86.

22 A. Grimshaw and A. Ravetz, 'Rethinking Observational Cinema', *Journal of the Royal Anthropological Institute (N.S.)* 15 (2009), pp. 538-56. A. Grimshaw and A. Ravetz, *Observational Cinema: Anthropology, Film, and the Exploration of Social Life* (Bloomington: Indiana University Press, 2009).

23. We report on the activities of these two groups because of the contrasting responses they elicited.

24. 'Coming out of our group meetings [I feel] like I'm merging with the patience of the anthropologists ... and thinking of it as this really beautiful long durational piece of art' (Peltz, see: www.miriad.mmu.ac.uk/caa accessed September 2009).

25. Group 1 comprised Bryony Bond, Mary Bouquet, David Chapman, Jos van der Pol and Lucien Castaing-Taylor.

26. Group 2 comprised Anna Grimshaw, Rosalind Nashashibi, Daniel Peltz, Soumhya Venkatesan and Lesley Young.

27. P. Ryan, *The Three Person Solution.*

28. H. Foster, 'The Artist as Ethnographer', G. Marcus and F. Myers (eds), *The Traffic in Culture: Refiguring Art and Anthropology* (Berkeley: University of California Press, 1995), pp. 302-9.

29. T. Ingold with R. Lucas, 'The 4 As (Anthropology, Archaeology, Art and Architecture): Reflections on a Teaching and Learning Experience', in M. Harris (ed.) *Ways of Knowing: New Approaches in the Anthropology of Experience and Learning* (Oxford: Berghahn, 2007), pp. 287-305.

30. A. Schneider and C. Wright (eds), 'Introduction', *Contemporary Art and Anthropology* (Oxford and New York: Berg, 2006), pp. 1-27.

Index